In beauty may I walk
In beauty may I walk
All day long may I walk
Through the returning seasons may I walk
On the trail marked with pollen may I walk
With grasshoppers about my feet may I walk
With dew about my feet may I walk
With beauty may I walk
With beauty behind me may I walk
With beauty above me may I walk
With beauty below me may I walk
With beauty all around me may I walk
In old age wandering on a trail of beauty, lively may I walk
In old age wandering on a trail of beauty, living again may I walk
It is finished in beauty
It is finished in beauty

A NAVAJO INDIAN PRAYER

John Lane

TIMELESS BEAUTY

IN THE ARTS AND
EVERYDAY LIFE

GREEN BOOKS

First published in 2003
by Green Books Ltd
Foxhole, Dartington
Totnes, Devon TQ9 6EB

Distributed in the USA by
Chelsea Green Publishing Company
PO Box 428, White River Junction, VT05001
(800) 639-4099 www.chelseagreen.com

Photographers' and artists' credits for plate section:
Plate I, Bororo Nomad from Sahel Region of Niger: photograph © Victor Englebert;
Plate V, American Indian Ceremonial drum: photograph courtesy of The Field Museum,
No. A112914, photographer Diane Alexander White; Plate VII, The Vision of St Francis,
from Scenes from the Life of St Francis: © The National Gallery, London; Plate X, the Nave
of Le Thoronet: photograph © David Heald, 1995; Plate XI, Didmarton Parish Church, 1961:
photograph © Edwin Smith/RIBA Library Photographs Collection; Plate XII, Chapel of Notre-
Dame-du-Haut, Ronchamp: photograph Paul Maeyaert/Bridgeman Art Library; Plate XIII,
Maiastra by Constantin Brancusi: photograph © Tate, London 2003. © ADAGP, Paris and DACS,
London 2003; Plate XIV, Minotauromachy by Picasso: photograph Fitzwilliam Museum,
Cambridge/Bridgeman Art Library © Succession Picasso/DACS 2003.

Designed by Libanus Press, Marlborough
The typefaces used are Albertina and Requiem

Text printed in Great Britain by MPG Books, Bodmin, Cornwall
on Five Seasons 100% recycled paper

British Library Cataloguing in Publication Data
available on request

ISBN 1 903998 33 6

Contents

For Kathleen Raine

Acknowledgements

I want to thank those friends who read my manuscript: Satish Kumar, who gave detailed comments on a early draft; John Moat, who made broader comments and suggestions; and Glenn Storhaug, who edited the final text. The suggestions made by each of you were essential to the improvement of the book. I am also grateful to Eliseo Lagano, Jeff Hunter and Philip Mann for general discussions about the subject of this book, to John Danvers for his comments on certain chapters and to Chris Coulson, Brian Goodwin, Stephan Harding, Jim Lovelock and Brian Nicholson for advice with Chapter Two. Harland Walshaw, Peter Burton and Adam Lane also gave invaluable assistance.

Finally I owe thanks to my publisher, John Elford, for his great patience and detailed corrections, to Susan Wightman of Libanus Press for her beautiful book design, and to two remarkable women: my wife Truda, who provided emotional and material support throughout the time it took to write this book, and Kathleen Raine, who gave unfailing encouragement and advice all the way through the book's gestation and production. I also owe her a particular debt of gratitude for writing its Foreword.

Foreword

Of Plato's three verities, the Good, the True and the Beautiful, none can be understood in terms of the materialist values of modern Western civilization, and beauty least of all. Truth can be confused with fact, with the measurable and quantifiable aspects of what is currently called 'the real world'. The Good may be seen as actions or events leading to desirable results; but Beauty cannot be quantified or measured in material terms. Perhaps it can be seen as corresponding to the sexually desirable, and as such can sell newspapers, but even in that form remains immeasurable and indefinable. Keats (following and paraphrasing Plotinus) wrote:

> 'Beauty is truth, truth beauty, —that is all
> Ye know on earth, and all ye need to know.' [1]

The heart responds to these words, which describe beauty as in the highest place. The saying that 'Beauty is in the eye of the beholder' is quite inadequate, for all Plato's verities are realities of the mind, of consciousness itself, which is in its nature immeasurable. Keats saw it as the highest value—because its reality can be known only to the soul. We may see it as the divine *imprimatur* or as the divine signature itself. In a world that denies the existence of the soul, and indeed of the divine order, this necessarily involves the rejection of the Beautiful as not true to 'life', which is seen in material terms as 'nasty, brutish and short'.

And yet throughout the world beauty is to be found in the humblest crafts, as in the highest expressions of human aspiration. Water-pots, cooking vessels, the walls of houses, garments, and the human body itself, are adorned with depictions of plants and animals, with fantastic and elaborate inventions of the human imagination. The human instinct is to adorn and beautify whatever is the work of human hands. Only since the industrial revolution, which has replaced the work of hand and eye with the mindless artefacts of machines, has the signature of beauty been absent.

Thus it has come about that beauty is no longer discussed or spoken of in relation to the arts; is no longer considered essential, or even desirable. I think

it was in the 'twenties of the last century that the term 'functional' was intro-
duced as the most desirable quality of our utilities—furniture and buildings,
and whatever we use in daily life. Decoration was banned, rooms and furniture
were painted white, the rectilinear replaced the grace of curves and arches—
flat roofs, plain doors and windows. I remember when my College (Girton)
replaced some elegant tinted glass from the windows of the library with
colourless utilitarian glass; to be reproached by John Betjeman, who looked
on the Modern Movement with disfavour.

There is no evidence that beauty benefits people materially in any way,
and yet it seems that it remains a need after all the conveniences and benefits
of technology—mass-production, washing-machines, fast food and the rest.
People are unhappy in a beautiless world, in ugly cities lit with neon lighting, in
high-rise blocks of flats without trees or gardens or fountains or birds circling
our skies. That beauty is a need cannot be proved, but it is everywhere felt, and
may be one of the causes of the widespread neurotic illness that afflicts modern
urban man. Primitive societies, lacking these benefits, have nevertheless found
happiness—Laurens van der Post describes how the Bushmen of Africa, who
have no property, feel themselves in harmony with their environment, with
earth and sky, and the living creatures around them.

Beauty is of many kinds and at many levels. Nature is not egalitarian, or
what is the significance of evolution? Still less so is the human spirit, or of what
value is aspiration? Beauty is heirarchic. We may speak of a footballer scoring
a 'beautiful' goal, but that is not of the same order or degree as Nijinsky
dancing *Le Spectre de la Rose*. There is beauty in many of the songs of the
Beatles, but again Monteverdi's *Incoronatione di Poppaea* or Schubert's *Winterreise*
belong to a higher level altogether, as does Indian classical music of the oral
tradition. It is to John Lane's credit that he responds to beauty of many levels
and degree, and speaks warmly of Elvis Presley's singing; he goes out of his
way to avoid comparative value judgments. However, one thinks of the
Kabbalistic Tree with its four 'worlds' and ten *sephiroth* as a heirarchic struc-
ture which had its equivalents in all traditional cultures, in the form of
pantheons, heirarchies of angels, and the like. This clearly corresponds to
a universal realization that there are kinds and degrees of value. John Lane
does not endorse Bernard Berenson's view that the head of an angel from
Leonardo's *Virgin of the Rocks* might be described as 'the most beautiful drawing
in the world' and himself prefers to avoid making such comparative value
judgments.

It is John Lane's especial gift to be able to 'read' works of art from different periods and different cultures and kinds, and to be able to communicate the delight he finds in them. He was himself trained as an artist and most of his examples are taken from the visual arts, of which he has a wide knowledge, drawn not only from European but also from Far Eastern, Indian, Islamic and Native American art. His commentaries are of praise and gratitude rather than the negative censorious criticism which has become fashionable in recent years. He has a fine gift of empathy which he communicates to us. Nor does he forget the sacrificial cost to the artist at which great work is produced.

A natural and trained gift of observation can certainly help its possessor to discern beauty; but much also depends on feeling and attention. Blake in a letter to a critical patron wrote:

> I see Everything I paint in This World. And I know that This World is A World of imagination and Vision, but Every body does not see alike. . . . The tree which moves some to tears of joy is in the Eyes of others only a Green thing that stands in the way. Some see Nature all Ridicule and Deformity, & by these I shall not regulate my proportions, & Some Scarce see Nature at all. But in the Eyes of the Man of Imagination, Nature is Imagination itself. As a man is, So he Sees. As the Eye is formed, such are its Powers. You certainly Mistake, when you say that the Visions of Fancy are not to be found in This World. To Me This World is all One continued Vision of Fancy or Imagination.

The beauty of the world is there, but not everyone sees it, and few indeed see it as 'one continued vision' as Blake did. But there are moments of stillness, of quiet attention, when a chickweed plant growing in the crack of the pavement can appear as beautiful as a masterpiece of painting, or a kitchen chair be transformed as it was for Van Gogh. These revelations are unpredictable and for most of us rare. John Lane has a word, unknown to art criticism, for which even Leonardo's angel might not qualify: he speaks of 'heartbreaking' beauty. By this he means the experience of a world beyond the ego, that we feel to be heartbreaking because we have known it once and lost it, it is our true home and our true self which in this unreal 'real world' we find but rarely. It could as well be called 'heart-healing' since for a while we are restored to our true selves, and our true world, beyond the ego which here prevails. It is an epiphany of the eternal. One thinks of the Buddhist sculptures of the sixth century exhibited at Burlington House earlier this year, excavated in 1996 at the Longxing temple

at Qingzhou in Shandong Province in China; or one might also use the phrase of certain Chinese landscape paintings. It seems that this quality belongs to civilizations grounded in the highest attainable spiritual values—Buddhism, or Indian classical music transmitted orally within certain families at the courts of the Moghul emperors. If this 'sacred' dimension is rare in the West it is because we lack such a civilization. It speaks more often from the icons of the Orthodox (Eastern) church than from the more 'incarnational' art of the Catholic West. In contemporary work it is rare indeed, but speaks perhaps from drawings by David Jones of women or of those young soldiers of the First World War as Jones saw them in the trenches he shared with them. David Jones himself was a Catholic convert, an experience that was for him transformative and, as it seems, raised him to the perfection of that level beyond the ego which John Lane calls 'heartbreaking'. By whatever name it is an experience we recognize.

Yeats, a life-long student of the esoteric, writes of the mystery of beauty with deceptive simplicity:

> If I make the lashes dark
> And the eyes more bright
> And the lips more scarlet,
> Or ask if all be right
> From mirror after mirror,
> No vanity's displayed:
> I'm looking for the face I had
> Before the world was made.

I see this courageous book as a sign marking the beginning of the turning of the tide of materialism that has prevailed for the last century. It meets a deep and as yet scarcely recognized need. If beauty is the highest of Plato's verities this is because it is in accordance with our nature: Plato did not invent that need. And did not Dostoevsky in *The Idiot* affirm his belief that the world can be saved only by beauty? We disregard and undervalue the beautiful at our peril and to our cost.

KATHLEEN RAINE

June 2003

Preface

To me the gift of continuous perception is all the heaven I want.
MAX NICHOLSON[1]

The preparation of this book was undertaken with trepidation. From the start I was aware of the hazards inherent in an attempt to consider the complex, controversial and elusive subject of beauty within the context of a culture which shows so little interest in it. Our civilization is a materialistic one, and the realm of beauty belongs to the soul.

So we must face it. As a subject of conversation, beauty is virtually taboo—don't discuss something so subjective, let's talk about something else. Friends shared my trepidation. Their response, if polite, was often noncommittal—'it's only in the eye of the beholder,' they'd exclaim, as if this observation backed up by science was all there was to say about the subject. They knew that with matter defined as the only reality, something as immaterial as beauty was bound to be controversial. Beauty has never been verified by measurements that are not dependent on one's state of mind. So please forget it.

And then they'd parry: 'Anyway, you're mistaken; things aren't getting uglier. What about Concorde and the London Eye, the pottery of Lucie Rie, the architecture of Hassan Fathy and the music of Arvo Pärt? Aren't they as fine as anything created in the past?' Yes, I admit that marvellous things are being created, but rarely of the same stature as in the past, and surely less frequently?

Many disagreements about which particular objects, buildings, kinds of music and works of art are beautiful or ugly are part of a profound and long-standing oppositional debate about aesthetic value and who determines what is considered beautiful. But to an important extent some of these cerebral controversies, fascinating but inconclusive as they always are, become more understandable when experienced from the perspective of soul.

Too often the debate about beauty divides on lines repeated within the two hemispheres of the brain; the left brain governing the logical, analytical portion of the argument and the right, the intuitive and non-verbal. As far back as the ancient Greeks, we in the West have maintained an almost unshakeable

belief in the superiority of the analytical side of the mind whereas, as Thomas Hoover observes, the civilizations of the East in general and Zen in particular have advanced a different view.[2] With a school curriculum stressing the 'useful' subjects—science, maths and English—it seems we are continuing to forget that it is only by transcending ourselves that we can know anything of value.

So if the bias of our culture has marginalized imagination, intuition and beauty, it's understandable why so many are muddled and neglectful of all three. Nonetheless, at the risk of sounding arrogant, I *know* that this featureless office block, this vandalized concrete underpass, this burger joint, this formless industrial estate, this shiny leather settee, are all horrendous; why should I pretend otherwise? I've spent a lifetime looking and loving, educating my perception, and see no reason to apologize for it, even in an egalitarian society such as our own. 'The eye is something we take for granted,' says the photographer Marc Riboud, who believes that vision needs more nurturing than the other four senses. 'Words cannot explain it. Photography is not an intellectual process. It is a visual one.'[3] So the idea that appreciation is a purely subjective experience is a myth; it is guided by discrimination, intelligence and prevailing cultural norms about what is and what is not acceptable.

Although the experience of the beautiful must surely be a function of the mind and heart and not solely located in the sensory organs of the eye and ear, it may be interesting to consider the reactions of another sense such as, for example, smell. Everyone can tell the difference between, say, the perfume of a spray of flowering honeysuckle and the smell of a putrefying body, yet no one seems too bothered about the subjectivity of a stink. Interestingly, our uncomplicated response to smell is replicated by the behaviour of one of the simplest of all creatures. Bacteria that swim are said to move towards 'good' smells but are repelled by 'bad' ones, a choice presumably dictated by their instinct for survival: unpleasant odours signalling the possibilities of bad health and pleasant ones a sense of security.[4] Is it possible that our much vaunted cleverness has largely overridden our instinct for survival?

It is my belief that just as we are ignoring the damage being inflicted upon the Earth, so we are ignoring the inherent psychological dangers of a no less dangerous ignorance: ugliness. Every field smothered by tarmac, every tree uprooted, every species decimated, every high-rise building constructed, can add to the brutalization of the world and, in consequence, our psychic sickness. And the growth of the ugly is not casual or peripheral, somewhere at the edge

of life; it is primary and pivotal, at the very centre of our industrial civilization. The streets we walk in, the offices we work in, the schools in which our children study, the stores in which we shop and the hospitals we are attending—all are tarnished by ugliness. The civilization in which we live has become hostile to the wisdom of vision and the enchantment of beauty. It is one alien to nature. It is an ugly one.

But, worse, this is happening with relatively few even noticing, and even fewer raising their voices in protest. It is this silence that obliged me, whatever the difficulties, to write this book.

But the primary reason why I wanted to write it is simpler: it was my desire to reinstate beauty as a vital aspect of everyday life. Beauty is critical to our future well-being, and a fundamental component of any civilized life. We neglect it at our peril. So if I were asked what I wanted to accomplish with this book, I would say it's to contribute to a necessary vision of sanity and hope.

Introduction

There are three Material things, not only useful but essential to Life. No one knows how to live till he has got them.
They are Pure Air, Water, and Earth.
There are three Immaterial things, not only useful, but essential to Life. No one knows how to live till he has got them.
These are, Admiration, Hope and Love.
Admiration—the power of discerning and taking delight in what is beautiful in visible Form, and lovely in human Character: and, necessarily, striving to produce what is beautiful in form, and to become what is lovely in character.
JOHN RUSKIN[1]

We have come to talk of music and drama and art and architecture as if they were technical words for remote abstractions or exceptional luxuries, but what is civilization for, if it is not to produce poetry, music, beauty and courtesy? These things are nothing in themselves unless they have a use for life. . . .
WILLIAM RICHARD LETHABY[2]

Writing this book has led me towards an astonishing conclusion: that for a timeless period our species was instinctively tuned to the beautiful. In those distant days before the advent of the motor car, the washing machine, the electric toothbrush and the wheel, craftsmen and musicians, masons and poets, painters and dancers, simply did not know how to make an ugly thing; they could not close their hearts to the light of heaven. For them, countless numbers of them, beauty was as necessary as the air they breathed. It had the ubiquity of water for fish. It gave dignity and meaning to drab and impoverished lives and inspired great (and often brutal) civilizations in which people lived creative and useful lives.

That this is no longer the case is a truism. Many of us in the industrialized West have lost this instinct. Look for instance at something as uncomplicated as the position of this window in a cottage wall; the placing, the proportions, the materials out of which it has been made, have an instinctive sensitivity; it is unpretentious, proportionate, dignified and beautiful. And here is another window in an newly built and expensive executive house; the placing is

insensitive, the proportions are insensitive, the materials are insensitive, the design visually unrelated to the adjoining surfaces. Perhaps the difference is too small to matter but, no, rather I see that bit by bit, window by window, room by room, house by house, street by street, the capacity to make sensitive aesthetic judgements has often been lost.

The soul has an instinct, like animals, for where healing herbs or water are to be found; but nowadays, that instinct, that unconscious feeling for the harmonious and beautiful, has, as it were, been 'jammed'. Nowadays things are designed, calculated on paper, conceived at a distance from the site. That the toxin of ugliness has invaded our souls may be denied, but one has only to look and listen to find confirmation of the truth of this assertion. And an obtrusive new service station, a village lit with sodium lights, a forest uprooted, are not mere aesthetic disasters. The wound they inflict is more grievous; they destroy the physical environment in which a culture orders its meanings.

People of the past existed under mental, moral, and physical circumstances so different from our own as to constitute almost a foreign civilization. Nonetheless, amongst much that remains strange, even alien, certain qualities of conduct have been revealed as permanent in human nature. Two such constants are human creativity—the desire and the ability to exercise the creative imagination—and its corollary, the expression and enjoyment of the beautiful in everyday life. Looking at the heritage of our long history, it is obvious that beauty played an important role. In all the forgotten civilizations, beauty mattered—it mattered in the design of a waggon or a rowing boat, the ornamentation of a scabbard, the decoration of a blouse—and the placing of a window. When it was at stake neither time, nor cost, nor labour were sacrificed. And when, as was so often the case, God was involved, cheeseparing was never an option. The Prophet Mohammed declaimed that 'God is beautiful and He loves Beauty,' and Christ urged the emulation of the lilies of the field. But such axioms required no enforcement; in those days beauty was never peripheral, but like food and drink to the body, a necessary ingredient of life.

Today, many living in the industrialized nations have chosen to endorse a different set of priorities. The wish of the majority (not excluding myself) is the acquisition of material comfort, good housing and medical and dental care. Even those who live in the Buddhist and Islamic countries have chosen priorities in which beauty is a low priority. Thus, if there are designers and artists,

gardeners and cooks, engineers and homemakers, teachers and dressmakers, hairdressers and typographers who go out of their way to create aesthetically pleasing effects, the prevailing situation is one in which beauty is ignored— amongst architects it not often discussed. But this is a norm. Within a civilization where objectivity is considered 'scientific', where material acquisition is regarded as the key to human fulfilment and technological development the key to social progress, it is hardly to be expected that beauty will carry much weight. It is bound to be ignored.

No wonder then that the American psychologist James Hillman laments about 'eighty years of depth psychology without a thought to beauty';[3] that the architect Lord Rogers writes that 'The politician's unwillingness to talk about design, architecture and, yes, aesthetics, is so total ... that it goes almost unremarked'; and that John Armstrong, Director of the Aesthetic Programme at the School of Advanced Study in the University of London, observes that, 'It has, for a long time, been somehow improper to like, or love, a work of art for its beauty ... contemporary works of art ... are mostly praised for their capacity to disturb or challenge the viewer, almost never for their beauty'.[4] And to sum it all up, the artist Mark Hutchinson confesses that 'ugliness has become interesting in recent work.' Or that a deconstructive Postmodernist can claim that beauty doesn't even exist, in that one manifestation of human activity is as good as the next.

There are of course millions who have made up their minds that an ugly environment is of minor consequence; many are barely conscious of their surroundings. What matters, they claim, are the things upon which our society already devotes its major resources: healthcare and employment, welfare and wealth creation, education and housing, and the consequences of global climate change. These undoubtedly matter; they are issues of unquestionable importance. Nonetheless, is it really a matter of either/or? Given the levels of private and public wealth in every Western country, one can only wonder at the widespread neglect of aesthetics. For how is it that the nomads of Asia and the Middle East can put so much emphasis on beauty, grace and nobility of spirit, when we, their less impoverished contemporaries, are relatively unperturbed by the visual squalor of our industrial cities, sprawling suburban estates, high-rise apartments, hideous shopping arcades, schools and universities. How is it that we can ignore such visual pollution? How is it that we can tolerate the denial of what in us aspires to nobility and dignity? Why do

we accept that the arts will always be bottom of the list of political priorities? Have we become so anaesthetized that our hearts no longer respond to the sensuous face of the world and must turn everything into monotony, sameness, brutality?

So today, while millions protest about the failing provision of the National Health service, the standards of state education and the damage that our species is doing in every corner of the globe, endangering and destroying hundreds and thousands of other species with whom we share this Earth, few speak out about a no less ubiquitous and spiritually damaging consequence of our industrial way of life: its ugliness. Few can see the latter as a pollutant as corrosive and dangerous as those which are disrupting the critical order of the ecosphere and reducing its capacity to support life. But this isn't the first time that populations have been deceived by a worldview which endangers them. Think of the damage caused by supposedly beneficial synthetic pesticides before Rachel Carson suggested that they did more harm than good and should be phased out. Before *Silent Spring* there was a confederacy of silence about the dangers; after it, the expression of considerable concern.[5]

I suspect a similar kind of reaction—silence, then comprehension followed by an unexpected commitment—will sooner or later greet the subject of our civilization's dispiriting aesthetics—its bleak and hostile cities, wasteful use of resources and lack of concern for quality, permanence and craftsmanship in designed products. But already there are signs of change: a new vision of the value of the beautiful; already the development of movements of ecological responsibility—the first shoots of a new cultural paradigm whose imperatives include the numinous message of wholeness, integration and the feminine principle. Further aspects of this development are discussed in Chapter Six.

Of all the mental phenomena we can experience, it seems that feelings are the least understood in biological and specifically neurobiogical terms. So I am on my own when it comes to any objective proof of the psychological conse-quences of ugliness. There appears to have been little research on this subject. I am also on my own in another sense—the world of beauty I am celebrating is coloured by the filter of my own culture. So I accept that this book is about me as much as its subject.

Nonetheless, it seems worth asking what human beings might be feeling on a soul or psychic level in an ugly, noisy and brutal environment and, conversely,

a peaceful, restorative one? What are the effects of environments which make us feel ill at ease, and those which make us peaceful? Is there any emotional difference between, say, walking around the Alhambra in Granada and the Broadmead Shopping Centre in Bristol? Of course, I imagine that avid shoppers may see the latter as a lively, colourful and enticing place, but I doubt that there have been objective studies of the different reactions to the two environments and their effects on our well-being.

But there is some evidence that environments have measurable effects on health. Studies in hospitals show that in windowless units, twice as many surgical patients developed post-operative delirium as those in units with windows. They also showed more symptoms of depression. According to Roger Ulrich at Pennsylvania Hospital in 1984, patients with views of trees and flowers took 9% less time to convalesce than those with views of a brick wall: 7.9 days as compared to 8.7 days.[6]

At this point it may also be useful to consider the scale and nature of contemporary Western disease—not so much tuberculosis and cholera as the endemic stress-related illnesses: smoking, speed-eating, alcoholism, road-rage, drug addiction, suicide, vandalism and angst, which now characterize Western society.

Violence in this country has rocketed. In 1950, a total of 6,000 crimes of violence against the person were recorded, but in 1997 there were 42 times more—253,000 cases.[7] Given that three-quarters of convicted violent men are suffering from depression, this is further evidence of a rise in depression. In fact, it has been estimated that 330 million people worldwide are suffering from depression, or what one researcher calls 'malignant sadness'. A study by the National Institute of Mental Health has revealed that one in six Americans will suffer a serious depressive episode at some time in their lives, and one in 15 (13 million people) have suffered from severe depression in the past.[8] In Britain, depression is also commonplace. Mild depression has risen from 22% to 31% in nine years from 1977 to 1986, and 5.6 million prescriptions for anti-depressants were issued in 1995. In the same country, some two and a half million people are estimated to be chemically and emotionally dependent on tranquilizers. Figures for the worldwide drugs pandemic are no less alarming.

Perhaps a crisis of this magnitude may have little direct, provable relationship to ugliness, but it has, I believe, an indirect one. A person living in the drab, featureless surroundings of a post-industrial city is surely more likely to suffer from unhappiness, angst and depression than one living in a close-knit,

supportive community such as Siena. In fact, one study of five European cities has found that rates of depression are six times higher in Liverpool (17.1%) than in Santander.[9] But who is to say that if this difference is undoubtedly attributable to the stronger extended family and social support of the northern Spanish city, beauty doesn't also contribute its own positive role? It is surely common sense to recognize the contribution of noise and ugliness alongside those of poverty, alienation, overcrowding and a mean culture.

Neglect the soul or feed it on a diet of violence, unloveliness and shallow stimulation, and you encourage a loss of love, imagination and contemplation; you encourage a disinterest in tenderness and beauty. You breed psychosomatic illnesses and brutality. As long as the soul is engaged, care of beauty always follows in its wake.

So the question remains: in losing beauty, are we losing anything vital to our lives? Given the common assumption that it is merely a superficial decoration, a mere adjunct to life, the answer can be given in the negative, but if it should be something more, something fundamental to our sense of well-being, something ennobling, healing, inspirational, something essential to our spirit and our health—as I believe it to be—the lobotomy of beauty is a matter of vital importance to each of us and the health of our society.

Beauty is the nourishment of the soul. It is something that gives us dignity as a species. Without it we are a meaner people, ignorant of grace, disregardful of the spirit.

Isn't it time to wake up to the possibilities of a culture that recognizes the importance of beauty in its life? Isn't it time to recognize that we are only fully human in contact with the beautiful?

The Consolations
of Beauty

THE MYSTERY OF THE BEAUTIFUL

Any material object which can give pleasure in the simple contemplation of its outward qualities without any definite and direct exertion of the intellect, I call in some way, or in some degree, beautiful. Why we receive pleasure from some forms and colours, and not from others, is no more to be asked than why we like sugar and dislike wormwood.
JOHN RUSKIN

To create and appreciate beauty is one of the supreme pleasures that this world can offer. Yet it is strangely controversial and even more strangely ignored. True, it cannot be proved, it cannot be explained and can barely be described. The poet Rainer Maria Rilke used to say that words are the last resort for expressing what is happening deep within ourselves. It is hardly surprising that beauty is not only beyond words but beyond meaning.

Its origins are also a mystery. The majority have often attributed the origin of the world's loveliness to its Creator; it is, they believe, His signature which we see in the common daisy no less than the multi-coloured beauty of the Victoria crowned-pigeon from New Guinea.[1] It is also to be found in the bluebell in an English woodland. Speaking of the bluebell, Gerard Manley Hopkins once said, 'I know the beauty of our Lord by it.'

Although Christ also celebrated the beauty of the natural world and more particularly its lilies of the field,[2] it may be that Islam is more explicit in its recognition of the divine role in the creation of beauty. It gives emphasis to the belief that Allah is both beautiful in Himself and loves beauty. Furthermore, to quote a *hadith*, 'God has "written" the mark of beauty upon all things.'[3] Augustine would have agreed. It was he who wrote that, 'All that is beautiful comes from the highest, which is God,' and so indeed would St Thomas Aquinas, who quoted St Dionysios the Areopagite: 'The Beauty of God is the cause of all the being that is.'[4] Yet in more recent times this attribution has been questioned and even rejected. Many scientists accept no comprehensive explanation of this transient phenomenon. They ask why nature is so ordered, so complex and so beautiful and come up with observations which reveal that, in truth, they do not know. And nor do I. Nor, it seems, does any biologist, any chemist, physicist or mathematician, at least

in terms of scientific observation rather than personal faith.

So let's agree that if beauty is one of nature's best bits of evidence for the existence of a Creator (and the naturalist W. H. Hudson called it 'God's best gift to the human soul'), we may yet have to live in a mystery, live with our extraordinary and ultimately inexplicable universe and respond with gratitude to its inexhaustible beauties.

For myself, I enjoy with Keats a state of emptiness that he described as 'Negative Capability': 'that is when a man is capable of being in uncertainties, mysteries, doubts, without any irritable reaching after fact or reason.'[5]

Incapable of finding words to describe the intensity of the moment of beauty, I am happy to remain in a mysterious condition of emptiness, silent awe.

For whatever we believe, beauty—beauty 'whereof one cannot speak'— remains unchallenged as a fact of everyday experience. We can see it, we can feel it, we can know it as a sensuous reality that accompanies us throughout life. It is something we encounter on street corners, in public buildings, waiting for a train or looking up from a book. We can also know that there is nothing so inspirational, nothing so transfiguring, nothing so noble, nothing so elevating as transient beauty. But its origins, its significance and destination must remain a mystery.

Indeed, the history of aesthetics is littered with unsuccessful attempts to rationalize and systematize this hugely evanescent experience. In the course of researching this work, I read a number of books on aesthetics, but none took me closer to any understanding of the beautiful; often the opposite. So much abstract, cerebral speculation may even take one away from the vivid beauty of a spray of cherry blossom or the painting of a little girl stroking a cat by Pierre Bonnard. Whatever else the beautiful may be it is certainly neither cerebral or egotistic; it has a quality of innocence and purity. Smelling a batch of freshly baked bread, regarding a photograph by Henri Cartier-Bresson, appreciating the serene austerity of mediaeval plainsong and the fierce elegance of a thrush, I am not thinking why the bread smells good, why the photograph is perfect or the bird so beautiful. It is enough to breathe the perfection of their being and stand in awe before the miracle of life. To marvel is enough.

So from the start I declare that I don't have the answer to the mystery of beauty and have little intention of looking for one, because I know that it will not be found. There is a poem by the Australian poet, Shaw Nielson, beautiful in itself, which says something about the mystery. There's this young

girl who sees a strange light in the orange tree. Someone keeps asking her what it's like, is it like that, is it like this? Finally she loses her patience:

> – Silence! the young girl said. Oh, why,
> Why will you talk to weary me?
> Plague me no longer, for I
> Am listening like the Orange Tree.[6]

So this book is more about 'listening' than analysis; more about asking than answering questions; more about an appreciation of beauty than any attempt to explain it. Nonetheless, the 'listening' process does raise a number of points which need some kind of response. So I'll now hazard a few reflections.

A BRIEF DIGRESSION ON LANGUAGE

There is no term of general aesthetic commendation in the English language. There is a related family of descriptive terms: words like 'beautiful', 'pretty', 'lovely',' handsome', a limitation shared by French and German alike. Both in our own and other languages more specific aesthetic terms, with narrower ranges of application, are also employed: terms such as 'graceful' and 'elegant'.

Personally, I am with James Hillman, who has pointed out the inherent weakness of the word *beauty*. 'It strikes the ear as so effete,' he contends, 'so ineffectual, lovely and etheric, so far removed from the soul's desperate concerns ... as if beauty had become relegated only to Apollo, the examination of invisible forms like music, belonging to collectors and subject to disputes in journals of aesthetics.' This is surely true. Given the contemporary resonance of words such as 'terrorist,' 'war' and 'sex,' *beauty* conjures up an atmosphere of elderly, even cloistered narcissism far removed from the pressing concerns of the soul.

Another factor is its almost mercurial elusiveness. Although Botticelli's painting of the *Birth of Venus* can be described as beautiful, the use of the same word to describe, say, the Hagia Sophia—the great Byzantine edifice in Istanbul—is inappropriate. Magnificent, awe-inspiring, inspirational, yes, but beautiful? It *is* beautiful, but beauty isn't the most appropriate word to describe its monumental and awesome majesty. But what's the difference? How is one thing unquestionably beautiful and another better characterized by the use

of different adjectives? The answer lies, I suspect, in the fact that beauty, like colour, never comes outside a context of a variety of other descriptive attributes. Thus the Himalayas are beautiful, but their beauty cannot be disassociated from their majesty. A late flowering red campion flower is also beautiful, but its beauty is tinged with transience and frailty. Consider, too, Beethoven's mighty choral symphony alongside the distant sound of a lonely voice singing O *Waly Waly*. Which of them is the lovelier? Perhaps neither is more beautiful than the other, but whereas the first can be described as sublime the other simply moves the heart with its poignant tenderness.

THE UNINTENTIONAL NATURE OF BEAUTY

There are further enigmas, the stuff of philosophic speculation. The first is that given the somewhat personal nature of an aesthetic judgment, how is it that there can be claims of universal validity? The second is no less intriguing. Some of the most beautiful things ever made, some would say *the* most beautiful, were created by those who had no conscious desire to make them beautiful. The Stone Age peoples who painted the walls of their caves never regarded the creation of beauty as a primary intention; likewise the wheelwrights who constructed the old farm wagons, the folk potters of Japan and the countless Indian craftsmen and women. The barns and furniture of the Shakers are perfect but their makers had no serious aesthetic intent.

The Shakers flourished in the middle of the nineteenth century but by the twentieth had died out. Famous as the most successful utopian society in America, they were appreciated by social reformers like Emerson and Tolstoy. Today the Shakers are most appreciated for the simplicity and timeless perfection of their furniture, houses and farm buildings. But the frank, straightforward qualities of their artefacts proceeded from the conscious, or perhaps subconscious, practice of what amounted to a moral law. 'Put your hands to work and your heart to God, and blessing will attend you,' preached their founder, Mother Ann Lee.

The beauty of Shaker artifacts was always unintentional. They shunned what they deemed to be wasteful and unnecessary, including ornament, focusing their work on what was useful and well made. For them the question of usefulness determined the worth of a tool, a chair, a building, or a person. In the Shaker universe, appearance mattered only to the extent that it revealed the

underlying function. Islam, too, never separates beauty from utility, or art from making.

The engraver and type-designer Eric Gill (1882–1940),[7] who as far as I know was unfamiliar with the Shaker movement, would have concurred with this approach. For him, 'beauty is an accident of right making'; he also believed that 'looking after the good and the true, beauty will take care of itself.' Elsewhere he contested that 'beauty comes to (the craftsman's) work unasked when he works in a spirit of plain justice; when he considers simply the use of what he is making and the service of his fellows.'

Gill's doctrine of art was derived from traditional Eastern philosophy. He had absorbed the writings of the hugely influential Indian scholar Ananda Coomaraswamy (1877–1947),[8] but not, I believe, those of his contemporary, the Japanese philosopher of the crafts Soetsu Yanagi (1889–1961),[9] a close associate of the potter Bernard Leach. Yanagi went so far as to argue that to be beautiful, the maker had to be free of self. In his view, no craftsperson had within themselves the power to create beauty; the beauty that came from 'self surrender' was incomparably greater than that of a work of art produced by individual genius. For work to be beautiful, its maker should get out of the way of his or her ego, and let nature do the creating (see Plate IX).

This is a philosophy common to the East. It was taught by Vinoba (1895–1982), a follower of Gandhi, and sage in his own right. In his *Talks on the Gita*, Vinoba expands on this view:

What is the touchstone of inward purity? Examine the outward action. If that is not flawless and beautiful, we may take it that there is impurity in the mind too. When does beauty come out in action? On the action performed with pure heart and unstinted effort, the Lord sets the seal of His approval, His grace. When the Lord, well-pleased, touches the action with the hand of love, beauty appears there. Beauty is the grace of the Lord granted to pure and unremitting effort. When the sculptor gets absorbed in carving, he feels that this beautiful image was not shaped by his hands. As he goes on chiselling, at the last moment, some-how, from somewhere, beauty comes of itself and settles there. Without *chitta shuddhi*, inward purity, how can the art of God manifest itself? The beauty, the loveliness of the image, is nothing but the beauty of the sculptor's soul that has been poured into it. The image is an image of our mind. If our mind is beautiful, its image in the medium of action will

also be beautiful. We should judge the purity of outward action by the purity of the mind, and the purity of the mind by the purity of the outward action.[10]

Of course this philosophy, an expression of the Traditional view which considers the arts of little consequence apart from their service to the faith, exists on a radically different path to that of the individualistic, post-Renaissance view of art with which we have since youth been imbued. This exalts the practice of art for its own sake alone. For the Traditionalist, the purpose of a sculptural image—a carving of Shiva or the Buddha—was, says Coomaraswamy, 'neither self-expression nor the realization of beauty'. Its sculptor 'did not regard his own or his fellows' work from the standpoint of the philosopher, or aesthete, but from that of a pious artisan. To him the theme was all in all, and if there is beauty in his work, this did not arise from aesthetic intention, but from a state of mind which found unconscious expression.'

This is the view held not only throughout the Middle East and Asia during our Middle Ages but in Europe itself. It is a view which finds eloquent expression in the words of Theophilus, who states that artistic activity of every kind should be dedicated to God rather than to man: *nec humane laudis amore, nec temporalis premii cupiditate . . . sed in augmentum honoris et gloriae nominis Dei*—a translation of which might read: 'neither for the love of men's praise, nor for the desire for temporal reward . . . but for the greater honour and glory of the name of God.'[11]

Such then was the spirit in which the great Indian temples, the cathedrals of Europe, the Central Asian mosques and the art of Phidias were created. So too, the smallest manuscript painting, the carvings of the capitals of a church or Thomas Tallis's 40-part motet *Spem in Alium*.

SOURCES OF SELFLESS BEAUTY

The origins of beauty are mysterious, often unexpected and selfless. The impulse, the image, the idea, the phrase, the equation, the solution to a pressing problem—all arise in the depths, the intangible chaos, of what we call the unconscious. And if the intellect and ego may have a great deal to do with the later shaping of this material, they have nothing to do with its origination.

In some words of the Inuit Orpingalik, well known both as a hunter and

a song-maker, we hear echoes of the universal experience of those who live imaginatively. He says:

> Songs are thoughts, sung out with the breath when people are moved by great forces and ordinary speech no longer suffices. Man is moved just like the ice-floe sailing here and there out in the current. His thoughts are driven by a flowing force when he feels joy, when he feels fear, when he feels sorrow. Thoughts can wash over him like flood, making his breath come in gasps and his heart throb. Something like an abatement in the weather will keep him thawed up. And then it will happen that we, who always think we are small, will feel still smaller. And we will fear to use words. But it will happen that the words we need will come of themselves. When the words we want to use shoot up of themselves—we get a new song.[12]

Although these words were spoken by an Inuit in the early years of the last century, the experience to which they allude seems universal. How else could Handel have written the first act of his last oratorio *Jephtha* in two weeks? How else could Rossini have completed *Il Barbiere di Siviglia* within thirteen days? Or Mendelssohn have written his overture to *A Midsummer Night's Dream* at the age of seventeen? And how could Mozart have been able to think in complete wholes to an astonishing degree? According to Erich Hertzmann, 'From the sketch material still in existence, from the condition of the fragments, and from the autographs themselves we can draw definite conclusions about Mozart's creative process. To invent musical ideas he did not need any stimulation; they came to his mind "ready-made" and in polished form.... Any Mozart theme has completeness and unity: as a phenomenon it is a Gestalt.'[13]

Another major composer, Gustav Mahler, provides a fascinating insight into the manner in which he received an inspiration:

> For a long time I had been considering the idea of introducing a chorus into the last movement, and only the fear of that this might be interpreted as a servile imitation of Beethoven made me hesitate for so long. Then Bülow died, and I attended his funeral. The atmosphere in which I found myself and the thoughts I dedicated to the dead man were very much in the spirit of the work I was then carrying within me. All of a sudden the choir, accompanied by the organ, intoned Klopstock's chorale 'Auferstehn'. It was as if I had been struck by lightning,

everything suddenly rose before me clearly! Such is the flash for which the creator waits, such is sacred inspiration.

After that I had to create in sound what I had just experienced. Nonetheless, if I had not already been carrying the work within me, how could I have experienced this moment? Weren't thousands of other people with me in the church? That's how it always is with me. I only compose when I experience something, and I only experience it when I create.[14]

Handel, Rossini, Mendelssohn, Mozart and Mahler were all in receipt of start-lingly beautiful material. I wonder if 'ugliness'—a condition of disharmony —is receivable from the same source? I doubt it, but it may be so. What I wish to stress here is that beauty arises from an impersonal source before the creator undertakes the process of developing it into a 'personal' work of art.

THE HIERARCHY OF BEAUTY

Three types of men have made all beautiful things. Aristocracies have made beautiful manners, because their place in the world puts them above fear of life, and the country-men have made beautiful stories and beliefs, because they have nothing to lose and so do not fear, and the artists have made all the rest because Providence has filled them with recklessness. All these look backward to a long tradition, for, being without fear, they have held to whatever pleased them.
W. B. YEATS

All that is excellent is as difficult to obtain as it is rare.
SPINOZA

We have now to consider a subject which in an egalitarian society can feel uncomfortable. It is the idea of hierarchical organization as the essential and distinguishing characteristic of life.

According to Ludwig von Bertalanffy, whose General Systems Theory is an indispensable guide to the subject, all natural systems are organized hierarchi-cally.[15] In the inorganic world, 'with its hierarchy of electron, atom, molecule, mycella and crystal,' no less than the organic world from the population, the organism, the organ to the cell, the same principle holds without deviation: life is organized on a hierarchical basis. Nature is not democratic.

Hierarchies are also commonplace within the spiritual field. In Christianity they are to be found within the angelic realm: in three hierarchies of three

choirs each, in the order of Seraphim, Cherubim, and Thrones; Dominations, Virtues, and Powers; and Principalities, Archangels and Angels. In Islam there are the five divine presences or levels—the level of Appearances, the Subtle or Psychic level, the Angelic level, and so forth. In the Kabbalah there is a similar ladder of levels of existence. Its teaching is summarized in a symbol called the Tree of Life; at its top is Kether, the sphere of God as the One from which emanate ten powers or entities, referred to as the Sephiroth. Different lists use different names, but at the foot there is always to be found the Sephira Malkuth, the material world of earth and the physical body and brain of Man.

But this is only a beginning; wherever one looks there are hierarchies, but hierarchies are by no means the same as the distinctions between classes and castes, or only in a certain sense.

Such ideas are unfamiliar to the majority of Western people and far removed from what is now thought of as 'common sense'. But the fact remains that throughout the greater part of recorded history, these were the ideas upon which men and women based their understanding of the human situation in the context of a cosmic one. 'Legitimacy' in the political and monarchical realms stemmed from a belief in a Supreme Being, omniscient and omnipotent, superior in all ways to his Creation.

Although our Western civilization has welcomed the idea of representative democracy as the most legitimate of political systems, we do well to register the uncomfortable fact that we are obliged to value works of art, however approximately, in some kind of hierarchical manner. Nonetheless, if this goes against the grain of a deep-seated egalitarianism isn't it sometimes obvious, even painfully so, that, aesthetically speaking, some people are handsomer than others, that some landscapes are more attractive than others and some performers more accomplished than their contemporaries?

Although this hierarchy of beauty can be difficult to identify and categorize with any degree of exactitude, I urge its consideration. Consider, for example, the sketch which Leonardo da Vinci executed for his *The Virgin of the Rocks*. It is of the head of an angel and obviously of great beauty. But is it, as the Italian art connoisseur, Bernard Berenson, once declared, the most beautiful drawing in the world? I would hesitate to grade it with such confidence. Nonetheless, I recognize it as a supremely wonderful drawing and one self evidently finer than anything by, say, Annibale Carracci, Domenico Campagnola, Thomas Rowlandson and even Henri Matisse. (The relative auction room values of these artists would tell their own story.)

No less self-evident, surely, is that Piero della Francesca's great fresco of *The Resurrection* in Sansepulcro (which Aldous Huxley called the world's greatest painting) is a more wonderful work than Stanley Spencer's *Christ in the Wilderness: The Scorpion*, wonderful as that is. It is also surely obvious that Mozart's *The Magic Flute* is a more sublime work than Stravinsky's *Les Noces*; that the church of San Miniato above Florence is finer than Ludwig Mies van der Rohe's *Seagram* building in New York; that Dante's *Divine Comedy* is a greater achievement than another long work like Browning's *The King and the Book*; and that Picasso is a more considerable artist than Raoul Dufy. It's not that I don't admire all the latter works, for I most certainly do: it is that the former are, quite simply, greater.

So there exists a scale of values and varying degrees of beauty; at the top there are the 'highest', and lower down the scale a multitude of other handsome and exciting works which, for one reason or another, are less compelling. Then even lower down the ladder are many serious artists—Alfred Sisley, Ottorino Respighi, John Betjeman, for example—who are perhaps even less substantial. But here I am getting into difficulties already. For just as a daisy flower is no less beautiful than a lotus bloom, so the beauty of one work of art is perhaps no less than that of another. Sorokin may be helpful here (see page 70); perhaps the greatest works may be characterized by a kind of radiant transcendence, whereas the 'lesser' ones may be more sensate, more carnal, less inspiring.

Here may be revealed, I suspect, the difference between the arts that arise from the order of a traditional society and those which arise from a culture informed by the egalitarian project. The former approach life with a religious awe which endows their art with a distinctive spiritual power; the latter (as with Brit Art, where nobility and sublime experience are regarded as intolerable), can sometimes reduce the arts to the dimensions of a commodity. Parody and sarcasm run riot; the exultant is forbidden. Art's inherent capacity to be communicative and compassionately responsive is undermined by alienation and egocentricity.

BEAUTY AND TIME

According to the latest calculation—or should I say speculation—the Big Bang which initiated the expansion of the cosmos occurred some fifteen billion years ago, when there came into being all the matter and energy of the universe. Isn't it possible that the particles, the very cells of this embryonic

universe were beautiful; that our mysterious world was intrinsically beautiful from its beginning?

Beautiful, too, are the wild places of this planet: its mountain ranges, deserts, savannas, boreal and tropical forests, oceans, sea shores and cultivated landscapes, each with its multitudinous inhabitants: the river hogs, the slender-snouted crocodiles, the green tree pythons, the Californian sea lions, the Andean condors, the blue whales, the forest elephants and, dressed like an Elizabethan courtier, the greater spotted woodpecker who regularly visits our nut bar. Nature is the timeless source and inspiration for the creation of the beautiful by the human species. The painter Paul Klee recognized this when he wrote: 'The artist cannot do without his dialogue with nature, for he is a man, himself of nature, a piece of nature and within the space of nature.'

In life on our planet, many generations have come before us. Our distant ancestors learned how to use fire around 500,000 years ago. They fashioned stone tools at least 400,000 years ago; *Homo sapiens* first evolved about 200,000 years later. The oldest cave paintings (of which some two hundred have been discovered in the south of France and northern Spain) are no less than 31,000 years old. No one disputes their piercing, other-worldly beauty, a beauty barely excelled by later humans.

In front of me is the portrait of one of my contemporaries: a tribesman from New Guinea.[16] His face is painted a cadmium yellow with nine red spots running down the nose. His beard is powdered with alazarin madder and he wears earrings, beads, and in his cap, viridian green parrot feathers. There is undoubted artistry in this startling ensemble.

Beauty is timeless, universal and intrinsic; like the woof of a fabric it runs through every cell, every creature, every artist.

MONEY AND BEAUTY

It is an indisputable fact that many of the greatest works of art could not have come into being without the initiative and support of the prevailing economic élite; that is to say, the priesthood, royalty and the aristocracy of the society in which it was made. There would have been no cathedral at Amiens, no Saint Chapelle in Paris, no Topkapi Palace in Istanbul, no Katsura Imperial Villa in Kyoto, no ceiling of the Sistine Chapel in Rome, no Taj Mahal

in Agra, no Ankor Wat,[17] no Stourhead in Wiltshire without the contribution of powerful, wealthy and influential patrons.

On the other hand, there have come into being countless imaginative acts created by peasants, natives and craftsmen with relatively little and some-times no expenditure. Simple nomad weaving is one of these. The pathway icons of rural India[18] are another, as is the sand painting of the Navajo and the punched decoration on Moroccan leather shoes. In the field of sound there is music: Negro 'blues' or 'spirituals', work songs, and the vast treasury of folk music of all the nations of the world. According to Edwin Muir, whereas English poetry is at its best in the work of the cultured classes, in Scotland the opposite is true. The greatest poetry is in the work of the people—the Ballads—and in music, the exquisite melodies of the Hebredian songs. It would be hard to find a finer poem by any English poet than *Sir Patrick Spens*.

In those inexpensive times, evidence of the instinct to beautify found elegant expression amongst the common people when they chose to decorate their homes, their environments and churches—consider, for example, amongst so much else, the scrolls on a decorative weather vane, the hinges of a church door, the delicate appliqué-work of a coverlet, the *sgraffito* decoration of a harvest jug,[19] the carving of an angel-head on a village tombstone. Such and similar decorative elements could never have been created let alone considered, if expenditure had been restricted to the utilitarian basics.

It is simply untrue that it was (and is) only the wealthy who can afford the luxury of aesthetics; the opposite may even be the case. Nowadays the affluent have become dependent on machinery for their needs, whereas the poorer people of the so-called Third World, described as 'undeveloped', are those who continue to take delight in the enhancement of decoration. In our house we have a creamy coloured tea-cosy from India. It is embroidered in red silk with prancing Indian elephants; nothing could be more soulful, more convivial. And if this chubby tea-cosy will never make it to the British Museum, it gives delight to us as I'm sure it gave to its anonymous maker.

A more sophisticated example of adornment is to be found amongst the nomads who live scattered through the nations of Europe, India[20] and West Africa—for example, the Wodaabe of central Niger. For these pastoralists life is hard, and for the most part short, but they do not live like people struggling to survive. Instead they cultivate an aesthetic sensibility that brings

great beauty to their existence. As the anthropologist David Maybury-Lewis observes:

> Creature comforts are in short supply in the Wodaabe world. Nevertheless, it is a world of bright colours and lovely things. Men treasure their finely worked saddlebags and handsome saddles bought from the neighbouring Tuaregs, their brilliant blankets, the decorated leather pouches that hold their charms. Women glory in the shiny wraps, shot through with gold and silver thread, that they wear around their heads, and the lovely sarong-like garments that set off their lissome figures. Most of all, a woman treasures her collection of exquisitely carved and painted calabashes, which are at once her most prized possessions and the expression of her individuality. . . . The Wodaabe surround themselves with beautiful things, but most of all they strive to be beautiful people.[21]

The purposes behind these efforts by the 'developed' and 'undeveloped' alike are manifold: sometimes it can be associated with competitive pride, sometimes with an assertion of status, with propaganda in aid of a particular belief system, with the promotion of a particular family or the status quo. More frequently, however—as with our tea-cosy with its elephants—its source is delight in beauty for its own sake.

BEAUTY AND ETHICS

The subject of beauty raises many questions. One of these concerns the relationship of disinterested aesthetics to ethics—our sense of the good. The Greeks had little doubt about their relationship. As G. Lowes Dickinson observes:

> [for them] the aesthetic and the ethical spheres, in fact, were never sharply distinguished . . . their conception of the good was identified with that of the beautiful so, on the other hand, their conception of the beautiful was identified with that of the good. Thus the most beautiful work of art, in the Greek sense of the term, was that which made the finest and most harmonious appeal not only to the physical but to the moral sense, and while communicating the highest and most perfect

pleasure to the eye or the ear, had also the power to touch and inform
the soul with the grace which was her moral excellence. Of this really
characteristic Greek conception, this fusion, so instinctive as to be
almost unconscious, of the aesthetic and moral points of view, no
better illustration could be given than (certain passages from) Plato.[22]

The poet Keats, after Plotinus, also suggested that truth and beauty were
synonymous, but others have argued for a less congenial relationship: that
between consummate art and self-seeking ambition; that between aesthetic
perfection and inappropriate livelihood; that between beauty and pain, beauty
and vanity. Were the sufferings of van Gogh and Paul Gauguin justified by their
work (the former committed suicide; the latter lived for a year in Mataiea with
barely any food and clothing)? Did the creation of the gardens of Versailles
justify the deaths of the labourers and soldiers who died of disease as they
worked on them? And what about the thousands who perished building the
cathedrals, Angkor Wat (see page 80) and the Taj Mahal (some 20,000 were
employed on the latter site)? The paradox continues: the supersonic Concorde
is visually beautiful but environmentally destructive.

AN ENTROPY OF VISION?

In his fine book *The Spell of the Sensuous*, the American ecologist David Abram,
describing his experience of living with Indonesian and Nepalese shamans,
gives accounts of his contact with non-human nature, the world of the spider,
the bison and the condor:

> Instantly, the condor swung out from its path and began soaring back in
> a wide arc. Once again, I watched its shape grow larger. As the great size
> of the bird became apparent, I felt my skin begin to crawl and come
> alive, like a swarm of bees all in motion, and a humming grew loud in
> my ears. . . . The creature loomed larger, and larger still, until, suddenly,
> it was there—an immense silhouette hovering just above my head, huge
> wing feathers rustling ever so slightly as they mastered the breeze . . .
> And then I felt myself stripped naked by an alien gaze infinitely more
> lucid and precise than my own. I do not know for how long I was trans-
> fixed, only that I felt the air streaming past naked knees and heard the
> wind whispering in my feathers long after the Visitor had departed.[23]

Returning to his own country, David Abram was quick to observe the absence of this primordial, participatory kind of perception; to him it seemed that his fellow Americans behaved as if unable to experience or focus upon anything outside the realm of human technology, or to hear as meaningful anything other than human speech. Such absence of the attentiveness so broadly practised in the countries in which he had learnt to experience it prompted him to question how it was that the modern West had become both deaf and blind to the vital existence of other species, and to the animate landscapes they inhabited. 'Nature, it would seem, has become simply a stock of 'resources' for human civilization, and so we can hardly be surprised that our civilized eyes and ears are somewhat oblivious to the existence of perspectives that are not human at all, or that a person either entering into or returning to the West from a non-industrial culture would feel startled and confused by the felt absence of nonhuman powers.'

It was an observation that set me wondering about what might prove to be another amnesia of Western culture: its mass failure or inability to perceive and appreciate the aesthetic—a conception that dominated the mind of the ancient Greeks and is still enjoyed by the tribespeoples of New Guinea. Could it be that modern 'civilized' humanity has lost its capacity to recognize beauty when it is lies before it? That it is losing or has lost its soul? 'Change of soul', 'loss of soul' and zombification are conditions not unknown in our time. In Haiti, sorcerers are said to extract a person's soul by magic or else to capture it after natural death. The body seemingly retains its animating principle but has lost its agency and awareness. In short, it has become a zombie which can be enslaved and put to work in the sorcerer's slave camps.[24]

One loss would be the world of vision and enchantment which William Blake experienced in and about him. Another would be the beauty of the world itself. Clouds in a majestic cumulus formation, the quivering and shiny envelope of leaves on a wind-blown poplar, the churning brown waters of a river after heavy rainfall, a dragonfly's jerky movement or one of Corot's paintings of a village in his native France—each can be summarily observed, but can they be truly *seen*, truly honoured, truly received with grateful attention? Seen, that is, with the closest attention to aesthetic qualities alone.

If so, what is it that induces this absence of attentiveness, this impatience, in the West? One cause might be our rushing lifestyle; too little time 'to stand and stare'; too much flippancy, irreverence, an anything-goes self-absorption;

too many preoccupations; the ever-shortening attention span so frequently reported of their pupils by teachers, the lure of money and our lack of tolerance for time-consuming, concentrated effort. Or might it be the emphasis so often given to thinking and utilitarian information in schools in the industrialized world? And what influence does an unrelieved diet of ugliness have on sensibilities already coarsened by violence and television? Whatever the cause, it seems that we are living in a culture that is losing the art of seeing and hearing for its own sake.

I learnt the distinction between close attention to what lies before one and mere looking for the purposes of gleaning useful information, as a student at the Slade School of Art. Here I spent mornings, whole days and even weeks, observing the exact curvature of a human shoulder, the subtle tones of a shadow and the hue of a small area of floor. In my room I would devote hours to analysing the colour of a shadow in a still life: was this a warm green or a bluish one? Was it a cobalt or a cerulean hue? And was there a hint of magenta? Or maybe cobalt violet? Glimpsing taught one nothing; sustained attention and slow analysis a great deal.

In this respect my education as a painter has stood me in good stead. It was an experience that trained me to slow down and practice what Thoreau called the 'habit of attention'. Is it possible that with eyes neglectful of visual appearances and ears neglectful of sound for its own sake, many are denying themselves the miracle of sight and sound?

THE DISCOVERY OF BEAUTY

The hours when the mind is absorbed by beauty are the only hours when we are really alive.
RICHARD JEFFERIES

We may discover a love for beauty in different ways. It has many mansions and many rooms. It could come to some in Florence; from Fra Angelico's *Annunciation* at the top of the stairs at San Marco leading to the monks' cells; from Simone Martini's altarpiece of the same subject in the Uffizi; from the restrained decorum of Alberti's façade of Santa Maria Novella or from Brunelleschi's magisterial cathedral dome. It could come from the Japanese gardens in Kyoto or the village churches of any part of England: from the towers of Somerset in the buttercup meadows; or from the carved screens of

the Devon churches and the angel roofs of Norfolk, from Norman fonts, from fragments of stained glass and seventeenth-century tombstones amongst tall straw-coloured grasses. Or it could begin with an Elizabethan embroidery of cornflowers or one of the grave and ashen oils of nuns by the English painter Gwen John; the dizzy space of Caspar David Friedrich's *Chalk Cliffs on Rugen*; or the incomparable glory of Duccio's tender *Maesta* which throws its spell upon us in the Museo dell'Opera in Siena (see page 85). Thence to the magical worlds of Edward Calvert, David Jones and Cecil Collins.

But music is not to be forgotten: the masterly unbroken harmonies of Mozart's *Cosi Fan Tutte*, Gesualdo's *Moro, lasso, al mio duolo* and the heart-yearning lyricism of the sailor's plangent song in Berlioz's *Les Troyens*. But if it begins with these memories with which nothing can compare, there is so much else: Handel's *Ombra mai fu* from *Xerxes* and indeed so much more of Handel—the oratorios *Theodora* and *Jephtha* for example—and the music of Heinrich Schütz which can be beautiful beyond any reckoning. But I forget the intoxication of so many moments: here are the bass sounds of Eastern and Orthodox chant; the tender beauties of Cavalli's *La Calisto* or the wondrous invention of Bach's *Goldberg Variations*. There is also the miracle of Bach's cantatas and the operas of Wagner and Tchaikovsky.

Persian and Mughal miniatures (see Plate VI), T'ang Dynasty and seventh-century Japanese sculpture are also icons of the human spirit in its perfection, as is much of the architecture of Islam. Nor should certain films—Ray's *Pather Panchali* and almost everything by Kurosawa and Bergman—be forgotten.

What, then, have these prodigies in common? Perhaps the answer lies in the Finnish composer Einojuhani Rautavaara's description of a great composition. 'It is my belief,' he writes, 'that *beauty* [and here I have substituted the word 'beauty' for 'great composition'] is great if, at some moment, the listener catches a glimpse of eternity through the window of time.' 'A glimpse of eternity through the window of time'—a phrase not so different from the philosopher Wittgenstein's emphasis on our need to see things *sub specie aeternitatis*.

Maybe, then, it is the absence of that 'glimpse of the eternal' which defines the difference between, on the one hand, the works of Bach and Mozart, Handel and Duccio, the masons who built Chartres and the Buddha statues from Gingzhou, and, on the other hand, the works of the post-Renaissance European masters: Rubens and Ingres, Chopin and Sibelius, William Butterfield and Robert Adam.

Much as I love the all latter, and the works of Monet, Braque and Matisse, the music of Shostakovich and Richard Strauss, the films of Hitchcock and David Lean, I do so with a degree of reservation. The same is even truer of a great deal of postmodern popular art—Rock and Rap, Eric Clapton, Elvis Presley and Bob Dylan—which challenge a number of our most deeply entrenched aesthetic conventions. Consider, too, some of the sensational engineering wonders of the modern world such as the Akashi Kaikyo Bridge, Kansas International airport and the Louisiana Superdrome in New Orleans. Dynamic, creative, innovative and exciting they undoubtedly are, but clearly not, I think, *sub specie aeternitatis*. I admire them very greatly, but in the final analysis they do not steal my heart. My heart goes out to those works in which a numinous world has been manifested—a world in which the polarity of outward and inward, conscious and unconscious, seem to have been resolved.

Needless to add, the glimpse of the eternal to which I have referred is forever to be seen in the realm of nature; it is there in the leaping movement of a salmon, the perfection of a head of flowering clover, a heavy rain storm, the face of a child and the awesome vastness of the Milky Way on a dark night. This morning it lies close to where I write: in the ivy climbing up a tree bole; in the starry cluster of daisies in the grass, in the full-leaved gently swaying branch of a hedgerow beech; the quivering and dappled shade it casts on a pinkish path and in the sky and clouds—always in the clouds.

The eternal is always around the corner. 'Rape the moment as it passes,' advises the novelist John Cowper Powys. 'It can never pass again; and for all you know its very drabness may prove a loophole into the eternal if you press against it hard enough.'[25]

THE NATURE OF BEAUTY

Beauty itself is a painful convulsion in the heart, an abundance of vitality in the soul, and a mad chase undertaken by the spirit until it encounters the heavens.
NAGUIB MAHFOUZ [26]

The basis of the visitation of beauty lies in the human psyche. It has a universal appeal rooted in the promise of escape from the burden of individual selfhood framed by the inevitability of death, the ultimate condition of chaos and dissolution. But as far as I can see, beauty, though it may originate in the

messiness of life, is ultimately a denial of disorder, destruction and chaos. It is a reenactment of the primacy of harmony over chaos.

Another interpretation holds that beauty originates within and guides the soul, the timeless part that wants to create paintings and music like the largo from Bach's *Air on a G string* from his first orchestral suite. The creation and appreciation of such works draws together the observer and the observed into a contemplative nexus; it is the result of a harmony or unity of consciousness which abolishes the distinction between the subject and the object of contemplation.

But whether we interpret the soul mystically as according to Plato, or psychologically as according to Jung, either way it should be understood that it is at least questionable whether beauty exists as an autonomous reality 'out there', a 'something' which the soul encounters or fails to respond to. It is, in fact, questionable whether there is a reality independent of a perceiving mind. 'Reality is always given together with the mind that comprehends it,' writes Henryk Skolimowski.[27] 'We have no idea whatsoever what reality would be like *as it is* because invariably when we think of it, when we behold it (in whatever manner), reality is presented to us as it has been transformed by our cognitive faculties.' William Ralph Inge contributes a further factor when observing that 'as in the case of other ultimate values, the emotion of beauty is aroused by the meeting of mind and its object; and not only must the object be beautiful; the perceiving mind must also be beautiful and healthy. The vile or vulgar mind not only cannot perceive beauty; it is a great destroyer of beauty everywhere.'[28]

There therefore seem to exist two interdependent factors: on the one hand, the thing seen or heard (it could be Preston in the rain, Leonardo's drawing of a Star of Bethlehem plant or Vivaldi's *Winter* from the *Four Seasons*), and, on the other hand, the recipient of these experiences. But the latter is no neutral participant: seeing beauty is an *activity* or process, and the act of seeing and hearing an active state or condition of soul—a state of soul influenced by the participant's temperament, life experience and aesthetic and cognitive faculties, refined or uneducated, as the case may be. As Plato observed, the perception of beauty is a deeply personal matter: 'Everyone chooses his love out of the objects of beauty according to his own taste.'

Current fashions also influence choice and appreciation. In the eighteenth century the beauty of the Gothic was not seen in England, and primitive Sienese painting was unappreciated until the first half of the twentieth century. In the first decades of the nineteenth, the reaction against the reason and strict

rationality of the late eighteenth induced a new romantic mood which encouraged introspection and the deeper irrational forces which lie within the soul. It was a shift which influenced all the arts. Wordsworth's *Lines composed a few miles above Tintern Abbey* (1798) could not have been written or appreciated in the early years of the eighteenth century, or the paintings of Jackson Pollock in the nineteenth.

Deep-seated emotional attitudes also disturb or prevent appreciation. Consider the reaction of a vegetarian to the carcasses of meat painted by Chaim Soutine (and Rembrandt in an earlier century). Or the coal tips of the northern mining towns regarded as eyesores in the post-war years but which are now being seen in a new light; for some they have an almost romantic nobility. Isn't this another argument in favour of the relativity of taste? Yes, it is; cultural conditioning, personal prejudice and the social construction of a particular time and place do make a contribution to what we admire or fail to enjoy.

But so does another even more important factor: the culture of the eye and ear, educated or uneducated as the case may be. William Blake was clear about this difference: 'A fool sees not the same tree that a wise man sees,' he wrote, 'As a man is, So he Sees.'

I have the good fortune to enjoy a reasonably educated appreciation of the visual arts, but a grievously smaller understanding of what some of my friends hear in music. And when it comes to snooker, tennis or football I am an ignorant spectator of what is going on in front of me. I have never really grasped the rules and, in consequence, the skill of the players.

So fashion, temperament, cultural prejudice and an educated or uneducated taste all play their part in revealing or blinkering out what we could or might appreciate. We may, as Chögyam Trungpa says, 'close off vastness' or 'allow vastness to touch us'.[29]

The subject of appreciation remains a complicated one. Crucially, one has to ask why one thing is beautiful and another dull or mediocre. Perhaps it is sometimes easy enough to see and hear the difference but it can be difficult, if not impossible, to explain it. At one level, everything is beautiful because it exists, and even the 'ugly', under certain conditions, is capable of transformation.

THE CHARACTERISTICS OF THE BEAUTIFUL

If the appreciation of beauty is an elusive and often ephemeral experience it is nonetheless one characterized by certain permanent features. One of the most important of these is harmony, an order or coherence which transcends the fragmentation of parts. 'We perceive beauty in the harmonious intervals between the parts of a whole,' said Aldous Huxley.

Let us return to Botticelli's painting *Primavera*, in the Uffizi Gallery in Florence. Let us look at the six interwoven arms and hands of the Three Graces—Beauty, Chastity and Pleasure—on the right hand side of the panel. Let us see how each part of the design, each curvature, each repetition, each rhythm, enjoys its own exquisite beauty: the intertwined fingers are beautiful, the choreography of the interwoven arms and hands are beautiful, as is the pattern of their movements, as slow-moving, complex but inevitable as a canon by Pachelbel. But this is only the beginning: as I become aware of how the hair tumbles down their backs like the natural flow of racing waters; how the diaphanous draperies ebb and flow like tides in a whirlpool; how their feet and the flowers on their dresses dance like an incoming tide, I am enraptured, spellbound by the painting's overriding lyricism—the tender sweetness of his composition. Nothing jars. Nothing is out of place. Nothing is limp or dull or lacking in vitality. Nothing is superfluous. Everything has been crafted so that the power of the painting would be diminished if any part of it, however seemingly insignificant, were to be changed. Everything has been conceived, not by intelligence alone (though that has certainly played a significant part), but with the artist's respectful deference to the archetypal origins of the original inspiration in the unconscious. The *Primavera* is a miracle of imaginative coherence.

Another of beauty's characteristics is the profundity of its refreshment. Unlike so many sensual pleasures, eating or the gratification of sex, it does not lead to satiety and even downright disgust. Cicero mentions all the senses as being subject to this passage from gratification to disgust. A bowl of strawberries and cream provides a summer's tea-time delight, two bowls maybe an additional pleasure tinged with satiety, four bowls is more than enough, six and we begin to feel sick. But with a Mozart piano sonata or a painting by Sassetta (see page 96), there is no exhaustion. There is elation, charm, renewal, energy. We do not tire of beauty; each experience of it enjoys an exquisite singularity but there can never be enough. It refreshes like a dip in an Alpine pool.

Robinson Jeffers touches on another characteristic, the relationship of beauty to wholeness:

> ... Integrity is wholeness,
> the greatest beauty is
> Organic wholeness, the wholeness of life and things,
> the divine beauty of the universe.[30]

Maybe it is this knowledge of wholeness which calls forth the deep-seated shock of recognition we describe as beauty? Maybe it is this sense of ordered harmony or ordered complexity which induces the sensation of expanded consciousness experienced when we are faced with something which is beautiful (like the *Primavera*), or which grows beautiful as we look at it.

The latter involves an ordering and integrating process such as a painter undergoes when, say, a landscape or a still life is being contemplated as a work of art. Faced by a seeming muddle of trees, fields, rocks and houses, an artist needs to bring order to the external confusion and internal harmony to his composition. The painter Cézanne did this with his landscapes of the Provençal countryside.

LOVE, THE SOURCE OF BEAUTY

Ubi amor ibi oculus est (Where there is love there is vision)
RICHARD OF ST VICTOR[31]

The word 'beautiful' (bello) is, or was, in the south of Italy, one of the first words which children learn. The first quality which good southern mothers notice in their new-born babies is . . . beauty. And the child is beautiful, not only because he is attractive, gorgeous, pretty, lovely; he is beautiful because he is loved. Love makes an object beautiful.
ELISEO LAGANO (private communication)

Speech is not of the tongue, but of the heart. The tongue is merely the instrument with which one speaks. He who is dumb is dumb in the heart, not in his tongue . . . As you speak, so is your heart.
PARACELSUS

Although the complexities of both nature and beauty have a subtle mathematical basis (see Chapter Two), reason by itself cannot tell us why beauty exists nor what is beautiful. Reason, and especially an unbalanced or over-developed intellectuality, can even prohibit or freeze the feelings which

stimulate *anandam* (the Sanskrit for aesthetic delight). There is often something spontaneous, even 'illogical' about these emotions; like love they can never be predetermined, let alone dictated. But neither can the other wise and splendid things which are most significant in human life, to which the greatest of the human race have contributed most, and in which our real refreshment consists—the love of truth, the sources of inspiration and the production of great works of art.

These, like beauty, ultimately pertain to the unconscious, the heart and the soul. They pertain to the heart because it is love which discerns the mystery inherent in those things we see as beautiful; love which abandons arrogance and stands in awe before the mystery of life. It is love that sees beauty which, in turn, is always loved.

THE OTHER ORDER

My focus is beauty. We live in a world of opposites tugging at us. Beauty alone has no opposite. . . . I should use beauty as an opiate and if I can pull it out of nature and hint at it in paint then I should, and hand it as an opiate to any who will have it.
MORRIS GRAVES[32]

The lotus is the flower of Buddhism; the pattern of its growth is understood as an allegory for spiritual development. The plant grows in shallow, still water, the bottom of which has become sedimented with a muddy silt or ooze. Into this dark substance the lotus sends it roots, thick and tubular. Later, as it grows, reaching out for the light, the plant pushes its splendid leaves above the water surface and eventually produces one firm large bud. Come the spring, the bud unfolds into a flower of matchless perfection.

Buddhists interpret the growth of the lotus as a metaphor for our earthly existence; the dark bottom-slime that produces the exquisite lotus is, they believe, the base origin of our mortal origins. In that sense ugliness can be conceived as the reflection of our ignorance.

I might be more comfortable with a different interpretation, yet it remains inarguable that beauty can originate in darkness, in adversity and chaos. The process of creation can involve a substantial struggle. Here there can be disorder leading to order; 'ugliness' leading to beauty. So could it be that ugliness is no more than unrealized potential; matter crystallized too early in the process of its realization?

Yet the Western tradition opposes this view. Largely based on opposites, it divides life not only into good and evil but into other polarities: mind and matter, thinking and feeling, the conscious and unconscious, and from the point of view of this essay, beauty and ugliness. So deep-rooted are these opposites, so entrenched in our language, that they are seen only in negation to one another rather than as elements of a totality in ever-developing orders of wholeness that form and dissolve, inhabiting possibility with the amplitude of all that is. There are times when contraries can provide the energizing field of their contending polarity.

Nonetheless beauty and ugliness, like feminine and masculine, do exist— they existed in Cambodia at the time of the Khmer Rouge and within *Primavera*—but not perhaps as intrinsic forces in nature? Ugliness cannot be abstracted, generalized and subsequently concertized in some supersensible realm of absolutes; it exists but it can and does metamorphose into the goodness of beauty. At the same time just as the beauty of a spring morning is heightened by the memories of cold winter days, so an entirely beautiful world could be as dull as uninterrupted days of fierce sunshine. Perhaps we need ugliness as much as we need beauty?

If beauty is what Alexander van Humboldt described as 'the harmonious unity of nature', then its opposite might be conceived as a kind of coma, a discordance, a lack of balance, graceful proportion, dynamic repose or equilibrium. Ugliness reveals monotony, disfiguration, discord, deformation, moral perversion, power abuse, intimidation, emotional torture, no thought and no responsiveness. It gives expression to the breaking down of relationships, proportional symmetries and concordances. It produces an awareness of the horror of belonging to a broken unity. It is impersonal and soul-less. It results from disrespect, cynical disregard and an anti-reverence that verges on arrogance. Ugliness always has something of human arrogance. Conversely, beauty has to do with care, compassion, spirit, authenticity—it is always moral and honest. Beauty appears wherever soul appears, and ugliness whenever the soul has been anaesthetized.

But things seen with the unifying activity of imagination help us to come awake from the coma. They reveal the intrinsic totality of the universe. Ultimately, this suggests that whatever we perceive to be ugly has some unique function in the whole; that in some way incomprehensible to the rational mind, that totality must even include the discordant.

The thoughts of Plotinus on the ugly and the beautiful are helpful here. 'We

possess beauty,' he writes, 'when we are true to our own being; ugliness is going over to another order: let the soul fall in with the Ugly and at once it shrinks within itself, denies the thing, turns away from it, out of tune, resenting it.'[33]

Thus if beauty nourishes the soul, ugliness can besmirch it with its angularities, its cramping, mechanical textures, clashing harmonies, repetitive textures, logical structuralism and shoddy manufacture; all of these are foreign to our deep-seated and unconscious vision of life formed by the subliminal perception of nature over vast periods. Ugliness makes us ill, out of tune. It induces the soul to shrink rather than expand. It depresses.

But beauty is an antidote to these afflictions. It gives the ecstasy, the self-transcendence that could otherwise take the form of drug addiction, terrorism or warfare. Yet for the moment it would seem that we are more prepared to depend on stimulation, therapies and pills than tackle the root cause of our depression and sickness. How long will it take us to tackle ugliness, root and branch? To hear the wake-up call! To wake up for beauty!

AIDS TO THE REDISCOVERY OF BEAUTY

A thing of beauty is a joy forever:
Its loveliness increases; it will never
Pass into nothingness; but still will keep

A bower quiet for us, and a sleep
Full of sweet dreams, and health, and quiet breathing.
JOHN KEATS[34]

How can we search for and encounter the beautiful? Are there ways in which its discovery can be cultivated? The answer is: undoubtedly so.

It is important to realize that the consolations of beauty are more dependent on our mindset than the subject under observation—in certain circumstances, a greasy puddle can be more soulful than a view of the Cheviots on a summer's morning. The importance of the right frame of mind cannot be exaggerated: a meditative mood, a measured slowness, a lack of distraction, patience and calm are essential attributes of the necessary attentiveness. With hurry, fidgeting and anxiety, nothing is to be gained. 'Attentiveness,' Simone Weil reminds us, 'is the heart of prayer.' It is certainly at the heart of any search for beauty.

Meanwhile we live in a society that is probably the least congenial for the discovery of this, the most elusive of aims. We rush around like water boatmen

scurrying across the surface of a pond—we dash to the shops, commute back and forth to work, drive the children to school, heat up prepared suppers, practice one non-stop activity after another and all the while we leave too little time for the enjoyment of a state of meditative calm.

Yet even when this proves elusive, the beautiful can honour us with a visitation. Stuck in a traffic jam or leaning over a bar for a drink, we can always, in absenting ourselves, flick over into a different world. John Cowper Powys provides good practical advice about this technique. 'The thing to do,' he writes, 'is to use your will to force the passing moment to become a medium for the eternal . . . These 'eternal moments' of lying back upon the soul and letting ourselves become nothing but pure awareness, nothing but a conscious mind face-to-face with the fragment of the inanimate that happens to be near us, are moments which, if we want to be happy and to live long, we ought to snatch from the flowing of time. Snatch them in buses, in waiting-rooms, in railway-trains, on park-seats, in hallways, in the entrances of hotels and theatres, in public lavatories, on ferry-boats, in taxis, in carriers' carts, in churches, on your bed, in a chair, in your kitchen, on the steps of your house, over the fence of your garden; snatch them whenever and wherever you can!'[35]

What we happen to discern in such moments—the reflections in the back window of the car in front of us or the glitter of a row of spirit bottles—could seem banal, but does it matter? All things await to be enjoyed—if, that is, if we seek to *see* them. The American painter Edward Hopper saw beauty in petrol pumps and cheap hotel bedrooms; Vincent van Gogh saw it in a billiard table and a rush-seated bedroom chair; Claude Monet in a Parisian railway shed; Stanley Spencer in a scrap-heap of rusting iron, Picasso in a coiled sausage. The work of the French painter Chardin is also filled with the surprise of what is often missed. The poet Gerard Manley Hopkins once lamented this omission: 'I thought how sadly beauty of inscape was unknown and buried away from simple people and yet how near at hand it was if they had eyes to see it and it could be called out everywhere.'

His contemporary John Ruskin had no doubts about the importance of seeing. He wrote:

> The greatest thing that a human soul ever does in this world is to see something, and to tell what it saw in a plain way. Hundreds of people can talk for one who can think, and thousands can think for the one who can see. To see clearly is poetry, philosophy, and religion—all in one.

To see things clothed in their fullest beauty it is imperative to approach them with an open-hearted receptivity; to jettison all negative and selfish feelings and the prejudice of unfeeling habit. And always, always, to try to see things as if for the first time. Christ recommended that to enter the Kingdom of Heaven we should become as little children, whilst Buddhists invite us to approach everything with what the Zen teacher Shunryu Suzuki called 'beginner's mind';[36] an approach in which everything is viewed as if it were happening in front of our eyes freshly. The seventeenth-century mystic Thomas Traherne also urged the advantages of virgin apprehension. 'My very ignorance was advantageous. I seemed as one brought into the Estate of Innocence. All things were spotless and pure and glorious,' he wrote. All those, like Wordsworth and Coleridge, who saw the world with an exceptional clarity, would have agreed. And so would Aldous Huxley who experienced the beauty of a small glass vase under the influence of mescaline.

> The vase contained only three flowers—a full-blown Belle of Portugal rose; shell pink with a hint at every petal's base of a hotter, flamier hue; a large magenta and cream-coloured carnation; and, pale purple at the end of its broken stalk, the bold heraldic blossom of an iris . . . the little nosegay broke all the rules of traditional good taste. At breakfast that morning I had been struck by the lively dissonance of its colours. But that was no longer the point. I was not looking now at an unusual flower arrangement. I was seeing what Adam had seen on the morning of his creation—the miracle, moment by moment, of naked existence.[37]

In seeking what Huxley called 'the repeated flow from beauty to heightened beauty,' within what you are observing and becoming—this nosegay of flowers, the 'suchness' of this grain on wood—it is helpful to adopt a mode of reverence towards the object of sight. Hindus describe this act of reverential seeing as *darshan*, sometimes translated as 'auspicious sight'. Beholding something reverentially can become in itself an act of worship.

John Ruskin, who spent much of his life seeking answers to the question of how we can possess the beauty of places, was clear in his conviction about the importance of drawing as an aid to seeing. For him both drawing and writing were not important in themselves but supremely valuable as helping us to see: to notice rather than to look; to meditate rather than to glimpse. He believed (and taught) that in the process of hard looking we could move from a position of observing beauty in a generalized kind of way to one where we acquire an

understanding of its constituent parts and hence a more intentional memory of it. In Ruskin's account drawing allows us, 'To stay the cloud in its fading, the leaf in its trembling, and the shadows in their changing.'

As he says, the rewards were considerable:

> Let two persons go out for a walk; the one a good sketcher, the other having no taste of the kind. Let them go down a green lane. There will be a great difference in the scene as perceived by the two individuals. The one will see lane and trees; he will perceive the trees to be green, though he will think nothing about it; he will see that the sun shines, and that it has a cheerful effect; and that's all! But what will the sketcher see? His eye is accustomed to search into the cause of beauty, and penetrate the minutest parts of loveliness. He looks up, and observes how the showery and sub-divided sunshine comes sprinkled down among the gleaming leaves overhead, till the air is filled with the emerald light. He will see here and there the jewel brightness of the emerald moss and the variegated and fantastic lichens, white and blue, purple and red, all mellowed and mingled into a single garment of beauty. Then come the cavernous trunks and the twisted roots that grasp with their snake-like coils at the steep bank, whose turfy slope is inlaid with flowers of a thousand dyes. Is not this worth seeing? Yet if you are not a sketcher you will pass along the green lane, and when you come home again, have nothing to say or think about it, but that you went down such a lane.

Another procedure is also valuable: the deliberate cultivation of a path to the source. Encounters with the beautiful can take place unexpectedly, but sustained preparation—looking at beautiful images, listening to beautiful music, reading beautiful poetry, collecting and taking delight in beautiful things—can encourage a necessary receptivity of soul.

Beauty teaches beauty; it teaches us wonder and, of course, humility. It carries secrets that we cannot fathom with all our analytical tools. It reveals, as nothing else does, the poetry of truth and calls forth an alertness and generosity of attention.

Beauty, East and West

For the reader to appreciate why I was so captivated (by Tokyo by night) it is necessary to explain that Japanese towns, seen from ground-level and by daylight, are indescribably ugly. This applies both to big towns, like Tokyo, Osaka, Nagoya, and to small ones like Hiroshima, Sendai, or Sapporo; it applies to them all, I should say without exception. Even Kyoto, which ends by turning out to be one of the most fascinating places in the world, is at first sight a bitter disappointment.

What is the explanation of this fact in a country so sensitive to all forms of beauty? To find the answer it is necessary for a moment to note some of the basic differences in the outlook of East and West. With us there is something essentially sunny and radiant about beauty, which would make it absurd to want to conceal it; it is almost necessarily accompanied by a certain need of bright light. When Hegel says 'das Schöne ist wesentlich das Geistige, das sich sinnlich aüssert' (beauty is essentially a material manifestation of the mind), he is expressing a profound belief of the West.

Keats's 'beauty is truth, truth beauty' illustrates another aspect of our Western attitude. Not only must beauty shine out in the world, but is linked to subtle, ancient, and deep subterranean veins with truth. All our aesthetic thinking, from Aristotle to Croce, turns in the last analysis on the relations between truth and beauty. Thus our cities declare themselves in squares and avenues, colonnades and cathedrals. Their beauty is spread out in the sun, is constructed, organic. They are the children of the social order and technique, but also the children of dialectics and geometry.

In Japan, however, beauty is something which has to be worked for, earned; it is the reward for a long and sometimes painful search, it is the final attainment of insight, a jealously guarded possession; there is great deal of vulgarity about beauty which is immediately perceptible. The historical links of this aesthetic approach are not so much with truth and understanding; they take us at once into the fields of intuition—illumination (satori), taste (shumi), and the heart (kokoro). In one way it can be called a romantic attitude to beauty; from another angle it can be said that, as the beautiful is always recondite, it is an aristocratic attitude.

Hence it follows to associate a town, the place where everyone comes and goes, the public domain par excellence, with beauty would be absurd. Japanese towns are always

mere tools for working and living in, impermanent entities serving mere practical ends. They contain beauty, of course, but first of all you must desire it and seek it out, and then, perhaps, in the end it may be granted you to find it. Then, if you find it, it will offer you subtleties unimagined elsewhere, among secluded gardens and temples, or villas where the most perfect communion between man is achieved. In Japan beauty is like an island, a whispered word, a moment of pure intoxication to be retained in the memory for ever.

FOSCO MARAINI, *Meeting with Japan*, 1959

Some Origins
of Beauty

Behind the cotton wool of daily reality is a hidden pattern. All human beings are
connected with this; the whole world is a work of art and we are part of it.
VIRGINIA WOOLF[1]

THE NATURE OF NATURE

Although human ingenuity makes various inventions, corresponding by various machines to the same end, it will never discover any inventions more beautiful, more appropriate or more direct than nature, because in her inventions nothing is lacking and nothing is superfluous.
LEONARDO DA VINCI

In his study of the Bedouin, the nomadic camel-breeding tribes of the Arabian desert, Wilfred Thesiger confirms how unmoved the desert peoples were by that which excited in him a deep emotional response: 'When we returned from Mugshin the year before,' he writes in *Arabian Sands*, 'and had come out from the void of the desert on the crest of the Qarra range and looked again on green trees and grass and the loveliness of the mountains, I turned to one of them and said, 'Isn't that beautiful!''. He looked, and looked again, and then said uncomprehendingly, 'No—it's rotten bad grazing.' And then Thesiger adds an important coda to which I shall return later in this book. 'Yet their kinsmen in Hadhramaut have evolved an architecture which is simple, harmonious and beautiful.'[2]

The Bedu's response to Thesiger's exclamation about the beauty of the landscape is confirmed by my own experience of the farmers, farm workers and gamekeepers amongst whom my wife and I have lived for more than half a century; for them their countryside is very largely and understandably evaluated on the basis of such practical criteria as, for example, the condition of the soil and weather. They think it fully understandable to enjoy the loveliness of nature—'Lovely day, isn't it?', my neighbour Geoffrey Lake will say on a bright May morning—but I think I'm right in saying that he won't take delight in the rare tones of a cloud formation or the subtlety of its shifting forms. Imprisoned by the sheer implacability of the fertility cycle—spring-birth, winter-death and in between, the harvest—for him nature or rather farming has one and only one imperative: the next job to be done, and in the final analysis, the economic livelihood of his family.

It is poverty rather than aesthetics that has been the dominant, recurring theme of English rural life for centuries. For the local farmer, as for Thesiger's Bedouin, a tamed, inhabited and productive landscape *is* beautiful. Like the Tudor antiquarian John Leland, their admiration is largely limited to 'marvellous

fair meadows', 'good corn ground', 'goodly gardens, orchards and ponds'.

Appreciation of natural beauty for its own sake is a relatively recent phenomenon. It is no coincidence that the birth of European landscape painting which emerged in the latter years of the sixteenth century and the beginning of the seventeenth more or less coincided with the rise of a consciousness committed to scientific measurement and observation. Nor is it a coincidence that some of Europe's greatest landscape painters, Rubens (who died in 1640), Nicholas Poussin (d.1682) and Claude Lorraine (d.1682), were the near contemporaries of Galileo (d.1642), Descartes (d.1650) and John Ray (d.1705).[3] But it was only in the nineteenth century, when the British countryside began to be threatened by the growth of industry, transport and population (by 1850 half the population of England and Wales was already urban), that landscape painting became something of a popular norm. By the time John Ruskin reached the third volume of his *Modern Painters* in the middle of that century, he realized this, and wrote a section entitled *Of the Novelty of Landscape* in which he claims that humanity has almost acquired a new sense. He concludes: 'The simple fact, that we are, in some strange way, different from all the great races that have existed before us, cannot at once be received as proof of our own greatness; nor can it be granted, without any question, that we have a legitimate subject of complacency in being under the influence of feelings with which neither Miltiades nor the Black Prince, neither Homer nor Dante, neither Socrates nor St. Francis, could for an instant have sympathized.'

If I turn my head to the left of the table where I am writing, I see a panoramic landscape: fields divided by a network of hedgerows, many trees, something of a coppice and on the horizon, the distant curvature of Dartmoor's blue hills. I have known this landscape in all weathers and in different seasons for over thirty years. But what I am seeing must have been mediated by my culture: all that I have read (Rousseau, Wordsworth, Edward Thomas, Thoreau, Hopkins, Raymond Williams, George Ewart Evans) and all that I have seen (Constable, Corot, Samuel Palmer, Turner, Monet, etc).

Thus my peculiarly English, twenty-first-century sensibility has taught me to see and respond to a landscape in ways alien to, say, the authors of the early epics, the sagas and Anglo-Saxon poetry, where references to nature are brief and hostile or dwell on its horrors, as in the description of Grendel's Mere in *Beowulf*. In the writing of the Anglo-Saxons the natural world is considered to be an enemy, whereas I consider it to be a benevolent but endangered friend.

As a latter-day Romantic, I experience nature without the concern of the

Romanian or Guatemalan peasant for making a living out of his land, but more akin to the manner in which Wordsworth's sister Dorothy experienced it— aesthetically. In a characteristically modern vision, on 24th October 1801 she observed a birch tree near her home in Grasmere: 'It was yielding to the gusty wind with all its tender twigs. The sun shone upon it, and it glanced in the wind like a flying sunshiny shower. It was a tree in shape, with stem and branches, but it was like a Spirit of water.'[4] Thus, like Dorothy Wordsworth, many present-day Romantics experience the beauty of nature not only as a continuous spiritual refreshment, but as an antidote to the noise, the crowding and blatant commercialism of modern life in the cities.

But there is an additional extension of our consciousness of nature; it is no longer simply 'Yorkshire', 'Cumberland', or the district where we live, but all the landscape that we have seen on our travels or on film. Furthermore, with the help of the microscope, time-lapse photography and advances in astronomy and microscopy, it is also the ancient world of cell formation and primeval microbial life. We stand in awe of information of which Dorothy Wordsworth had no direct experience.

We can also stand in awe at the beauty of the wild depths of the universe, depths in the process of being revealed by the magnification of the largest optical telescopes: immense voids—regions billions of trillions of miles across—in which no light seems to shine and in which no matter seems to exist; dark matter, quasars, galactic components, supernovae and our own Milky Way with its hundreds of billions of stars—perhaps a total of some one hundred thousand million stars (or suns), of which only six thousand can be seen with the naked eye. Just to gaze at photographs of these astonishing phenomena is to be awed by the primordial mystery of existence and its gorgeous, intricate, inventive, self-regulating, ever-evolving superlative *beauty*. It is a quality no less intrinsic to every one of these mighty manifestations of cosmic grandeur than the exquisite delicacy of a spider's web and a white iris flower.

SELF-ORGANIZATION

Nature uses only the longest threads to weave her patterns, so each small piece of her fabric reveals the organization of the entire tapestry.
RICHARD FEYNMAN[5]

The impulse for many natural and human systems towards self-organization has been known for some time, but it is only recently that James Lovelock's and

Lynn Margulis's hypothesis—the hypothesis of Gaia—has suggested that all life on earth is part of a single, indivisible, self-regulating system acting to preserve the conditions which make life possible. Similar perspectives have appeared in other times and places, going back as far as Plato's description of the *anima mundi*, the soul of the world. In the *Timaeus*, Plato describes the world as a living being with intelligence in soul, and soul as being 'woven right through from the centre to the outermost heaven'.

Contemporary philosophers have taken a fresh look at the idea that qualities of soul—which must include qualities of beauty—are not limited to human beings or perhaps even animals and plants, but in some sense belong to the earth—its stones, its seas and elements.[6] That the universe is alive, a living entity, there can it seems be less and less doubt, and that it is beautiful there can be none at all. As we have seen, the beauty of it runs deep into the heart of every cell, every plant, every animal and tree, the interior world of the oceans, the mountains and the deserts. Perhaps our hunger and quest for beauty is nothing less than a search for unification with the original and underling order of the universe? The deep response we feel for it is engendered by our empathy for the ordered complexities of nature.

To think like this—that everything in the universe is inherently related to everything else, to acknowledge the importance of reciprocity, mutual support and concern for the welfare of the other, even to believe that the principle of consciousness must extend to all beings and the Earth itself—is to revise our current understanding of the cosmic significance of love. Love becomes, as Dante taught, the primary quality of the universe; not marginal but intrinsic; not desirable but essential, not isolated but ubiquitous. Interestingly enough, Peter Sterry saw the importance of the connection between the two primary experiences when he decided that: 'The Object of Love is loveliness or beauty.'[7]

There is only minimal reference to either love or beauty in the scientific literature; the subjectivity of experience has been ignored within a discipline solely committed to quantity, calculation, certainty and measurement. In fact as far as I know, mainstream science has never offered an explanation, Darwinian or otherwise, for the existence of beauty; beauty is absent from the contents pages and indexes of nearly all the scientific books I have perused. The discipline is more committed to the matter of selfish genes (the choice of mates and the sexual drive) and chemical reactions within the brain than to our spontaneous sensory experience of living on this Earth—experiences of love and beauty intimately known to everyone alive.

BEAUTY AS A GUIDE TO TRUTH

Nonetheless, although beauty is an intangible concept, it continues to provide a source of inspiration for the professional scientist. In some cases, when the road ahead may be unclear, mathematical elegance is at hand to guide the way. As the great physician Heisenberg observed to Einstein, 'If nature leads us to mathematical forms of great simplicity and beauty . . . that no one had previously encountered, we cannot help thinking that they are 'true', that they reveal a genuine feature of nature.'

Heisenberg went on to discuss 'the almost frightening simplicity and wholeness of the relationships which nature suddenly spreads out before us,' a theme echoed by many of his contemporaries. Paul Dirac went so far as to declare that 'It is more important to have beauty in one's equations than to have them fit an experiment.' The point that Dirac is making here is that a leap of creative imagination can produce a theory which is so compelling in its elegance, its beauty, that physicists may become convinced of its truth before it has been subjected to experimental test, and even in the face of what appears to be contradictory experimental evidence.

According to Graham Farmelo,[8] the concept of beauty was especially important to Einstein. According to his letters to his son Hans, 'He had a character more like that of an artist than of a scientist as we usually think of them. For instance the highest praise for a good theory was not that it was correct or exact, but that it was beautiful.' He once went so far as to say that 'the only physical theories that we are willing to accept are the beautiful ones,' taking it for granted that a good theory must agree with experiment.'

Dirac was even more emphatic than Einstein in his belief in mathematical beauty as a criterion for the qualities of theories. In the latter part of his career he spent much time touring the world, giving lectures on the origin of the equation which bears his name, stressing that the pursuit of beauty had always been a lodestar as well as an inspiration. During a seminar in Moscow in 1955, when asked to summarize his philosophy of physics, he wrote on the blackboard in capital letters, 'Physical laws should have mathematical beauty.'

Evidence of nature's underlying mathematical harmonies has existed for centuries, and they were comprehended by the ancients. The Golden Section was known to the Etruscans, the Egyptians and the Greeks. Pythagoras, the

Greek geometer, was especially interested in it; he showed how the Golden Section was the basis for the proportions of the human body. He also demonstrated that the latter is built with each part in a definite golden proportion to all the other parts.

After the Greeks, who made use of the Golden Section in the design of their temples such as the Parthenon (see page 73), in Europe it sank away into the background until the Renaissance and the discoveries of another influential mathematician, Leonard Fibonacci.

Fibonacci was the nickname of the monk Leonardo of Pisa, whose book on arithmetic, *The Liber Abaci*, was a standard work for two hundred years and is still considered the best book on the subject. It was Fibonacci who discovered the existence of a significant sequence of numbers: 1, 1, 2, 3, 5, 8, 13, 21, 34, 55, 89, 144, 233, 377, 610, and so on, each new number generated by the sum of the two previous ones. This series underlies many features of the natural world: it determines the number of leaves grown and extended by any plant for optimum chlorophyll production. It also governs the spiral seed display on pineapples, the spirals generated by snail shells and the chambered nautilus; the horn configuration of deer and antelopes; and the mating patterns and number of generational descendants of bees, rabbits and other small mammals, even insects. One of the most spectacular examples of the Fibonacci Series can be seen in the head of an ordinary sunflower. Scientists have measured the number of its spirals and found not only one set of short spirals going clockwise from the centre, but also another set of longer spirals going anti-clockwise.[9] These two sinuous spirals reveal the astonishing double connection with the Fibonacci Series:

> *The pairs are always adjacent numbers in the Fibonacci series*
> *e.g. one pair could be 21 and 34 and the next pair could be 34 and 55*
>
> *The adjacent numbers divided yield the Golden Section*
> $34/55 = 0.618$ or $55/34 = 1.618$

In nature lies the deepest harmony which makes ugliness alien to it. This harmony is suggestive of some hidden principles at work. 'Beauty in Nature,' observes Eric Newton in *The Meaning of Beauty*, 'is a product of the mathematical behaviour of Nature, which in its turn is a product of function; whereas beauty in art is a product of man's love of . . . the mathematics of Nature.'[10]

At this point it may be of interest to look at, as it were, the reverse side of the picture: not at nature as the artist's inspiration, but at nature as the artist. One example of this unconscious propensity is famously found in the activities

of the orange-crested gardener bird (*Amblyornis subularis*) which lives in the mountain forests of New Guinea.

To attract its partner, this little bird constructs an elaborate bower. Its central stem is carefully built around a young sapling which has been surrounded by velvety moss. The central divide is also marked by carefully positioned yellow flowers, and two collections of objects arranged on a platform on either side of it. The left-hand side is decorated by embedding the moss with dozens of iridescent blue beetles, while the right-hand side is composed with pieces of carefully selected blue snail shell. Boldly enhanced by rows of coloured fruits, the front of the platform is embellished with a network of tightly-woven twigs. The stage has been set for the live action, a courtship dance.

Once sighted, a female bird calls forth the male who, displaying his orange crest to advantage, excitedly dances. And if he and his work are sufficiently impressive, she will be attracted and eventually join the dance.

SACRED GEOMETRY

It is the magic of mathematics, the rhythm which is in the heart of all creation, which moves in the atom, and, in its different measures, fashions gold and lead, the rose and the thorn, the sun and the planets.

These are the dance-steps of numbers in the arena of time and space which weave the maya, the patterns of appearance, the incessant flow of change, that is ever and is not.

It is the rhythm that churns up images from the vague and makes tangible what is elusive. This is maya; this is the art in creation and art in literature which is the magic of rhythm.

RABINDRANATH TAGORE[11]

Elements of the ordering process, sometimes associated with mathematical harmony, are to be found in all the arts. The mystique of number goes back a long way—to the pyramids of Egypt, the ziggurats of Mesopotamia, the temples of the Hindus, the cathedrals of the Christians and Islamic mosques. In the Judaic tradition it began as early as the time of Moses, when he was told to make a holy tent (a tabernacle) according to the measurements which he had been shown by God on Mount Sinai, and to the measurements of the Temple of Solomon, whose proportion were given by Yahweh to King David.

In the early centuries of Christianity, this tradition from Moses and Solomon was grafted onto the Greek philosophy of numbers and geometric proportions, as propounded by Pythagoras and Plato. Hebrew and Greek traditions

thus combined to create what is known as Christian Platonism. And these, expressive of deeply held symbolical and metaphysical beliefs, were influential in the design of many of the Gothic cathedrals, Chartres in particular.

In his magisterial study of this building, Titus Burckhardt writes: 'The use of a modal or geometric "governing pattern"—which itself remains hidden, but which nevertheless harmoniously unites the various parts of a work—is in the last analysis the expression of a particular spiritual perspective, which Dante formulates as follows: *Le cose tutte quante hann'ordine tra loro: e questo è forma che l'universo a Dio fa simigliante.* (All things whatsoever observe a mutual order; and this is the form that maketh the universe like unto God.)'[12]

The selfsame spiritual perspective is to be found in the Islamic tradition where a love of arithmetic especially geometry, number, and numerical symbolism is also directly connected to the essence of its message, which is the doctrine of Unity (*al-tawhid*). God is One. Hence, writes Seyyed Hossein Nasr, 'The number one in the series of numbers is the most direct and intelligible symbol of the Source. And the series of numbers themselves is a ladder by which man ascends from the world of multiplicity to the One.'[13] Elsewhere the same authority writes: 'From sublime treatises on metaphysics to pottery used in homes, one is faced everywhere in the Islamic world with an order and a harmony directly related to the world of mathematics understood in its traditional sense. Likewise, it is because of this element within the total spectrum of Islamic spirituality that Muslims became attracted to the various branches of mathematics early in their history and made so many contributions to the mathematical sciences for nearly a millennium.'

But if the role of sacred geometry was pronounced in both Islamic and Gothic architecture, it is also found in the context of the buildings and paintings of the Florentine Renaissance, where the architects Brunelleschi (1377–1446) and Alberti (1404?–1472) designed buildings largely dependent on a mathematical system of harmonic proportions. It was Alberti who defined beauty as 'a harmony and concord of all the parts, so that nothing could be subtracted except for the worse.'

His façade for Sta Maria Novella in Florence is an example of his philosophy of beauty, widely copied by later architects. What Alberti does is to divide the whole space in such a way that the height is equal to the width, thereby forming a single large square. This is then further subdivided halfway up its height by the base of the scroll forms which he introduced to hide the aisles. The lower part of the façade, divided by the main door, thus forms two squares,

each of which is one quarter of the large square. The upper storey screening the end of the nave and crowned by a classical triangular pediment is of exactly the same size as the two lower squares below it. This division into proportions as simple as one-to-one, one-to-two, one-to-four, is characteristic of all Alberti's work. It is this dependence on mathematics in both Brunelleschi and Alberti which marks the decisive break between them and their predecessors.

To conclude this short survey of the role of the mystique of number in the creation of beauty, I turn to Piero della Francesco, whose art was also shaped by his sense of a lucid and rigorous system of measurement. One has only to see his *The Flagellation* (see page 97) to sense its underlying mathematical perfection: it is not merely a masterpiece of perspective, but of the most perfect and precious harmony. Clearly, for Piero the work involved was no intellectual game, but an intellectual revelation of the divine.

ANOTHER EXPLANATION: PLATONISM

If geometry permeated the minds of the Islamic pattern-makers, Platonism permeated the minds of the founders of Gothic architecture. The early philosophy of Beauty, promulgated by Plato and his follower and interpreter Plotinus, has been hugely influential. Numberless European poets and artists have believed it to be the necessary foundation of all imaginative art. These include Dante, Botticelli, Raphael, Michelangelo, Milton, Spenser, Traherne, Blake, Coleridge, Wordsworth, Keats, Shelley, Samuel Palmer, Edward Calvert, Yeats and T. S. Eliot.

Plato's theory revolves around the supremacy of the soul's cognition over the sensory apprehension of the world of appearances. It proposes the existence of a transcendental archetype as the one stable reality—a reality that underlies, motivates, and orders the flux of all phenomena. According to him the realm of Beauty exists at a deeper, timeless order of absolutes behind the surface confusion and randomness of the temporal world. 'This Beauty, in the first place, is everlasting, not growing and decaying, or waking and decaying; secondly, it is not fair from one point of view and foul from another, or in one relation and in one place fair and at another time or in another relation foul, so as to be fair to some and foul to others ... but Beauty absolute ... Beauty itself, entire, pure, unmixed ... divine, and coessential with itself.' In other words, nothing in this world *is*, because everything is always in a state of becoming

something else. But the transcendent archetype does enjoy real being, as distinguished from merely becoming, and it exists in the realm of Ideas of which Beauty is one of the major embodiments.

Plato proposes that the soul is immortal (existing before birth as well as after death), obtaining knowledge of this eternal reality before it enters into the body at birth. In this myth the soul 'descends' from an eternal world or state, undergoes experience and suffering in the world of generation, and then returns to her native purity. Yet the postnatal condition of bodily imprisonment causes the soul to forget the true state of affairs. In this world of generation, Beauty is then veiled, and it is the philosopher's and the artist's task is to 'recollect' the transcendent Ideas, to recover a direct knowledge of the source of all things. Something then is 'beautiful' to the exact extent that the archetype of Beauty is present in it. Thus works of art are perfect in so far as they are embodiments of the eternally perfect and inherent forms. This myth had an important influence on Plotinus.

Plato's cardinal doctrine is based then on the postulation of the existence of two parallel worlds: a world of sense, transitory and always in flux (it is the here and now of our earthly existence); and a unified world of what he called Ideas (or Forms), not available to our senses but only to the intellect, which in its highest state has direct access to the Ideas governing reality. The number of Ideas is numerous and includes such timeless essences as the mathematical forms of geometry and arithmetic; such opposites as male and female, love and hate, unity and multiplicity, the forms of man (*anthropos*) and the Ideas of the Good, the Just and the Beautiful. These are the transcendent entities, and they exist independently of both the phenomena they order and the human mind that perceives them.

It is crucial to the Platonic understanding that Ideas are primary, while the visible objects of everyday temporal reality are their direct derivatives. Richard Tarnas explains: 'Platonic Forms are not conceptual abstractions that the human mind creates by generalizing from a class of particulars. Rather they possess a quality of being, a degree of reality, that is superior to that of the concrete world. Platonic archetypes form the world and also stand beyond it. They manifest themselves within time and yet are timeless. They constitute the veiled essence of things. Thus something is "beautiful" to the exact extent that the archetype of Beauty is present in it ... For when one speaks of something as "more beautiful" or "more good" than something else, the comparison can be made only against an invisible standard of absolute beauty or goodness—Beauty itself and the

Good itself. Everything in the sensible world is imperfect, relative and constantly shifting, but human knowledge needs and seeks absolutes, which exist only on the transcendent level of pure Ideas.'[14]

Plato believed that the soul's task in its thousand-year cyclical journeys is to strive towards the eternal values and escape from the contamination of the flesh. He also believed that we carry within our souls a latent knowledge of an order inherent within it, a wholeness, a harmony to which the outer life is scarcely even an approximation. So whatever is congruent with the ground of our nature seems to us beautiful. The square, the circle, the laws of geometry and number are, in this sense, intrinsically satisfying to some innate sense of order.

During the centuries following Plato's death in the middle of the fourth century BC, numerous philosophers sustained and developed his thought by amplifying its metaphysical and religious aspects. Plato himself was already a strongly religious philosopher, but under Plotinus it became more exclusively a religious and moral philosophy. This philosophy is nowadays called Neoplatonism.

Features of Neoplatonism include the highest transcendent principle, a divine Intelligence of perfect wisdom and goodness, 'the One', with the Platonic Ideas or Forms generally held to be the thoughts of this supreme God, existing eternally in His mind. It is He who makes the material world on their pattern. There is also an emphasis on 'the flight from the body' as necessary for the soul's philosophical ascent to the divine reality. Plotinus urges us to turn away from 'the profound and horrid darkness' of material life. 'Let us depart from hence,' he writes, 'and fly to our father's delightful land.' According to him, the material world perceptible to the senses is the level of reality furthest from unitary divinity; and the human being, whose nature is soul-in-body, can only enjoy access to the highest intellectual and spiritual realms by means of his or her liberation from materiality.

Whereas Plato never loses sight of the fact that his ultimate aim is the betterment of society, Plotinus ignores the social needs of people and concentrates upon the mystical union of the soul with God. He is concerned less with justice or happiness on earth than with rapture in heaven—an ecstasy which is the product of mystical contemplation and unification with the 'One' which is the ultimate source of all things, rather than of intellectual research into causes. Yet like other mystics, Plotinus describes (in the *Enneads*) his union with the One in ways which make it clear how he experienced that everything is one with everything else.

The *Enneads* contains a fine and influential chapter, *Beauty*. Here is its opening in Stephen MacKenna's famous translation:

> Beauty addresses itself chiefly to sight; but there is beauty for the hearing too, as in certain combinations of words and in all kinds of music, for melodies and cadences are beautiful; and minds that lift themselves above the realm of sense to a higher order are aware of beauty in the conduct of life, in actions, in character, in the pursuits of the intellect; and there is the beauty of the virtues.[15]

Keats read this essay in Thomas Taylor's translation of 1792, and so it seems had Wordsworth and no doubt other Romantic poets, too. Yeats knew it in MacKenna's translation, some of which he says he had read several times. And Yeats was a devotee of beauty.

Others influenced by Plotinus include Marsilio Ficino, Giordano Bruno, Spinoza, Berkeley and Hegel. The German poets Novalis and Goethe were also interested in his ideas. More recent poets include T. S. Eliot and Ezra Pound, whose *Cantos* are surely Neoplatonic in origin.

Varieties of Aesthetic Experience

The mind of a new baby is no *tabula rasa* waiting to be filled with the experiences of civilization. The infant has a family and a future determined and limited by biology. These are factors which will have a powerful influence on his or her future behaviour, development and beliefs. So it is with the beautiful when it is an aspect of what we call a work of art.

Works of art come into being rooted within the context of a particular time and culture, a culture whose aspirations, history, language and belief-systems can differ very widely from that of others. Some societies are quite sedentary, their tools designed to enhance life as fishermen or farmers. Some are mobile; others traditional with a belief that all perceptible objects are in some way living; others secular with a belief that the same objects are in some way dead. Some are based on small-scale human settlements, others have developed with huge and specialized populations. Some, too, are highly refined with superb accomplishment in the arts and crafts while yet others place their emphasis on comfort and materialism.

Let us consider one of the oil sketches of skies which John Constable painted in London in the early years of the nineteenth century and, by way of contrast, a small religious panel by Giovanni di Paolo painted in Siena in the middle of the fifteenth; in each case the subject matter is different, the destination of the picture was different, the role of the artist in society was different, the technique is different and so are the media—in almost every respect the work by Constable is different from the work by the Sienese. Thus the two artists produced work not only personal to themselves but influenced by their time, their place and its prevailing assumptions. Giovanni di Paolo could not have painted naturalistic clouds because his culture was uninterested in the objective observation of meteorological phenomena, and Constable could not have painted the *Birth of St John Baptist* because his culture was broadly indifferent to the idea of illustrating biblical themes. Each artist produced beautiful works, but the beauty of the Constable is not that of the Giovanni di Paolo. We love their work in different ways and for different reasons.

Or, if that is insufficient to make my meaning clear, let us look at two other things: a simple but elegant North Cheyenne deerskin dress with its extensive beadwork and tinklers, and the formal court attire of the time of

Marie-Antoinette—one as natural and inexpensive as can be imagined, the other both costly and artificial. Nonetheless, both are beautiful.

Thus the beautiful is a universal value but one that clothes itself in an extensive variety of forms and an infinite variety of manifestations. The beauty of the bluebell is different but no less marvellous than the beauty of the dandelion; the beauty of the magnified patterns on the surface of an olive leaf is no less wonderful than the beauty of Saturn's rings; the beauty of a young girl is no more marvellous than the beauty of an old woman—as Rembrandt revealed to us in the wonderful painting of his aged mother. The beautiful recognizes no boundaries, no 'language', style or creed. It simply *is*.

In this chapter I hope to describe a variety of works emanating from a selection of different cultures each expressive of their respective spiritual realms and associated feelings. In the first part I consider the art of some of the 'ideational' cultures—Buddhist, Hindu, Orthodox, Islamic, Zen and early Christian—and in the second half, the art of the Humanist or 'sensate' phase of European history which lasted from the Italian Renaissance until the late nineteenth century.

A SHORT INTERLUDE ABOUT SOROKIN

At this point, having mentioned the concepts of ideational and sensate, it would perhaps be as well to introduce Pitirim Alexandrovich Sorokin,[1] who invented both these terms.

In this book his theory has only an incidental role, but an important one in its overall design; it provides a valuable foundation on which to build an interpretative framework. Like the great Muslim scholar Ibn Khaldun,[2] Sorokin explored a cyclical interpretation of history, the idea of one culture collapsing and being replaced by another. The cycle is one of many efforts throughout history to find meaningful patterns in time.

Sorokin was a Russian emigré writer, the son of an icon-maker and silver worker. He enjoyed the distinction of being jailed by both the Tsarist government and the Soviets before emigrating to America, where he became the founding Chairman of the Department of Sociology at Harvard. Under his leadership, the university became a major centre for this new social science. Sorokin wrote a number of books elucidating his ideas about the evolutionary cycle of civilizations, tracing his theme through the rise and fall of ancient Greece, Rome, mediaeval Christendom, and England after the Reformation.

In these books he developed the argument that in the early stages of a civilization truth is not a matter of observation but of authority. Religion rules supreme, underpinned by sacred texts and ancestral wisdom, amended by revelation to sanctified officials in dreams or intuitions, and enforced by stringent codes of conduct. Law and morality are strict; art and literature are limited to religious themes and drama exists only as religious ritual. Sorokin categorized this phase in the development of a civilization as 'ideational'.

Ideational art, which includes the art of the Hindus, the early Christian, Buddhist and Islamic cultures, had one major premise—that the true reality-value is God—and one theme: His supersensory kingdom. 'Its "heroes",' writes Sorokin, 'are God and the other deities, angels, saints and sinners, and the soul, as well as the mysteries of Creation, Incarnation, Redemption, Crucifixion and Salvation, and other transcendental events. It is religious through and through . . . Its objective is not to amuse, entertain or give pleasure, but to bring the believer into a closer union with God. . . . Its emotional tone is pious, ethereal and ascetic. . . . Wholly immersed in an eternal supersensory world, such an art is static in its character and in its adherence to the sanctified, hieratic forms of tradition.'

We can surely recognize these characteristics in, say, the great bronze Buddha in Kamakura[3] and the hieratic figures of the Royal Portal at Chartres.[4]

The successor phase to the ideational, which was categorized by Sorokin as 'sensate', is characterized by features that are almost diametrically opposite. 'Sensate art,' he writes, 'lives and moves in the empirical world of the senses. Empirical landscapes, empirical man, empirical events and adventures, empirical portraiture —such are its topics. . . Its aim is to afford a refined sensual enjoyment: relaxation, excitation of tired nerves, amusement, pleasure, entertainment. For this reason it must be sensational, passionate, pathetic, sensual and incessantly new . . . Its style is naturalistic, visual, even illusionistic, free from any super-sensory symbolism.' Examples of sensate art could include the paintings of Watteau and Claude Monet.

It is of interest to note that the word aesthetics, invented by Alexander Gottlieb Baumgarten,[5] an eighteenth-century German philosopher, was defined as 'the science of sensuous knowledge'. 'The end of Aesthetics,' Baumgarten wrote, 'is the perfection of sensuous knowledge as such; this is beauty. The defect of sensuous knowledge is ugliness.'

In this chapter, following a consideration of some examples of ideational art, we will turn our attention to the successor culture: the sensate art of

Renaissance and post-Renaissance Europe. At a later stage we will consider the crisis of our present over-ripe sensate culture and the beginnings of the transition which, according to Sorokin, could lead from this to a new ideational phase (see also page 107).

1 · The Art of the Ideational Cultures

THE VERNACULAR APPROACH TO THE 'ARTS'

Art is the introduction of order and harmony into the soul, not of trouble and disorder. . . . If an artist does not accomplish the miracle of transforming the soul of the spectator into an attitude of love and forgiveness, then his art is only an ephemeral passion.
NICHOLAS GOGOL

Some explanation about the word I have placed between inverted commas—'arts'—may provide a helpful introduction to the subject at this stage. The inverted commas are intended to draw a distinction between, on the one hand, the European's self-conscious, self-expressive and individualistic art within the context of what might be described as *l'art pour l'art* aesthetics, and on the other the almost impersonal aesthetics of the indigenous peoples whose 'art' originates from a different source: the unselfconscious dimension of their productive lives. Of the many thousands of different cultures I could have chosen to consider, I will start by discussing the culture of the Native North Americans. There is no particular reason for this choice except that their work illustrates very well some points I would like to make (see Plate V).

As far as I know, among the 9,000 original native tribes, there were no professional artists. Everyone participated, and everything, however decorative, was basically intended for a functional purpose. In fact, in the hundreds of native American languages, not one word comes close to our understanding of art or, for that matter, close to our understanding of religion.

For the Native American, everything was religious. Yet it was a religion informed by a spirituality so pervasive that when the first missionaries arrived in America, they missed seeing it entirely. Because they saw neither priests or churches, they concluded that the indigenous people had no religion. Yet their world was the exact opposite; it was a world circumscribed, empowered and characterized by spirituality. Even the embroidered symbol on a shirt

or the design of their sweat lodges and tepees had metaphysical meanings.

For the Native Americans, art and religion, art and life, were not separate; nor were the beautiful and the functional.[6] Art, beauty and spirituality were so firmly intertwined that words neither existed nor were needed to separate them. This wholeness was a function of the fact that everything in their universe worked together: poetry didn't exist apart from ritual, and ritual didn't exist apart from vision and meditation and even healing. This philosophy of relating all life and all materials permeated even the simplest of objects—a Pawnee drum, a pair of slippers or a Crow Medicine Bag.

Yet, in spite of the number and wide diversity of native tribes and their huge geographical spread—some from the forests, some from the plains, some from the cold north, some from the heat of New Mexico—a North American artifact is broadly speaking recognizable as such. It is characterized by sensitivity to nature and a heart-stopping natural elegance. But this is an elegance so far removed from the European's use of colour and materials that it takes time to get used to. Natural and sacred materials—skin, bone, wood, suede, feather— keep their integrity in spite of their passage through human hands. Although their 'art' is often characterized by a dry and dazzling elegance, no sign or symbol is based on aesthetic choice alone (see page 120).

THE GREEK VIEW OF BEAUTY

The Parthenon, Athens, Greece, 432 BC

Philosophers of history have long been justified in characterizing the whole Greek epoch as pre-eminently that of Beauty.
G. LOWES DICKINSON

My discovery of the beauty of Greek art and architecture (see Plate III) dates from 1962, when I visited Greece for the first and only time. Every morning for about a week I climbed the Acropolis, the great isolated slab of limestone upon which the Athenians built their sanctuaries and temples, the most celebrated of which is the Parthenon.

This was a revelatory experience. In the Parthenon I saw a beauty absolute, a beauty greater than I had ever experienced before or had been prepared for by my 'education'. It is impossible to speak of beauty without speaking of form, and the harmonious perfection of this building has haunted me—and countless others—ever since.

The Parthenon, dedicated to the Athenians' patron goddess, Athena, was begun in 438 BC and completed six years later (apart from its sculptures, which took another six years to complete). The architects were Ictinus and Callicrates, working in some sort of partnership, and they designed the building on a magnificent scale. It was the largest Doric temple on the Greek mainland, but the fame of this building rests not so much on its size as on its beauty: the flawless harmony of its proportions, the subtlety of its forms and the refinements of its structure, honed to an incomparable perfection. (According to A. W. Lawrence, the errors made when laying it out total a mere quarter of an inch.) Although it is now in ruins, it is in the eyes of many the most beautiful temple, even the most beautiful building, in the Western world.

The perfection of the Parthenon was the result of the coexistence of a number of unrepeatable elements: civic identity, a festival of the greatest religious importance, the cultivation of the arts, the employment of the finest materials, the existence of highly sophisticated mathematical knowledge and a skilled artisan class. For me, not then knowing much of this background, the result astonished nonetheless. It showed that 'mere' matter—marble and space—could give expression to the affirmative wonder and nobility of life. Chartres had taken my breath away with its soaring transcendence, but this building was different: it was rooted; it was not God-like but human; it was a place that could raise those who worshipped there to a finer human consciousness. It possessed a beauty which, as always, I desired to appropriate for myself.

I had read that its architects had introduced refinements to give life to the design and correct optical illusion—perspective and foreshortening had been countered by means of scarcely perceptible distortions, and curved lines had been introduced to counter other visual illusions (*entasis*). But when I saw the building with my own eyes, I could not have imagined the importance of these adjustments, which gave it an absolutely perfect balance; a balance between heaven and earth, between man and the gods, between its spirit of celestial brightness and the pull and power of the elemental rock on which the Parthenon is built. The building celebrates a shining intellectualism—control and clarity—but at the same time a mysterious counterbalancing imaginative passion. Unlike so many other classical buildings—the British Museum, for example—it is not a cold exercise in classicism but something lying between fire and ice; something at once calculated and restrained, sensual and imaginative. In some way I sensed that its primary impulse had been to defy the enormity of death by the creation of an artifact which time could not harm.

The power of the building has been diminished but not destroyed by over two thousand years of abuse: its partial destruction in 1687 by an explosion of gunpowder during the siege of Athens by the Venetians, the removal of its sculptured frieze and figures from the pediments by Lord Elgin, further clearance of stones from the site, weather erosion and so forth. As you walk around it, as I did on numerous bright June mornings before the armies of tourists reached the site, the spell of its beauty can be overwhelming.

THE ORTHODOX VISION

Hagia Sophia, Istanbul (532–7)

The cathedral church of Constantinople — the church containing the cathedra (seat or throne) of the city's bishop—is unusual in that it was never dedicated to a saint, but to an idea or attribute of God, namely Wisdom. It is Hagia Sophia, meaning Holy Wisdom. After 1453 the massive building, originally a church, was converted into a mosque, and in 1935 into a museum. Today it is the shuffling feet of tourists that are heard, rather than chant.

The building we are visiting, the third on the site, is in large part the St Sophia erected on Justinian's orders in the sixth century. Until that time, no building of even half its present size had ever been undertaken, and it has been suggested that no architect of the time could have calculated the thrust that would be generated by a masonry dome seeming to hover some 56 metres above the floor. Yet the task was achieved by Isidoros of Miletos and Anthemios of Tralles, a Greek from Asia Minor. Both were mathematicians in the Graeco-Roman tradition. Isidoros edited the works of Archimedes, as well as writing a commentary on the technical treatise on vaults by an earlier mathematician, Heron of Alexandria.

The audacious plan of these two 'architects' involved placing a vast dome on a square base of 30.95 metres (c.100 Byzantine feet), supported at a height of some 41.5 metres (c.136 Byzantine feet) above the centre of the building. The resulting thrust was then carried on four great arches. Yet remarkable as this achievement most certainly was, the church of Hagia Sophia is much more than a colossal engineering feat: in it, weighty stone somehow undergoes a metamorphosis into spirit. Its solid walls cease to be barriers and become like passages into a higher reality; the threshold of another world, a level of reality

that exists beyond this commonplace one. Thus the beauty of this building belongs to the sphere of the invisible, the supernatural life. Its vast interior, clad in coloured marbles, coloured inlays and glimmering gold-backed mosaics, glows with a refulgent richness. And today, even without the aid of the liturgy, the chant, the incense and the candlelight which once echoed throughout, scenting and illuminating its awesome spaces, even as a museum thronged with visitors, the building belongs to the transcendent realm. Here Blake's Gates of Perception had been opened so that and one could catch a momentary glimpse of the Divine.

No wonder Justinian, entering the completed building for the first time on 27th December 537—just five years, ten months and four days after the laying of the first stone—stood for a long time in silence before being heard to murmur: 'Solomon, I have surpassed thee.'

The Orthodox Icon, Novgorod, Russia

The Gospels were 'writing in words', but icons are 'writing in gold'.
ST THEODORE

Shortly before the end of the tenth century, the Grand-Prince Vladimir of Kiev was baptised, thus establishing the Christianity of the Byzantine rite as the official religion of his kingdom and its people. The sumptuous, mysterious ritual of the Orthodox Church was introduced into Rus (Old Russia), and with it the icon, those distinctive paintings which, rooted in Christian dogma, conformed strictly to Biblical and hagiographical prototypes.

I already had some minimal acquaintance with Orthodoxy; I knew something about the famous fourteenth-century icon painter Andrei Rublev, about whom Tarkovsky made his famous film, and was to some extent familiar with Russia's ancient bulbous-domed churches. But it was only on a visit to Novgorod and its Cathedral of St Sophia in September 1993 that my wife and I awakened to an art and architecture infused with a depth of spirituality almost unparalleled in any other age.

To see the cathedral of Novgorod, we had had to leave St Petersburg at the crack of dawn and travel on a freezing coach through a wintry, windswept landscape to reach our goal. But cold as it was, the cathedral was no disappointment; it was superb. Finished in 1050, it is the town's centrepiece and possibly the oldest building in the Russian Republic. It is crowned with five onion domes with a sixth over the stair-tower, each surmounted with gilded

crosses shining against the azure sky. The interior has very high proportions, painted mosaics and a dark iconostasis portraying Christ and the Virgin, St John the Baptist and various Evangelists. Here, unlike the interiors of such museums as Hagia Sophia and Le Thoronet (see page 82), there was the powerful presence of an ecstatic silence.

At the time of our visit the cathedral was empty (save for a small Orthodox wedding taking place), yet somehow it was far from deserted: one heard the bells ringing, heard the sound of the Russian Orthodox liturgy, smelt the fragrance of the incense and sensed the centuries of prayer which impregnated its spaces. To be there was to experience, as it were, something of the psalmody of angels; the hidden order of the beautiful through every one of the senses.

In the Orthodox tradition there is an explicit prescription that a place of worship should be beautiful. The directive comes from the fifth-century Dionysios the Areopagite, who taught that a church should be experienced as an image of the heavenly Church, and that everything within it should orient the worshipper toward the Celestial Court. The belief also comes from no less an authority than the Bible, which states in Psalm 27: 'One thing have I desired of the Lord, that I will seek after: that I may dwell in the house of the Lord all the days of my life, to behold the beauty of the Lord'. In short, an Orthodox service and an Orthodox church should be *beautiful*. According to a conversation I had with Metropolitan Anthony from the Orthodox church, it should be not only visually beautiful but beautiful to every other sense. The lavish employment of solemn ritual, stately processions, deep-throated chanting and rich vestments; the use of incense, candlelight and venerable images, all refer to a beauty beyond this world; ultimately to the Beauty of God.

Although my wife and I visited the excellent Novgorod Museum of History & Art, I confess to failing to remember any particular icon; yet there is an icon from Novgorod in the Tretyakov Gallery in Moscow, *Our Lady of Vladimir* (which I have never seen but know from reproduction), possibly painted by a follower of Theophanes. Here is something at once venerable yet as fresh as a May tree in flower, something imbued with the deepest theology but innocent, something deeply impersonal yet alive to the tenderness of motherhood.

One characteristic of the Russian icon which strikes the eye of the foreigner was summed up by the novelist Nicholas Gogol in 1848: 'Art is the introduction of order and harmony into the soul, not of trouble and disorder. . . . If an artist does not accomplish the miracle of transforming the soul of the spectator into an attitude of love and forgiveness, then his art is only an

ephemeral passion.' To my eye, the artist who painted *Our Lady of Vladimir* achieved this miracle.

THE HINDU VIEW OF ART

Many Hindu sages have remarked that very few are able to understand the abstract, formless essence of the Absolute. Most individuals, they state, need to approach God through images and with rituals specific to that deity, not so much because the deity requires it but because of the limitations of the devotee. They believe that humans need something concrete on which to focus in prayer. Hinduism fulfils that need through innumerable manifestations. Although many images are exquisitely and elaborately fashioned by sculptors or painters, and for the devout Hindu, artistic merit is important, it is secondary to spiritual content. Images are created as receptacles for spiritual energy; each is an essential link that allows the devotee to experience direct communion with the Gods.
STEPHEN P. HUYLER[7]

The Hindu view of art shares much in common with that of the North American: both have limited concern for individualistic expression, both are created in the service of a religion, both are social rather than personal inventions. It is true that the peoples of India have created a wide range of artifacts—fabrics, pottery, utensils, toys—but most of their art and architecture is of a strictly devotional kind and exclusively designed for the transmission of religious feeling. A deep sense of divine immanence, an absorption in the immediate presence of the numen, has meant that realism plays almost no role in Hindu art.

So the themes of most Hindu art are focused on a nucleus of holiness. It is concerned to represent, to tell the stories, to evoke the lives and values, of the continent's vast pantheon of gods and goddesses: Shiva, Vishnu and the Great Goddess, in their numerous manifestations. In addition, all the accessories needed for their ritual worship—holy water vessels, incense-burners, candelabras, chariots and umbrellas—also have a significant role.

This material is fashioned by skilled craftsmen working in a tradition which dictates strict canons of iconography and manufacture. Hindu art, governed by precise laws, is unchanging and cosmic. So the individual craftsperson has little or no concern for self-expression; the concern is to give expression to the archetype. For these reasons there exist no separate words for 'religion' or 'art' in the Indian languages. Neither are there strict divisions between

ritual, craft, painting, sculpture, dancing, instrumental and vocal music.

Given the vast age of the Hindu tradition, its huge geographical size and numerous artistic traditions, some abstract, some representational, it is not possible to characterize Hindu art as a whole. Nonetheless, a popular print of Shiva, a bronze processional image from Tamil Nadu and the Surya Temple of Konarak, do perhaps have something in common: a prodigal but impersonal imagination, an unplaceable strangeness, a ripeness and grave sensuality.

The Shiva Nataraja in Thanjavur, India, c.1010

In 1994, I travelled to Tamil Nadu to visit the temples constructed by the Chola rulers between 850 and 1270. One of these is in the modern town of Thanjavur (Tanjore), at one time their capital.

Monumental in concept, design and execution, the Brihadishvara Temple (c.1010) at Tanjore is one of the world's greatest buildings, and one still performing its traditional role as a vibrant devotional centre. Here is my journal entry of the visit:

> In the cool of the evening with hundreds of others, we return to the Temple already crowded with happy, almost merry devotees praying at the shrines, sitting on the grass, walking about the courtyards and listening to a white-dressed performer singing devotional songs. In the night sky, the full moon is a milky golden disc; crackers and rockets explode over the town. This is a festival night, Kartik Deepan, and returning to our hotel we pass dozens of wick-lamps and candles burning in front of shops and homes.
>
> The statues of the gods in the Temple, swathed in coloured robes and dressed with garlands, also stood amongst waving forests of lights, their vestments glowing in the dark. Only in this part of India have I experienced the mystery of the Gods in their shadowy sanctuaries.

Nonetheless, in place of a description of this monumental temple—and the Brihadishvara Temple is a building of matchless grandeur—I will discuss one relatively small but deeply powerful Hindu sculpture, a Chola figure: the Shiva Nataraja which I saw in the city's Art Gallery. This was possibly made during the reign of the builder of the Brihadishvara Temple, Rajaraja the Great, at around 1000 AD. Many of these icons were created in south India and their manufacture has continued into our own time.

Beautiful as it is, the purpose of the Shiva Nataraja was neither self-expression nor the realization of beauty for its sake alone. Its purpose was educational in the broadest sense of the word. It is a visual scripture rather than 'a work of art'. As Ananda Coomaraswamy observed of its anonymous creator: 'To him (the maker) the theme was all in all, and if there is beauty in his work, this did not arise from aesthetic intention.'[8]

At the time, hot and sweaty as I was, I remember marvelling at its great beauty; its athleticism, its poetry and symbolism. In the Hindu pantheon, Shiva[9] represents a prodigious display of attributes expressive of the poly-centric nature of the Indian imagination; dancing is but one of these. In this sculpture Shiva is dancing; he is the cosmic dancer, creating and destroying the universe (see Plate IV).

The figurine has four arms and braided and jewelled hair in which we can see a wreathing cobra, a skull, and the mermaid figure of the goddess Ganga; upon it too rests the crescent moon. The figure is adorned with necklaces and arm-lets, a jewelled belt, bracelets and finger and toe-rings. One right hand holds a drum, the other is uplifted in the sign of the 'do not fear' gesture: one left hand holds fire, the other points down upon the demon Muyalaka. The god is encircled by a ring of everlasting fire which symbolizes the phenomenal world.

For the traditional devotee, a Shaivite, every one of these features—the drum in the god's upper right hand, the 'fear not' gesture (*abhaya hasta*), the figure of Ganga in his hair, the dwarf upon whom Shiva tramples in his dance—would have meanings as powerful as the crown of thorns, the cup and the sponge for a devout Christian. For me, of course, I know these things only intellectually; I do not experience them in my blood. But I can dimly grasp that this icon is beautiful not only because of its exquisite sculptural qualities but because it so gracefully intimates the multiplicity and oneness of the divine.

Ankor Wat, Siem Reap, Cambodia, mid-twelfth century

In 1948 I chanced across a travel book, *Escape With Me* by Osbert Sitwell, which in spite of—or maybe because of—its rather overblown prose left behind an indelible impression of the jungle ruins of Angkor, contemporary with our Middle Ages. There and then I vouched to try to see these ruins for myself. A half century later, in February 1998, I was able to do so.

Angkor's one hundred or so temples are scattered over a rural area of 120 square miles, an area so extensive that it takes days to visit. The largest and

most famous of these are Angkor Thom, the Bayon and Angkor Wat, the last being the best preserved. It is not for nothing that it rates among the great achievements of the mediaeval world.

Angkor Wat (literally 'the capital which is a temple') was probably constructed in the first half of the twelfth century and is therefore contemporary with some of the finest of the European cathedrals—Notre Dame and Chartres in France, Lincoln and Ely in England—but in scale and grandeur of conception it almost outshines them all. Angkor Wat, a vast, complex, intimidatingly extensive building, was built by the Sun King Suryavarman II (who ruled from 1112 to 1152) to be both a royal Vishnu temple and his own mausoleum.

On ascending the central tower it can be seen that the surrounding jungle opens to reveal a square moat, its waters shining in the tropical heat. (In fact the accumulated surveying error around the 5.6 kilometres of the moat's external dimensions amounts to barely a centimetre). The moat is crossed by an extensive stone causeway leading to the main entrance. Following the cosmological precepts on which the entire building and its environment were based, this gateway, one of four aligned with the cardinal points, faces east to receive the rising sun. The causeway leads to an inner courtyard, vast enough to accommodate thousands of people. A second, lower wall, itself more than a mile in circumference, protects a further enclosure, from the centre of which rise, on a base of three tiered stages, the shrine's five majestic towers of the shrine: four towers at the mid points and one, the highest—it rises in all two hundred and fifty feet above the waters of the moat—at the centre.

If this seems (and it is) exceptionally complicated, the visitor can more readily grasp the three-dimensional nature of the design when it is understood that Angkor Wat, like other temple mountains, was not built as a meeting place for the faithful but as an abode for a god (or gods). A place where the divinity could bestow his protection and munificence on the founder and his familiars. In the case of Ankor Wat, the deity was Vishnu, one of the most important of the Hindu gods; his statue originally stood in an opening of the sanctuary tower.

The concept behind the building is one of untrammelled imaginative complexity and cosmic beauty. As the residence of a divinity, the sacred territory on which the temple is situated needs to be understood as a recreation of the universe inhabited by the gods. Here, the pivot around which the whole creation revolves is the central tower which symbolizes Mount Meru, an archetype of the Divine centre; this in turn is surrounded by smaller peaks, surrounded by continents (the lower courtyards) and the Cosmic Ocean (the surrounding moat).

No less imaginative are the dozens of carved reliefs which cover the walls of the central part of the temple complex. These include gods, goddesses and sensuous nymphs (*asparas*), while animals and soldiers act out scenes from the two Indian epics, the *Ramayana* and the *Mahabharata*. The south section of the east gallery is decorated by perhaps the most renowned of these scenes, the Churning of the Ocean of Milk from which spurts the nectar of immortality. Lastly, the eastern part of the north gallery features a mammoth battle scene. In the midst of a tangled mass of warriors, the twenty-one major gods of the Brahmanical pantheon are to be discovered, each in single combat with a demon.

Any description of Angkor Wat runs the risk of failing to comprehend its subtleties and at the same time do it justice. Yet in spite of the alien nature of Khymer culture, the outright exoticism of one of the largest stone buildings ever created, and the difficulties in appreciating the language of its symbolism, I found the experience, quite stupendous—often heart-lifting, even over-whelming. Its scale is gigantic, its complexity extraordinary, and so, too, the ambition of its conception and execution. Only the huge number of people involved in its creation—and its enormous cost—could have been commensu-rate with the importance of the project to contemporary Khymer society.

I visited the site several times a day for the better part of a week, gazing at the building from every angle and distance, reflecting on its cosmological design and the mastery of its execution. Looking, say, at yet another impersonally carved battle scene, I may have missed the sensitivity of the carving to be found on the Parthenon, but then at sunrise, at twilight and in moonlight, my enthu-siasm was gloriously renewed. Angkor Wat is particularly responsive to the changing moods of the light; its many-towered silhouette carrying (for me) an unforgettable, dream-like presence. I would call it the most haunting building I have ever seen.

ART AND BEAUTY IN THE CHRISTIAN MIDDLE AGES

The Abbey of Le Thoronet, France, 1176 AD

The temple dedicated to Shiva at Thanjavur, which has to be ranked as one of the greatest Hindu monuments in Asia, was erected between c.995 and 1010, that is about a century and a half earlier than the founding of the abbey

of Le Thoronet in Provence (see Plate X). Yet here is another monumental building characterized by an aura of gravity, effortless command and rare poetic candour.

But if one might liken the Hindu temple to a ripe fruit, Le Thoronet could be said to resemble a rock: built in the spirit of Cistercian Christianity, it is characterized by an almost fanatical austerity. Here there is neither ornament nor decoration, but neither is needed; its classic, cubic strength, which speaks at once of faith and confidence, is enough. Its very nakedness and immensity have something of the solemn grandeur of the ocean.

The abbey's cool empty nave, sun-baked cloisters, chapter room and other buildings announce a life of Christian simplicity. Le Thoronet was one of a group of abbeys inspired by three devotional factors: the life and writings of St Bernard (1090–1153), the foundation of the abbey of Citeaux (in 1098) and the publication of an influential guide for living a communal life in a monastic setting which was completed by the mid sixth-century: the *Rule of St Benedict*.[10]

Through a return to strict asceticism and a life of poverty, the Cistercians sought to follow the *Rule* to the letter and thus recover the ideals of the original Benedictine order. The ordered harmony, the utilitarian beauty—the nakedness—of Le Thoronet, all mirror it; as I saw on my first (of many subsequent) visits, the building gives expression to St Bernard's values and spirituality. Thus the walls are bare and both statues and stained glass are absent throughout. The stripping away of anything superfluous to, as it were, the elemental bone, was not in itself an end but a condition and means. Austerity, severity, simplicity, humility, poverty; these were the lived aspects of the monk's imitation of Christ.

Le Thoronet closed in 1791 when the last seven monks were transferred, but happily it escaped the devastations of the eighteenth century and the Revolution; today it is preserved as a museum and it is the haunt of tourists. Yet its monumental power continues to speak across the centuries.

In describing his own religious feeling, Albert Einstein wrote that it 'takes the form of a rapturous amazement of natural law'.[11] When visiting the sternly simple building of Le Thoronet, which impresses on the soul a feeling of sublimity, I also feel something of that inspirational rapture. Apart from Chartres, I never experienced a more beautiful building.

Chartres Cathedral, France, 1194—1260

On the feast days of the Virgin, patroness of Chartres, when the bells in the western towers peal out over the city and surrounding countryside, the doors of the cathedral stand open to admit and release a constantly changing crowd of men, women and children. The bustle in the entrances and the aisles comes to a great still oasis at the crossing, where the priest intones at the altar while incense drifts up in patches of colour, and the tall blue-robed Virgin of the window called La Belle Verrière shimmers in the background. Then we become aware that a disorganized multifarious jangle of human thoughts and sentiments is coalescing and passing into a single supreme act at once religious and artistic, and we can understand in some measure how the great church which houses this altar and welcomes this congregation came originally to be built.
GEORGE HENDERSON[12]

A great maxim from the Middle Ages, translated, reads: 'The essence and existence of everything on earth is derived from the beauty of God.' 'The Beauty of God is the cause of the being of all that is', wrote St Dionysios the Areopagite,[13] and the art and architecture of the European Middle Ages took as its mission the reproduction of His timeless beauty in paint and glass and stone.

Gothic art is always God-intoxicated, exultant and expressive of the presence of an unending celestial chorus of praise. And if this is true of, say, the smallest reliquary, it is nowhere more eloquently evident than in the vast stone building constructed barely a century after Le Thoronet: Chartres Cathedral. The building's constructional and aesthetic forms—lean and pointed arches, soaring flying buttresses, and an organic rib vault—first combined here in this building, were to achieve that feeling of lightness and supple and energetic concentration which were to characterize many later Gothic buildings—churches, guildhalls, monasteries, bridges, universities and chapels alike.

At Chartres these elements were combined to create a soaring transcendentalism: columns are high, sculpture richly in evidence, and stained glass—azure, cobalt, ruby-red, viridian green, magenta—burning in a dazzling sea of fiery colour. Here, as in the other great Gothic cathedrals, the soul is carried on and up, past the central crossing, through to the sanctuary and its slim lancets, carried towards eternity.

Yet this extraordinary building is but one example of the feverish activity of the period; about the year 1200 over a dozen cathedrals were under construction in the region around Paris; there were also some four hundred churches, thousands of abbeys, bridges, town halls and houses. Chartres may be remarkable, but even more so is the phenomenon (that has yet to be fully explained)

that exploded across Europe at that time; the miracle of religious enthusiasm which inspired a relatively small population to acts of endurance, technology, speed and beauty which have probably never been excelled.

So what were the aims of those who conceived, designed and built this cathedral? Their first aim was to replace an earlier eleventh-century building damaged by fire in 1194. Their second aim was to build a cathedral worthy of God and, in particular, His mother, whose mantle (said to have been worn by Mary when she gave birth to Christ) survived the conflagration. And their third aim was to give expression to the highest ideals of the time: to build in accordance with sacred principles and eternal laws.

At the time of the rebuilding, the School of Chartres was the most important institution of learning in Western Europe. Greek and Arab science informed its scholarship and the writings of Dionysios the Areopagite (see Note 7, Chapter 1) provided an additional mystical and intellectual basis. It was Dionysios who taught that the order on earth should as much as possible resemble the order in Heaven.

In their studies of the natural world, the scholars, patrons, geometers and architects of the cathedral thought that they had found biblical authority for the idea that God disposed all things in number, weight and measure. This insistence on number was not unusual, for, as Augustine had written almost a thousand years before, 'God made the world in measure, number and weight: and ignorance of number prevents us from understanding things that are set down in the scripture in a figurative and mystical way.'

Thus a many-layered symbolism, a complex iconography and the authority of number formed the basis of the new cathedral's design.

The Maesta by Duccio, Siena, Italy, 1308–1311 AD

The painter, the mosaic worker, the worker in gold and silver, the illuminator of sacred books, were almost impersonal, almost perhaps without the consciousness of individual design, absorbed in their subject-matter and that the vision of a whole people.
W. B. YEATS[14]

In Siena there is a work of incomparable, heart-lifting beauty, a beauty so deep that it is almost troubling to experience. This is Duccio's great panel of the *Maesta* or Virgin in Majesty, created between 1308 and 1311 for a venerated position on the high altar of the city's cathedral. Painted on both sides, it comprises a vast central scene (whose front faced the congregation) and over fifty much

smaller narrative ones, as well as a number of surrounding single figures.

On the main panel, which is the largest composition of the altarpiece, we see the Virgin Mary, the Queen of Heaven, with the Christ Child on her knee surrounded by a company of saints and angels, forty in number, standing and kneeling on either side of her throne. The saints pictured here have a special function; they are interceding on behalf of the city. On the reverse side, visible only to the clergy, Duccio and his assistants painted forty-six smaller representations of the Passion of Christ—Christ scourged, Christ before Pilate, Christ's entry into Jerusalem, Christ's crucifixion—and on the altarpiece's predella and frame, further scenes from the Life of Christ and the Virgin.

The *Maesta* had been commissioned to replace the single most revered object in the city of Siena, the *Madonna degli Occhi Grossi* which had stood in pride of place on the high altar of the cathedral. It was to this icon that the Sienese attributed their victory over the rival city of Florence at the Battle of Montaperti in 1260. The story goes that on the eve of the battle, the syndic had dedicated the threatened city to the Virgin and in the afternoon Mary's mantle, a sign of her grace, had been seen flowing across the sky over the battlefield. The next morning the enemy was defeated; Siena had been saved.

Even in Europe where the cult of the Virgin was omnipresent at that time, the Sienese had exceptional reason to give civic expression to their devotion and gratitude. Siena was now the Civitas Virginis. Henceforth the Virgin's seal was to be set upon all affairs of state, and she was rendered homage not merely as Queen of Heaven, protectress of the city but as chief mediatrix with the Deity. This may help to explain why Duccio and his assistants chose to expend their best efforts on the commission, and why on completion the altarpiece was carried in triumph through the crowded streets of Siena to the high altar. Not for nothing does the visitor still feel that Siena is among the most, if not the most, feminine of all European cities.

Siena was also the modern or post-classical city that exhibited the most self-conscious concern for the beautiful. It was the first to make lavish patronage of the arts an essential arm of government policy; the first to create an ambiance in which festivity, town planning, civic architecture, painting, sculpture and literature were highly valued and encouraged. Nowhere else in Europe, not even in Florence, were the visual arts so closely integrated with so many aspects of civic life. To achieve these ends demanded an exceptionally large number of artists, most of whom also played their part in the city's civic, political, religious, economic and recreational life. It was in this context of civic veneration

and delight in beauty that Duccio's altarpiece was admired and loved.

Yet what is the nature of the *Maesta's* powerful magic; what is behind its elusive supernatural beauty? Is it beautiful because there is no place for anguish and doubt in Duccio's work? Is it beautiful because he presents the world as it would be seen through the eyes of God? Is it beautiful because of Duccio's fidelity to the passionate mysticism of a city intoxicated by the sovereignty of the Feminine? Or is it the fastidious elegance of his technique, the sensitivity of his drawing, the fine colouring, the subtlety of his compositions? Or is it a combination of all these things? Here again we are approaching the inexpressible. And as Wittgenstein observed: 'Whereof one cannot speak, one must remain silent.'

THE ISLAMIC EXPRESSION OF BEAUTY

The absence of images in mosques has two purposes. One is negative, namely, that of eliminating a 'presence' which might set itself up against the Presence—albeit invisible—of God, and which might in addition become a source of error because of the imperfection of all symbols; the other and positive purpose is that of affirming the transcendence of God, since the Divine Essence cannot be compared with anything whatsoever.
TITUS BURCKHARDT[15]

The Attarin Madrasa, Fez, Morocco, 1323–25

Across the world of Islam, art and architecture share much in common. They form one unified entity. Whether you are in the Sheikh Lutfullah mosque in Isfahan (see page 90), the Alhambra in Granada (where in the sky above the Patio de los Leonnes the swallows scythe the air with their exultant whoops) or the Madrasa of al-Attarin in Fez, there is evidence of a shared spiritual context and ambience: a manifestation in the world of forms of the spiritual realities of the Islamic revelation.

The traditional city with its mosque is a reminder of the presence of God for its dwellers and worshippers at every turn: the dome is a symbol of the dome of Heaven. In this way the Muslim is forever reminded of God's presence in his life and acts, whether great or small. Even a decorated plate or a sculptured calligraphic frieze is designed to inspire a remembrance and contemplation of God.

The building to demonstrate this to me was the Madrasa of al-Attarin—the first great Islamic building I had ever visited.

It is approached inauspiciously—through a dimly lit and unimportant L-shaped entrance passageway. This opens out into a deeply civilized, exquisitely proportioned and miraculously perfect courtyard; an oasis of peace after the confusion of the nearby market selling spices and other goods. At its centre stands a fountain, which not only provided running water for ablution but created a white noise to mask the urban hubbub. Narrow colonnades along the sides of the court provided shade, and a hall at the far end served for instruction and prayer. From the hallway, a passage led to a large latrine, and a stairway to rooms for fifty or sixty residential students and faculty on an upper floor overlooking the court. (A Madrasa is a public school for teaching the doctrine of the Koran and Islamic law.)

This interior is covered with a web of intricate decoration: the walls and floor with fine stucco panels, exquisite wood carving and a lucid pattern of glazed small black and white tiles. The skirting or dado is also decorated with superb geometrical patternings and articulated by a series of slender onyx columns.

But no description can suggest the lucidity and serenity of this courtyard which reflects or rather distils the peace of a soul at one with God, with Allah. It possesses a crystalline perfection, described by one author as 'a world filled with a limpid and almost unworldly beatitude'.

'Art to the Muslim,' writes Titus Burckhardt, 'is a proof of the divine existence only to the extent that it is beautiful without showing the marks of a subjective individualistic inspiration; its beauty must be impersonal, like that of the starry sky.' The Islamic art I have seen in Morocco, Turkey, Iran, India and most recently in Spain certainly attains to a kind of impersonal but very human perfection independent of its author, whose triumphs and failures disappear before the universal character of its forms.

That great masterpiece of Orthodox spirituality, *Philokalia* or love of beauty, and the famous *hadith* which asserts that 'God is beautiful and loves beauty', both provide an inspiration for a much later Islamic building than the Madrasa in Fez. This is the Rüstem Pasa Mosque designed by the great Ottoman Imperial architect Sinan (*c.*1491–1588), which lies close to the water of the Golden Horn and the Istanbul's busy Spice Market.

Sinan choose to elevate the mosque on a platform high above street level; the approach is inconspicuous: a small archway and some darkly-lit and winding stairs which open out to the expanse of a broad terrace and harmonious arcade. Yet even here where there is space and light, there is only a foretaste of the mosque's interior: the panels of blue and white tiles from the northwestern

Anatolian city of Iznik. Two of these are placed on either side of the mosque's entrance. One of them, with a cobalt-blue ground, features a tree in blossom. The tile decoration was completed in 1561.

But it is the mosque's interior, its prayer hall, which is of supreme beauty, a beauty different from the gravity and seriousness of Le Thoronet or the exultant transcendentalism, the pull to a heavenly ideal experienced at Chartres. The interior of the Rüstem Pasa mosque in Istanbul is characterized by a light-hearted, exuberant joy, with its tile-work suggesting the splendour of a field of flowers, the kind of flowers cultivated in an Ottoman garden: peonies, carnations, roses, hyacinths and tulips.

The city of Shah Abbas: Isfahan, Iran, 1598 onwards

A thousand travellers have reported that the most beautiful cities in Asia are Peking and Isfahan. [The latter] is not a great city—only one mosque, you tell yourself, and the houses are all stucco, without grace, without enchantment: and then you come to a great open yellow square, and round this square are the most perfect, the most jewelled, the most incredible displays of architecture you have ever seen. The name of the square is Maidan-i-Shah, the parade ground of the Shah, but there are hardly words to describe its exquisite beauty, the cunningness of the arrangement of the palaces and mosques around it, the delight which comes from the heart when, for the first time, you set eyes on it.
ROBERT PAYNE[16]

The city of Isfahan was essentially the creation of Shah Abbas (1588–1629), the great Persian king of the Safavid dynasty. Inspired by a vision of beauty and his determination to make the capital the most prosperous and beautiful in Asia, he imported companies of craftsmen, artists, architects, gardeners and artisans. He ordered the construction of a giant square, the Maidan (now Imam Khomeini Square), home to some of the most majestic buildings in the Islamic world. The square is supposedly seven times the size of the Piazza di San Marco in Venice. Shah Abbas also planned a grand approach to the capital: an avenue known as the Chahar Bagh.

In the middle of this 50-yard-wide boulevard there once flowed a canal, with water dropping in little cascades from terrace to terrace, now and again arrested in big rectangular or octagonal basins. In the summer months these tanks used to be filled with the cut heads of roses which floated on the surface of the water. And on either side of the canal were laid, successively, a row of plane trees, a walkway, parterres abloom with plants and flowers, and another row of trees.

Nonetheless the Shah's grandest achievement was (and remains) the Royal

Mosque, one of the most beautiful mosques in the world. It is the Masjed-é Emam (from 1611), which dominates the southern end of the Maidan. It has a dramatic portal, almost 90 feet in height, two minarets and a slightly bulbous pointed dome, blue in colour 'as if fashioned from the feathers of a bird of paradise'. This entrance also displays the finest decoration in mosaic in a full palette of colours: dark blue, light blue, white, black, yellow, green and biscuit. The rest of the building is like a vision of paradise on earth.

No less wonderful is the Sheikh Lutfullah Mosque (1603–18) on the eastern side of the Maidan, with its magnificent tilework and unglazed *café-au-lait* dome covered in turquoise and deep blue spiralling arabesques. Here is a symphony of colours, geometric forms and arabesques dominated by the calligraphy of the Sacred Word. The interior is a vast glowing room that is probably the most perfectly balanced in all Persian architecture. The apex of its dome is filled with a giant sunburst, from which descend tiers of ogival medallions filled with floral motifs which swell in size with the curve of the surface. Light streaming through the screened windows flickers across the glazed surfaces.

Yet if this ensemble of exquisite buildings is to our Western eyes enjoyable for its decoration alone, it is important to remember that they were con-structed not only with a civic purpose but a religious one: to give expression to the interiority of Islam. In the Isfahan of Shah Abbas, art and beauty were not considered aesthetic luxuries but created as manifestations of a God for whom beauty is of the greatest importance.

The Taj Mahal, Agra, India, 1632–53

The Taj Mahal is another undisputed masterpiece of Islamic art. Yet it is not a mosque but a mausoleum sheltering the tomb of a woman, Mumtaz-i-Mahal, whose glorification depended upon her being the beloved wife of the fifth Moghul emperor of India, Shah Jahan (1628–58). She died in 1631 giving birth to her fourteenth child, and it is reported that so great was the Emperor's grief that his hair turned white in a few days and that he needed to wear spectacles to hide the effects of weeping.

The great white mausoleum he built as her memorial—and at the same time almost certainly his own—was constructed between 1632 and 1653 with as many as 20,000 workmen. No expense was spared in its construction.

An enormous complex surrounds the mausoleum—it includes a great square, the Jilau Khana, residential facilities for tomb attendants, subsidiary

tombs, a guesthouse, four free-standing minarets and an extensive and very beautiful (if damaged) garden. The garden in Islam holds a position of special importance not only as a place of refuge and contemplation but in its role as the earthly reflection of the Paradisical Abode—a reminder of both the immanence and transcendence of God. Every flower within it, every feature of it, is a reminder that God is the source of all beauty.

The garden is also a preparation for the heavenly perfection of the Taj Mahal itself—its dome, its portal niches, its sepulchral chamber, its marble kiosks, its white marble façades, its carving; every single part of it, projecting a shimmering vision of beauty and calm remote from the suffering and disorder of the world.

No less paradisical is the monument's responsiveness to light: orange at dawn, harsh white at noon, at twilight crepuscular and later, at the setting of the sun, dusky sienna, carmine, ruddy gold—the dome glowing with its own light seen against the deepest ultramarine of a starry Indian night. The Quran asserts that 'God is the Light of the Heavens and the Earth,' and a prophetic saying adds a cosmogonic and cosmological dimension: 'The first being created by God was light.'

BUDDHIST AESTHETICS

According to Shakti Maira,[17] the heart of Buddhist aesthetics is the realization of beauty—'the beauty of an inner state of mind and being, the beauty inherent in the experience of profound realization, the beauty of Nirvana: peace, calm, gentleness, spaciousness.' This, he argues, is the heart of Buddhist aesthetics: the experienced beauty of inner calm and clarity. 'In Buddhist aesthetics beauty is more than pleasing. Beauty is something that is uplifting. It takes us out of our usual state of constricted consciousness, and gives us a taste of unity as we connect and resonate at a deeper level of consciousness.' The central purpose of all the Buddhist arts is the attainment of this inner bliss.

But this is not remote and unattainable. In Japan it is an almost commonplace experience. The famous scholar of their culture, G. B. Sansom, says that the Japanese have been endowed with a special appreciation of form and colour and a feeling for simple elegance.[18] To ponder this appreciation in the midst of Tokyo's throbbing and over-lit shopping centre is to question Sansom's grasp of reality but elsewhere—at a meal, in a temple garden, during a tea ceremony

or in the arrangement of a vase of flowers—there is evidence of this Japan's exquisite feeling for refinement in aesthetics.

Interestingly, too, the Japanese possess a special vocabulary of aesthetic terms: they make use of the word *wabi-sabi*[19] to describe a philosophy of sufficiency, restraint and an economy of means (see page 94). Its existence is a recognition that beautiful things do not, like Versailles and St Peter's in Rome, need to be either large or expensive. They can be inconspicuous, impermanent, humble and as commonplace as, say, the grain in old wood or the sound of rain washing over a stone lantern in a garden.

Meditating Bodhisattva, Chugu-ji convent, Nara, Japan, early 7th century

The wooden statue of a meditating Bodhisattva in the Chugu-ji convent outside Nara is for me one of the most beautiful objects in the world (see Plate II). The statue is a representation of the Bodhisattva Maitreya (in Japanese, Miroku), 'The Buddha of the Future'.

Little is known about this sublime work except that it may have been associated with Prince Shotoku, considered to be the patron saint of Japanese Buddhism. It may also be the work of a Korean sculptor and has been dated at about 650 AD. Either way, like another similar meditating Maitreya (in the Koryu-ji temple in Kyoto), it is a carving of heartbreaking beauty, with its calm, contained energy, at once noble and serene. The melting roundness of the torso, the wave-like folds of the pleated garment, the elegance of the fingers lightly touching the chin, the calm face and subtlety of the carving suggest a quality of deep compassion.

In Mahayana Buddhism a Bodhisattva is one who, having attained enlightenment, chooses to make and keep a vow to help other lives attain salvation. Having reached the goal of nirvana he 'postpones' his own release from the world in order to give aid to others. Thus this lovely enigmatic figure may be said to embody not only the teachings and values of Siddhartha Gautama in much the same way that Fra Angelico's frescoes in the monks' cells of San Marco in Florence[20] realize the spirit of the New Testament, but the growth of the Bodhisattva ideal.

For many years following the Buddha's demise no Buddha images were attempted. 'It was considered illogical,' writes Nancy Wilson Ross,[21] 'that a truly enlightened Being "who had gone beyond the fetters of the body" could ever be represented in human form, and so the Buddha's presence in early

narrative sculptures was merely indicated by an empty throne, a footprint, a royal umbrella or other symbols of his non-physical presence.' However, all this was to change with the emergence of the Bodhisattva doctrine and the concept of the Divine or Cosmic Being. Among these beings are to be found Manjusri (the Bodhisattva of Meditation or Wisdom), Kuan Yin (in Japanese, Kwannon—the Goddess of Mercy and Love), and Maitreya, a Bodhisattva seemingly outside the earth's space-time and awaiting to reappear at the appropriate time in the future: the Buddha of the Future.

The garden of the Ryoan-ji Temple, Kyoto, Japan

Progress would have been slow. . . . But finally, all was perfected. The ground was smoothed, the wall built, the sand spread and raked into long, straight lines. Then the rain fell, brightening and darkening the colours. And as its pearly, misty light filled the garden, there appeared that feeling of yugen, tranquillity, and the mystery of beauty in harmony.
LORAINE KUCK[22]

Kyoto, the ancient capital of Japan, has many temples and gardens. Ryoan-ji is one of the boldest and most austere of these. It is also deceptively simple: an uninterrupted stretch of carefully raked coarse whitish sand about the size of a tennis court, upon which fifteen rocks of varying size are arranged in five separate clusters. Some are fairly good-sized boulders, some much smaller but none of exceptional character. Interest lies almost wholly in their relative shapes and sizes, their spatial relationships to each other and to the areas of sand around them. Not one stone could be added, eliminated, or altered in position without destroying the composition and hence its meaning.

About the base of each group is now a cushion of coarse moss, but apart from this there is not even a blade of grass. On the three sides of the garden opposite the darkly polished wood of the Abbot's long veranda stands an ancient courtyard wall, whose oil-stained earthen brown contrasts with the white of the sand. Not altered since 1799 (when records began to note the presence of fifteen stones), Ryoan-ji is customarily experienced from this veranda which extends for the length of the garden. No one ever sets foot in the garden except the lay brother who keeps it raked. Yet it is reported that the garden draws nearly a million visitors each year.

This is an abstract garden, a living lesson in the Zen concept of nothingness and non-attachment. Loraine Kuck, the late scholar of Japanese gardens, has described Ryoan-ji as 'a sermon in stone, a whole philosophy . . . one of

the world's great masterpieces of religiously inspired art'.

True, there are many explanations of its 'meaning': some dependent on its name—it is the garden within the Temple of the Peaceful Dragon (Ryoan-ji); some based on interpretations of the triadic interrelationship of people, nature and the human-created landscape; some related to the proportional relationship of 7: 5: 3; some on the Rinzai Zen Buddhist belief that asymmetry negates the illusion of the reality of dualism and encourages an apprehension of the harmony of apparent disharmony. Others, too, are based on the idea that the sand and stones recall the shifting tide of notes and intervals in music; they are also meant to evoke a sense of motion; there is, it seems, no end to these intriguing interpretations. But if of interest, such speculations have relatively little bearing on the physical *presence* of a place that cannot be explained. There is nothing to explain. Ryoan-ji *is*.

The garden does not evoke a mood of loneliness; it arouses feelings of timelessness, serenity, interiority—something of the highest value, above status and social position, wealth and utility. So let us be left in silence to look, feel, think, *be*.

The Tea Ceremony, Kyoto, Japan

To be poor, that is not to be dependent on things worldly—wealth, power, and reputation—and yet to feel inwardly the presence of something of the highest value, above time and social position: this is what essentially constitutes wabi. Stated in terms of practical everyday life, wabi is to be satisfied with a little hut, a room or two of two or three tatami (mats), like the log cabin of Thoreau, and with a dish of vegetables picked in the neighbouring fields, and perhaps to be listening to the pattering of a gentle spring rainfall.
D. T. SUZUKI

A few days earlier than my visit to the garden, I had arranged to take part in a Tea Ceremony at the Ura Senke school in Kyoto. On arrival, I found a young, shaven-headed acolyte tending the garden as part of his morning chores. He was hosing the street entrance; the winding path through the school's small but perfectly maintained garden (roji) was glistening with water. In the general striving for aesthetic perfection, everything connected with the Tea Ceremony becomes an object of extreme care.

I waited on a narrow bench (koshikake) before being escorted to an old room of cell-like simplicity hidden in the midst of a complex of small tea rooms. On entering, I at once imbibed something of the Buddhist ideal of serenity and

reverence: the room's rustic simplicity, my host's graceful movements, the vase of flowers in the *tokonoma*, the hanging scroll on which a poem had been inscribed and the merry sound of the charcoal brazier singing, like 'the wind in the pine trees', all spelt out a universal calm.

My host was an American, Bruce Hamada, and it was he who conducted the ceremony. He scooped some steaming water from a pot, poured it into a bowl, added some powdered tea, and then after whisking it with one of those perfectly crafted bamboo whisks (as on the cover of this book), invited me to taste a chrysanthemum-shaped sweetmeat before drinking a bowl of pea-green coloured tea. The tea was thicker than the European variety, foamy, astringent but delicious. Bruce Hamada conducted the ceremony with a ritualized gravity.

According to Thomas Hoover, 'the Tea ceremony combines all the faces of Zen—art, tranquillity, aesthetics. It is in a sense the essence of Zen culture.' Leaving I felt I had tasted not only tea but the calm, intuitive spirit of Zen.

2 · The Art of the Sensate Cultures

Some time between the beginning of the eleventh century and the beginning of the Renaissance, a sea-change begins to occur in the mind of Western culture. The old religious ardour had already begun to lose its appeal, and in its place was arising a new interest in the phenomenal world—the world of actuality. The pre-eminence that had been accorded to the world of the spirit now began to be exchanged for a growing respect for the material world as the repository of 'reality'. The minds that thirsted so avidly for knowledge of God began to turn their attention to the conditions of their material existence and to strive to improve it.

During the early centuries of the second millennium this sea change over-whelms the art of painting: the supernatural is abandoned in favour of another kind of miracle, the natural; the symbol is replaced by a concern for literalism; curiosity and exploration are encouraged with an unstoppable momentum. There is even a growing emphasis on the humanity of Christ. The formal, stylized, infinitely distant God of the Byzantine mosaic gives way to the human God of Duccio's *Maesta* and the face of Christ in the tympanum at Chartres carved between 1145 and 1155.

Here is something fresh and wonderful: a new kind of beauty. The beauty of things as they are: the beauty of the leaves of Southwell,[23] the beauty of Leonardo's drawings of the paws of a wolf, the beauty of the dawn light in Bellini's *Agony in the Garden*.[24] From now on and increasingly, as Annie Dillard writes: 'What you see is what you get.'[25] It is this attitude which Sorokin describes as sensate.

Sassetta: *St Francis Giving his Mantle to a Poor Man and the Vision of the Heavenly City, 1444*

The National Gallery in London exhibits a series of seven paintings from a dismembered altarpiece of the life of St Francis which possess features of the new kind of beauty (see Plate VII). These are irradiated with sense of the immanence of the supernatural—but at the same time they also register fidelity to the wonder of natural appearances. They are as calm and confident, fresh and innocent, and as joyful as anything ever made by a human being.

They are by Sassetta (1392–1450), and were originally painted for a double-sided altarpiece that stood on the high altar of the church of San Francesco in Borgo Sansepulcro. At the time when these works were being painted, new concepts of quasi-scientific artistic theory originating in Florence were replacing the traditional methods and understandings of the theocentric or ideational culture. As the last remains of Gothic disappeared, a style emerged which gave expression to fresh approaches to the visible and the new reliance on the methods of reason—including the representation of the external world by means of perspective and anatomy. Sassetta lived during this transition and is generally—and mistakenly—regarded as a 'backward' painter; e.g. one more traditional than progressive (or, if you prefer, ideational than sensate)—more Sienese than Florentine. But in my view his work attained a delicate balance between the natural and the supernatural, between the world of imagination and the world of 'reality'. In this particular panel, there may be numerous naturalistic effects but the overriding feeling is poetic, mystical, even magical—in a word, Sienese.

Why is this work so lovable? One answer lies in its unsurpassable beauty—its refreshing spring light, its jewelled detail, its sheer pictorial skill. There is also the beauty of Sassetta's control of tone, his delicate sense of drawing and the purity of his crystalline colour, as pellucid as a sunrise in the month of May. These are qualities as different from the mood of the meditating Bodhisattva

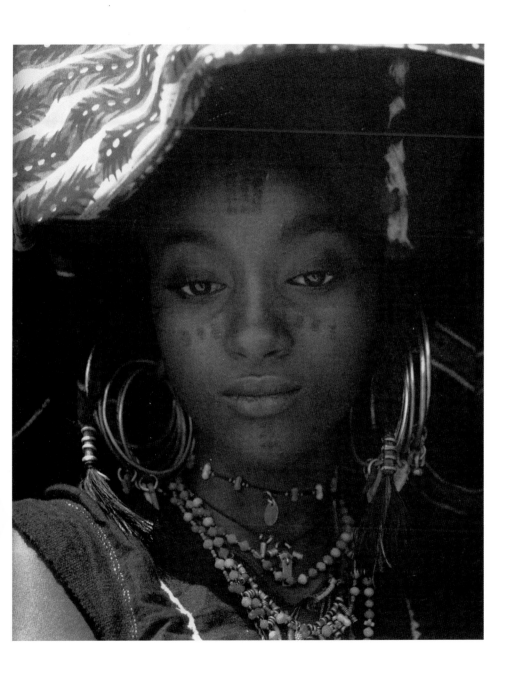

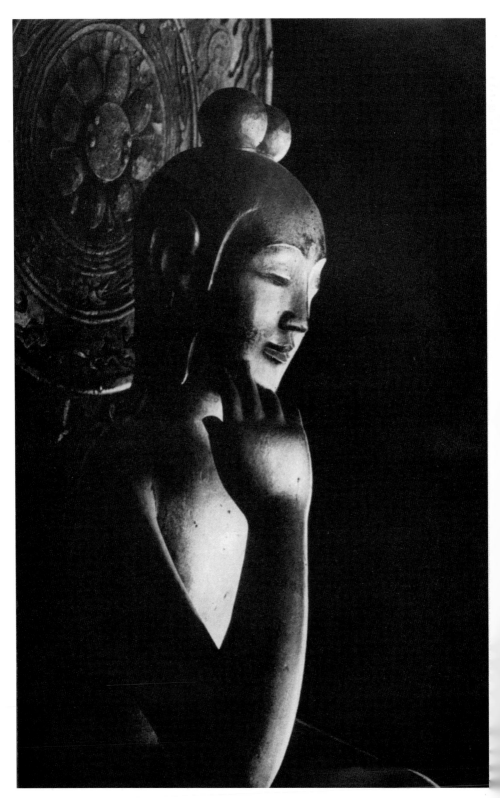

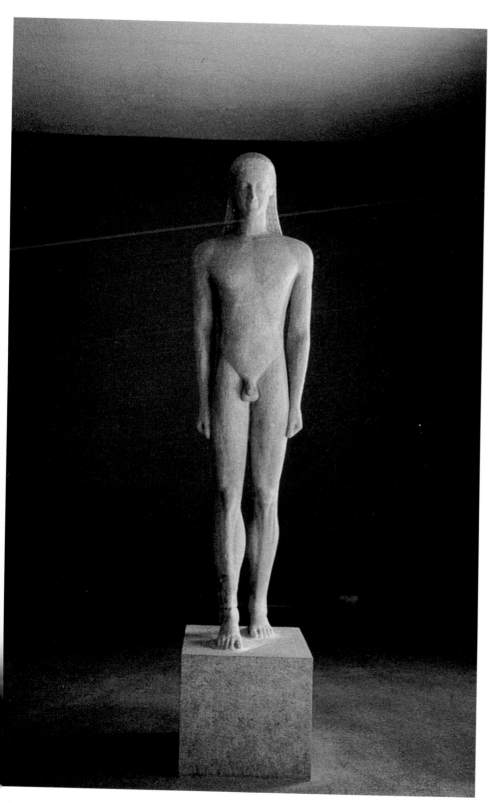

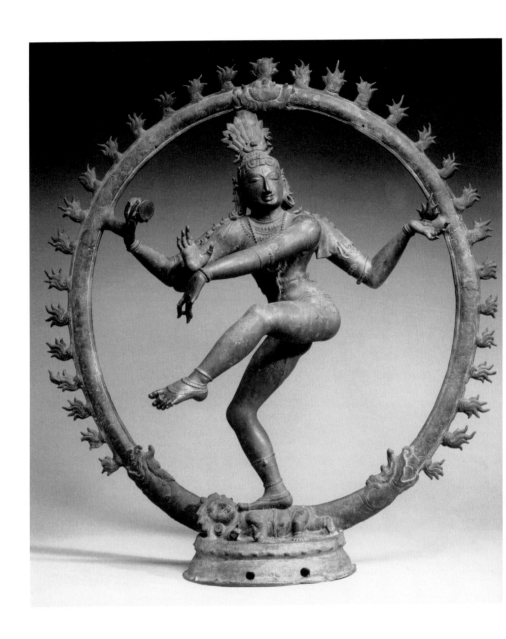

IV

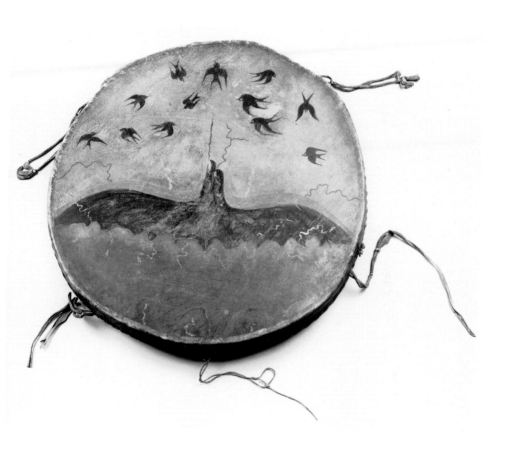

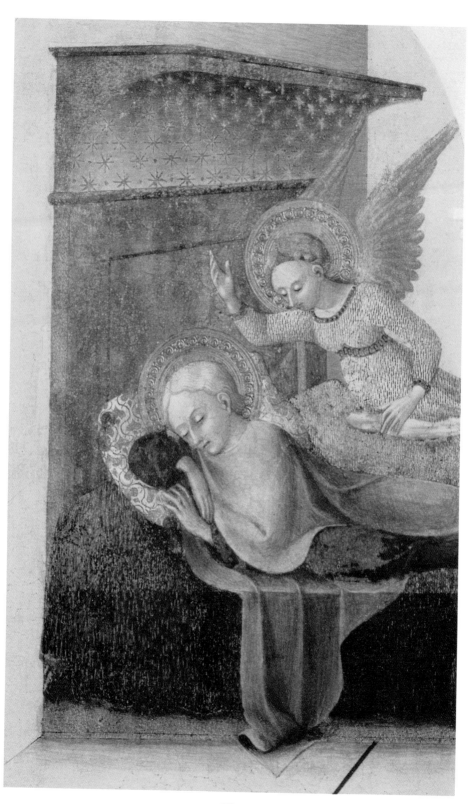

VII

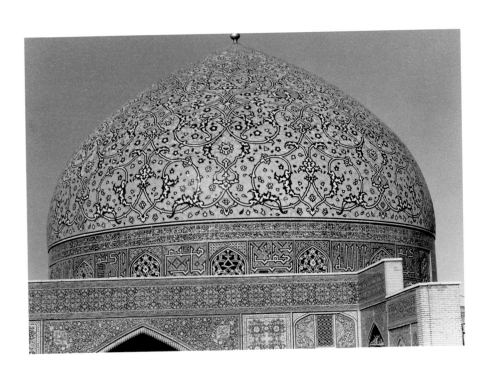

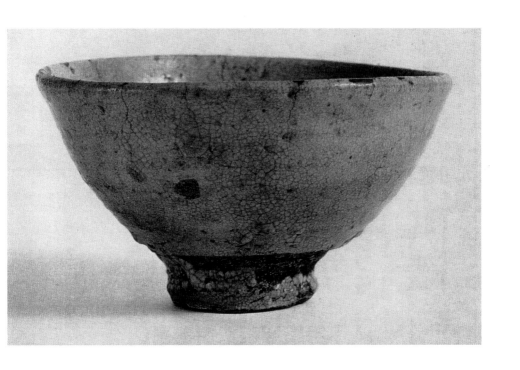

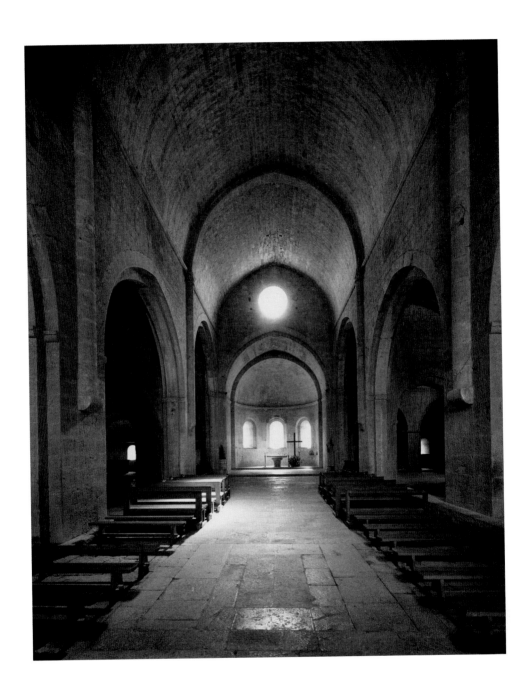

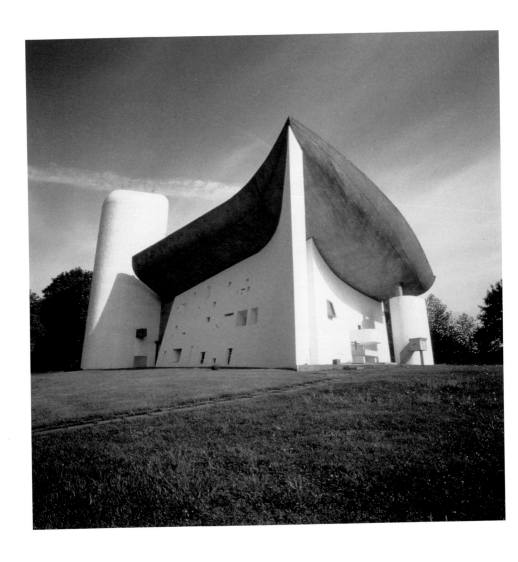

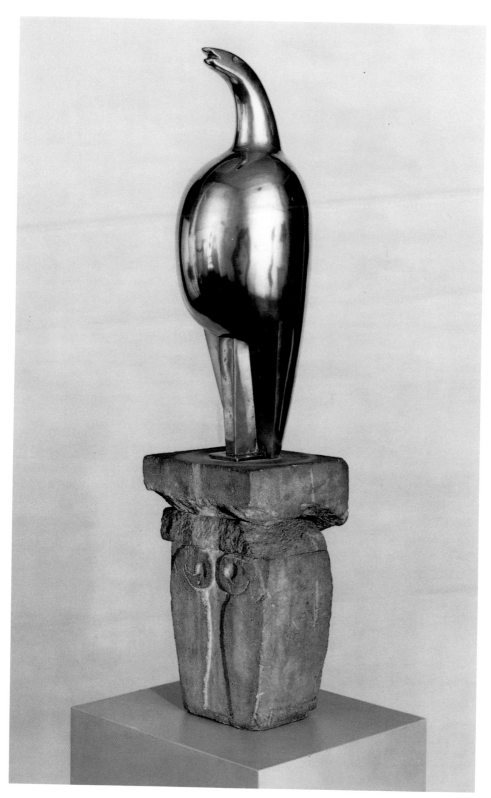

XIII

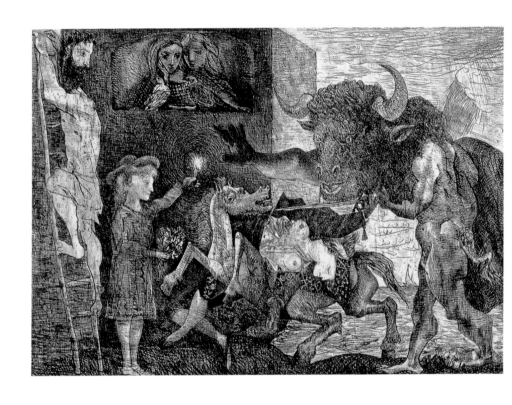

VARIETIES OF AESTHETIC EXPERIENCE

This plate section contains fourteen photographic reproduction of sculptures, architecture, a painting and various objects chosen chiefly for their beauty. Given the countless other things which could have been chosen, the images do not represent any kind of ultimate choice.

PLATE I · BORORO NOMAD FROM SAHEL REGION OF NIGER, AFRICA

The heart-stopping loveliness of this young girl has been enhanced by her choice of jewellery—ear-rings, necklaces and a patterned head-covering.

PLATE II · HEAD AND TORSO OF THE 'BUDDHA OF THE FUTURE', CHUGUJI TEMPLE, NARA, JAPAN

This suavely contoured wooden statue of a Bodhisattva dates from around 650 AD. It possesses a nobility of expression and radiant sweetness of gesture which is mesmerically beautiful (see pages 92–93).

PLATE III · STANDING YOUTH FROM MELOS, GREECE

This funerary monument or votive offering in a sanctuary was produced shortly before the middle of the 6th century BC. 'The body,' writes Reinhard Lullies, 'seems to be growing with something of the unconscious life of a plant.'

PLATE IV · NATARAJA, SHIVA AS THE KING OF DANCE, INDIA

Bronzes such as this were produced in South India during the Chola period (11th century). They are among the most accomplished metal sculptures ever made in India, as well as worldwide (see pages 79–80).

PLATE V · AMERICAN INDIAN CEREMONIAL DRUM, NORTH AMERICA

The painting on this Pawnee drum shows Thunder Bird, mythical creator of the storms that rolled over the great plains, swooping down out of the sky above a small group of swallows and hurling lightning flashes (see page 72).

PLATE VI · AN ASCETIC IN A PATCHWORK COAT, BIKANER, RAJASTHAN, INDIA, 1705

This Moghul-inspired painting, produced in the desert kingdom of Bihar in Western Rajasthan in 1075, is of an ascetic being presented with a newborn prince brought to him by a lady and an old woman.

PLATE VII · THE VISION OF ST FRANCIS from SCENES FROM THE LIFE OF ST FRANCIS (detail), SIENA, ITALY

The altarpiece of which this is a detail was painted by Sassetta before 1444. It shows the saint dreaming of the Order he is about to found. Its style is derived from the gentle, courtly Gothicism of the late 14th century (see pages 96–97).

PLATE VIII · DOME OF THE SHEIKH LUTFULLAH MOSQUE, ISFAHAN, IRAN

Soon after the Maidan was completed, Shah Abbas I of Persia ordered a new building: the Lutfullah Mosque, dating from 1603–1619. The exterior of its dome, one of the most beautiful of its era, is covered with curling arabesques in blue and white, on a creamy café-au-lait background (see page 90).

PLATE IX · KIZAEMON IDO TEA BOWL, YI DYNASY, KOREA

The reposeful simplicity of this sixteenth-century artefact gives expression to a beauty which is forever new. 'It is,' says Yanagi, 'like a fountainhead from which one may draw water a thousand times and still find fresh water springing forth.'

PLATE X · THE NAVE OF LE THORONET, PROVENCE, FRANCE

In this silent, prayerful abbey, the Cistertian monks achieved with their hands what, within themselves, they sought to accomplish with their spirit (see pages 82–3).

PLATE XI · DIDMARTON PARISH CHURCH, NEAR TETBURY, WILTSHIRE, ENGLAND

This photograph by Edwin Smith of Didmarton Parish Church, near Tetbury, Wiltshire, was taken in 1961. The honest simplicity of this unspoilt interior is redolent of prayer and quiet usage.

PLATE XII · CHAPEL OF NOTRE-DAME-DU-HAUT, RONCHAMP, NEAR BESANÇON, FRANCE

Towards the end of his life Le Corbusier designed two remarkable buildings, the pilgrimage chapel at Ronchamp (1950–53) and the monastery of La Tourette (1953–59) in Eveux. The former's incisive sculptural form characterizes one of the most remarkable buildings of the twentieth century.

PLATE XIII · CONSTANTIN BRANCUSI: MAIASTRA

'When you see a fish,' Brancusi once commented, 'you do not think of its scales, do you? You think of its speed, its floating, flashing body seen through water . . . Well I've tried to express just that . . . I want just the flash of its spirit.' Brancusi captured that 'flash of the spirit' in this sculpture of a bird poised for flight. It was made in 1912 of polished bronze.

PLATE XIV · THE ETCHING: MINOTAUROMACHY

Picasso's stunning etching of 1935, a forerunner to Guernica (1937), is rich in metaphysical, symbolic and political overtones: its menacing minotaur and the purity and innocence of the little girl holding a lighted candle and a bouquet of flowers create a host of subtexts.

in Nara, Duccio's *Maesta* and the cathedral of Chartres, as the landscape of Botswana from the snow-bound forests of Russia. Beauty is inexhaustible, it takes innumerable forms and styles, it speaks a hundred different languages and hides inside a thousand guises.

Piero della Francesco: *The Flagellation of Christ, c.1455*

Another very different kind of beauty—still Italian, still with religious subject matter, still early Renaissance—is Piero della Francesco's *Flagellation of Christ* of about 1455.[26] Whereas the painting by Sassetta is mystical, warm-hearted and unaffected, the Piero is informed by a supreme intelligence; it has the atmosphere of something cool and calculated.

Little is known about the origins of this work and there is little to be said about it anyway. Words are superfluous; it exists and it is beautiful. Of course, its colour—pink, gold, ivory-white, black, warm greys and a milky chocolate—and beauty of tone are exceptional. But it remains a mystery why the *Flagellation* should delight us so profoundly.

Both its subject matter and the identities of the three figures on the right hand side of the painting remain obscure. Its design is also enigmatic, though for a certainty the Renaissance mystique of number lies like a lietmotiv beneath the painting's calm, harmonious, almost crystalline perfection. This has everything to do with Piero's understanding of the formative principles which underlie the manifest world, the mystique of measurement and the science of perspective.

Its painter was a close associate of one of the period's leading intellectuals, Leon Battista Alberti. Alberti's importance now rests on a few buildings, but he was also something of a universal genius, not only an architect but a sculptor, painter and a writer on philosophy, religion, and various branches of natural history. He was also one of the most important Humanist exponents of beauty. In his *De Re Aedificatoria* he provides us with a definition which is roughly the same as the one to be found in Vitruvius.[27] Beauty, he says, is 'a certain regular harmony of all the parts of a thing of such a kind that nothing could be added or taken away or altered without making it less pleasing'. Piero would have endorsed this definition, which points forwards to the encroaching intellectualization of art at the expense of soul.

Yet can the *Flagellation* be called a religious picture? Its Christ is remote and insignificant, its subject matter obscure, its ethos as far removed from the

affirmative presence of Le Thoronet or Chartres as it is possible to get, yet mysteriously it remains a deeply spiritual painting. As Alberti sagely observed, 'Painting has within it a divine power', a power which resides in the secret heart of this mysterious work.

Perhaps Piero is intimating that divinity is not limited to subject matter but can be embraced by an unanalysable imaginative essence. For as Julian of Norwich understood that you can see the world in a walnut, as Blake saw the world in a grain of sand, Piero knew that you could catch its essence in a chequered floor, a gilded statue, and the turban of a man who is watching the flogging of Christ.

Nicholas Poussin: *Summer, or Ruth and Boaz, 1660–1664*

As we have seen, the art of any period, ideational or sensate, is characterized by certain defining features: in the case of the ideational by spirituality; in the case of the sensate by sensory pleasure. Divorced from religious and increasingly moral values, art is gradually becoming little more than a diversion or entertainment. The work of the three painters Vermeer, Chardin and Poussin (1594–1665), which I should now like to introduce, illustrate this development. It took place from the fifteenth and sixteenth centuries onwards.

Nicholas Poussin's great painting *Summer, or Ruth and Boaz,*[28] ostensibly a scene from the Old Testament, is in effect a summer landscape, one of a set depicting the Four Seasons whose subjects were all drawn from the Old Testament.

In this painting the two participants are placed in the centre foreground; the Moabite Ruth kneels before the Israelite Boaz, begging permission to glean wheat in his fields. It helps us to know that in due course the couple will marry and that from their union will spring the line of David and thereby of Christ. A scholarly connoisseur would also have known that the meeting of Ruth and Boaz represents the union of Christ and his bride, the Church, and that the harvesting of wheat symbolizes the consecrated bread and the sacrifice of the Mass.

The mood of this canvas is pastoral and gravely dignified. Beyond the harvest scene we see a shining green landscape above which cumulus clouds climb into a radiant shot-silk blue sky. Here nature is at her most fertile, most magisterial and benign—ripeness is all. Poussin is remarkable in his capacity to convey a sense of wonder at the never-ending bounty of the earth, at the succession of dark umbrageous trees, ripe corn and sunlit mountains. This is

the golden age of Virgil, in which all life follows the rhythm of nature and great harmony prevails.

In a letter to a friend he wrote: 'My nature compels me to seek and love things which are well ordered, fleeing confusion, which is as contrary and inimical to me as is day to the deepest night.' So the work of this artist, the greatest of the *peintre-philosophes*, gives expression to a deeply satisfying aesthetic and moral order. *Summer* presents us with a meditative calm, a perfect but dynamic equilibrium that refreshes and, at the same time, satisfies the soul. Yet, of course, this canvas is beautiful not so much because it presents the loveliest of scenes but on account of its aesthetic qualities alone: *Summer* is a deeply sensual work; the colour is rich, even gorgeous and subtly orchestrated. The shocking splash of red on the left of the canvas reverberates like a gong, while the colour of Boaz's ochre cloak speaks to the colour of the dark gold wheat with an extraordinary beauty.

The same is no less true of the *View of Delft* painted by Johannes Vermeer at roughly the same time.

Johannes Vermeer: *View of Delft, c.1660—1661*

Thanks to art, instead of seeing one world only, our own, we see that world multiply itself and we have at our disposal as many worlds as there are original artists, worlds more different from one another than those which revolve in infinite space, worlds which, centuries after the fire from which their light first emanated, whether it is called Rembrandt or Vermeer, send us still each one its special radiance.
MARCEL PROUST

This is a painting that depicts the Dutch city of Delft as seen across the waters of an inland harbour on a summer afternoon, c.1660-61.[29] Although it appears that there has been a recent cloudburst and dark clouds still loom ahead (they shade the foreground and some of the buildings on the far shore), much of the city is bathed in strong sunlight. Roofs sparkle, as does the tower of the Nieuwe Kerk rising to right of centre. Other prominent buildings include the city walls, the Schiedam Gate with its clock tower and the Rotterdam Gate with its twin spires. In the foreground a group of people are going about their daily affairs; two women are chatting. The waters of the harbour are a placid sheen.

It was the art critic John Ruskin (whom Proust so much admired) who observed that a painter has only to concentrate upon 'what he sees, not what

he knows'. Is this then the secret of the extraordinary beauty of this painting? Or does its uncanny perfection—no messiness, no sickness, no noise, only silence, stillness and peace—have another cause? Could it be as the author Anthony Bailey suggests, when he writes how Vermeer presents Delft 'as a prototype of Heaven, with its inner harbour waters ruffled by the merest cat's paw and the sunlight diffused by high unthreatening clouds'? Or do we get closer to the mystery of sensate art when we remember the observation of the painter Fromentin that 'the art of painting is merely the art of expressing the invisible through what is visible'? Beauty here may be palpable, but it is also mysterious.

Jean Baptiste Chardin: *The Copper Fountain, 1734*

A copper fountain painted by Chardin[30] has much in common with the Vermeer. Both take the world as it is, both are masterpieces of observation and the poetry of life and both, as Robert Hughes has understood, are reminders that lucidity, deliberation, probity and calm are the chief virtues of the art of observation.

As an artist, Chardin only painted what he could see: the mundane objects of hearth and home—a cup and saucer, an earthenware pitcher, a pile of strawberries, a woman returning from market or, as here, the dully gleaming copper of a kitchen urn, the lustrous black glazes of a large water pot and the tinned surface of a storage container—but he paints these as if they were being seen for the first time. 'I must forget everything I have seen, even including the manner in which objects have been treated by others,' he writes.

Thus, through his eye and his magical handling of the textures of his paint, we may see the world in its most commonplace aspect for the extraordinary miracle it is and has always been. No need to travel to exotic destinations: just look at the shimmering transparency of that glass of water or the folds of a tablecloth. 'When you walk around a kitchen, you will say to yourself, this is interesting, this is grand, this is beautiful like a Chardin,' promised Marcel Proust, a great admirer—as were the painters Paul Cézanne and Henri Matisse.

What other artist has ever revealed the material world with such devotion, such tender objectivity, such harmony, and then endowed it—without distortion—with what I can only call a moral force? 'All great art is praise,' wrote Ruskin, and how fully this is in evidence in this loving celebration of a simple kitchen urn.

Samuel Palmer: *The Valley thick with Corn, 1825*

Created slightly less than a century later than Chardin's urn, *The Valley Thick with Corn*[31] is another (but very different) act of praise. It was drawn by the twenty-one year old Samuel Palmer, in a condition of religious rapture. On its mount, a passage from Psalm 65 establishes the spiritual tone of a work which in its own way is as devotional as Duccio's *Maesta*. 'Thou crownest the year with thy goodness; and the clouds drop fatness. They drop upon the wilderness: and the little hills shall rejoice on every side. The folds shall be full of sheep; the vallies also shall stand so thick with corn; that they shall laugh & sing.'

This then is a drawing of praise of the natural world on the edge of Paradise. This is an ode to the beauty of Creation. Only once in centuries could someone give expression to this degree of invention, the splendour and power of a Wordsworthian intimation of 'something infinite in everything'. Fertility and abundance are also the themes of this work, which calls to mind not only the psalms but the prose and poetry of the seventeenth-century priest Thomas Traherne, to whom the whole material creation, even in its smallest parts, was a 'deep and infinite' revelation. In a famous passage from Traherne's *Centuries of Meditation* (which Palmer could not have known, as the text was not discovered until 1908), its author writes with the kind of spiritual rapture which informs Palmer's work of this period. 'The Corn was Orient and Immortal Wheat, which never should be reaped, nor was ever sown. I thought it had stood from Everlasting to Everlasting. The Dust and Stones of the Street were precious as Gold. The Gates were at first the end of the World. The Green Trees when I first saw them through one of the Gates Transported and Ravished me, their Sweetness and unusual Beauty made my heart to leap, and almost mad with Ecstasy, they were such strange and Wonderful Things. . . . Eternity was manifest in the Light of Day, and something infinite behind everything appeared: which talked with my expectation and moved my desire.'

Of course, there was (as Palmer knew) great poverty and discontent amongst the farm workers who laboured in the Kentish countryside during the years in which he lived in their midst and celebrated the supposed joys of pastoral simplicity. Here is a case of the prosaic 'real' and the imaginative 'eternal' meeting and clashing in an unresolvable conflict. But Palmer's vision never belonged to the former, the world of time, but to the world of which we seem, as Traherne acknowledges, in one sense always and for ever to have known.

Vincent van Gogh: *The Starry Sky, 1888*

Another deeply religious vision, closer to the 'real' but not one jot less exultant, is *The Starry Sky* as it was painted by van Gogh on the outskirts of the village of St Rémy in Provence soon after he had moved there from Arles.[32] At this time the painter was living in an asylum—in two cells, one for work and one for sleep—and started to work without delay. Initially he was afraid to leave the hospital or its garden, and for a time contented himself with painting and drawing the view from his window, leaving out the bars. But in June of that year, 1888, he went into the surrounding countryside and painted *The Starry Sky*, as if he'd seen the Burning Bush.

The canvas is the register of an experience of clairvoyant intensity, combining calmness with an unprecedented sense of mystical euphoria. In it van Gogh presents a new kind of beauty: naked, high voltage, in tune with the soul of nature whose energies are coursing throughout the cosmos. 'No superlatives seem apt to encompass its beauty and emotional range,' writes one of the most perceptive critics of our time, Robert Hughes.[33]

Few people before van Gogh had experienced this degree of communion with a living cosmos vibrating in a dance reminiscent of the Shiva Nataraja, which the painter could never have seen. Nor, of course, could he or any of his contemporaries have known about the speculations of the new physics which have allowed us to see the cosmos as a flowing movement that co-arises along with everything else, moment by moment, in a process of continuous regeneration. Yet by a leap of visionary intuition, van Gogh experienced—and painted—its beating heart as if it had been revealed by spiritual x-ray.

If one thing is certain about the thirty-six year old painter it is the intensity of his worship of nature—not only stars but grasses, weeds and mountains—and the unconditional homage he offered to all of it. In the middle of the nineteenth century, the faith that had created the cathedrals had largely disappeared; yet here and there it still flamed out in individuals such as the poets Gerard Manley Hopkins and Elizabeth Barrett Browning, who rejoiced that 'Earth's crammed with Heaven, and every common bush afire with God.'

The Starry Sky is a work of astounding power. Gone is the poetic serenity of Sassetta's *St Francis*, gone the heavenly calm of Vermeer's *View of Delft*, gone, too, the almost pagan nobility of Poussin's *Summer, or Ruth and Boaz*. In their place is another kind of beauty.

Paul Cézanne: *Still Life with Apples and Oranges*, 1898

Not so many miles from the village of St Rémy lived another loner, Paul Cézanne, seeking to realize his own singular vision.[34] Fortunate in having inherited enough money to work without the distraction of having to earn a living, Cézanne spent incalculable hours painting the local Provençal landscape and the still lifes that he set up in his studio. In this respect he resembled one of the Desert Fathers with their lives of prayer and meditation. Yet against the odds, Cézanne produced works of such exalted affirmation that they can compare with the greatest paintings of the past.

Still Life with Apples and Oranges is a work of the greatest beauty. The colour is superb: a conflagration of vibrant reds and oranges orchestrated against the cool whiteness of a folded cloth and the dark, sumptuously patterned carpet at the back of the group. Against the complication of the whiteness and the subdued chords of the mottled drapes, the rich clear notes of the fruit play like flutes above the sound of an orchestra. Although the leanness of this painting is remarkable, its sensuality is even more pronounced. Its chords have something of the raw originality of the music of Berlioz.

The composition is no less vibrant. The white cloth is magnificent in its curving lines, its multiplicity of contrasted directions, its great rise and fall, and the spectrum of the colour delicately toning its alpine whiteness. It is wonderful how the syncopation of the cloth's linear and angular forms are contrasted with the repeated theme of the rounded fruits which have their own magisterial grandeur. There remains another factor to add richness to the whole: the all-important difference between depth and surface.

But no amount of descriptive writing can take us far into the source of the painting's abstract beauty. Yes, it is monumental, it has an unanalysable purity and, like the Chardin of the copper urn, a remarkable moral integrity. It is superbly painted; is energetic and complete. But in the final analysis no one can say why or how this painting moves us so deeply. It simply does. Perhaps, in part, this is recognized by the critic Lionelli Venturi who writes: 'Something astonishing (has) happened, something that critics still refuse to accept: the artist's very soul is captured within a painted apple.'[35]

Cézanne died at the beginning of the twentieth century, and I conclude this chapter with his heroic and single-minded quest. This is not, of course, because

beauty died with him—far from it—but because the point I have been hoping to make about the mystery, the unexpectedness and incalculable varieties of beauty has been made.

Yet in some ways it could be that something also died with Cézanne, something that was dying long before his birth. The craftsmen who designed and constructed Chartres or carved the Bodhisattva in Nara did not work for themselves; they worked on behalf of a tradition of belief and for the communities who shared it with them. Later artists like Chardin and van Gogh could only speak for themselves, and sometimes even in opposition to their communities. This, of course, is not to suggest that the works of painters such as, say, Corot, Braque or Mark Rothko, such sculptors as Brancusi (see Plate XIII) and Henry Moore, such poets as Edward Thomas, Baudelaire and Ezra Pound, and film makers like Satyajit Ray and Kurosawa, are not superb. Their works are magnificent, but in the final analysis they can lack the affirmative power and amplitude of the work of earlier centuries.

It is reported that the film-maker Humphrey Jennings observed shortly before his death 'that the coming of the Machine Age is destroying something of our life.'[36] His contemporary Ingmar Bergman amplified Jennings's observation when he stated that 'art lost its basic creative drive the moment it was separated from worship. It severed an umbilical chord and now lives its own sterile life, generating and degenerating itself. In former days the artist remained unknown and his work was to the glory of God. He lived and died without being more or less important than other artisans; "eternal values", "immortality", and "masterpiece" were not applicable in his case. In such a world flourished invulnerable assurance and natural humility.'[37]

Perhaps, though, I may need to stress that in admiring Chartres Cathedral I am not suggesting a return to the Middle Ages, or in praising a Shiva Nataraja, that we should become Hindus. Both the construction of the cathedral and the creation of the devotional image flourished in a world that has largely gone forever in the West. Recidivism and nostalgia for a lost Golden Age have no appeal for me. It may sometimes seem that I believe the past to be both better and brighter than the present, furnishing examples of beauty all too manifestly lacking from the contemporary industrial estates. But if this can seem so, I know that the past, if visually and aurally exceptional, was unacceptably uncomfortable, tormented and violent.

I live in the twenty-first century, and for all its shortcomings I am eager and

fascinated to do so. Yet without longing to return to any of the vanished cultures, we may see that the city of Shah Abbas, ancient Kyoto and the work of Vermeer and Samuel Palmer can reveal qualities and values, disclose diverse archetypes and different levels of reality from those which are normal in our own more materialistic age. To interpret the discoveries to be gleaned from each of them in the idiom of our own time is surely the task to which some of us are called.

Art, Past and Present

The art of Greece prior to the third century BC and that of the Middle Ages was never debased to a mere means for sensual entertainment or utility. By the artist, as well as by the public, it was regarded as the incarnation either of Plato's ideal of absolute beauty or of the absolute value of God. It was not divorced from religious, moral, cognitive or social values. It was indissolubly bound up with all their fundamental values—with God, truth, goodness and the majesty of absolute beauty itself. As such, it was never the empty shell of 'art for art's sake'. Thus, it was sublime and serene, instructive and elevating, religious and idealistic, intellectually, morally and socially inspiring. It almost entirely ignored the negative aspect of man and of his empirical world. Nothing coarse, vulgar, debasing or pathological found place in it. Its topics were the noblest mysteries of this world or the other world; its heroes and personages, as we have seen, were mainly the gods and demigods or the saints. Hence without specific intention, it uplifted man and his culture to celestial heights, immortalized the mortals, ennobled the commonplace, embellished the mediocre, and idealized the whole of human life. It was the incarnation of absolute values in a relativistic empirical world. And the artist himself created, to quote once more the dictum of the famous Theophilus of the Middle Ages, nec humane laudis amore, nec temporalis premii cupiditate . . . sed in augmentum honoris et gloriae nominis Dei—neither for the love of men's praise, nor for the desire of temporal reward. . . but for the greater honour and glory of the name of God. His creation was for him a service rendered to God and man, the discharge of his religious, social, moral and artistic duties. . . .

As we move nearer and nearer to contemporary art, we are well-nigh shocked by the contrast that we encounter. Art becomes increasingly a commodity manufactured primarily for the market; motivated largely by humane laudis amore and temporalis premii cupiditate; and aimed almost exclusively at utility, relaxation, diversion and amusement, the stimulation of jaded nerves or sexual excitation. . . . Instead of elevating the masses to its own level, it sinks to the level of the common herd. Since it has to entertain, thrill or relax, how can it avoid becoming progressively more sensational, 'stunning', exotic and pathological?

PITIRIM A. SOROKIN

The Everlasting Stream

O Beauty, so ancient and so new
ST AUGUSTINE

One of the arguments of this book is that the native love of beauty, acknowledged and unacknowledged, persists through time and circumstance. In short, the beautiful is therefore a permanent feature of all our lives. How then could it disappear when the imaginative impulse is an integral element of existence itself? How could the old spiritual life be obliterated when countless people continue to cherish its forms harboured in contemporary styles and settings? How could we fail to be enchanted when we see those glimpses of the world *ensouled* by its presence? For a start, nature herself, however eroded by the materialistic worldview, unfailingly continues to offer an ever-present reminder of its presence in our world: the dawn is permanent, as is the night sky; so, too, the play of sunlight on new grass and the wind on the waves of the sea. Whatever idiocies human beings are now perpetuating, nature remains inexhaustibly beautiful and attractive to our souls. It can never cease to guide us towards a sensibility where soulfulness and beauty touch the heart.

At the same time, although some have let go of the golden thread of good aesthetic judgement and are content to live within the functional, plastic, disposable aesthetic of modern Western life, others continue to hold out against the tide. In the midst of a drab, inhuman townscape they will create oases of beauty, transforming their gardens into small reflections of Paradise and their living rooms into places that radiate homeliness and comfort. Elsewhere, someone will take care over a shop window, the decoration of a Christmas Tree, a birthday cake, and their own appearance. They sing in a local choir, and enjoy the preparation of a flower arrangement. Their kitchens are pungent with the smell of baking and the dishes they serve to their guests can be called works of art. Their children dance, and at their primary school are encouraged to paint.

True, if the desire to decorate and embellish remains something of an instinctive gift, it is a gift that in the West is now far from universally honoured. Ferocious consumerism has put paid to a great deal of personal invention while professionalism has eroded confidence; fewer people make their own clothes and many rely on prepared foods. Nevertheless, if the vigorous imaginative invention of the preindustrial cultures remains a thing of the past, if no Western church is any longer decorated as it would be in, say, Mexico or

Guatemala, or a Western vehicle painted as it would be in India, a substantial number of Westerners continue to make the effort to enhance their personal territories. Often these may be small, peripheral gestures of the creative imagination, but if all of them could be added together in this country alone they would be seen to make a substantial total. Nonetheless, let us not be deceived, for we have been careless of our countryside and our cities; there is widespread aesthetic ignorance, an anaesthesia of sensibility of the profoundest proportions. And the greatest ugliness, the greatest impersonality, is to be found in the unloving and unloved public domain.

The reasons for this calamity are manifold: twenty-first-century monopoly capitalism and its sad apology for a living human culture must be the major cause. But others include the breakdown of any unity between scientific, spiritual and aesthetic life; the perceived lack of money for what is seen as an unimportant feature of contemporary life; the influence of a culture antipathetic to delight; the emphasis on literacy, numeracy and science in secondary education; the use of prefabricated industrial components; the democratization of taste; the loss of the spirit of local identity; the rush of speculative building; the emphasis on short-term solutions at the expense of more expensive longer-term ones, and the fact that decisions are so often made by people at a distance—all are working to create hideous and unfriendly environments.

Some of the above-mentioned factors are also influencing the so-called High arts. These have been weakened by their marginal position within society; the ideology of Modernist progress; the fast obsolescence of avant-gardeism; the fads and fashions of the mass media and the hegemony of the market. Compare the work of the majority of living or recent artists of merit with the great masters of the past—for all their strengths, the loss of significance becomes unmistakably apparent. Although the eye and ear of the future will find artists to respect when it looks back on our time, it will have to ignore the inconvenient fact of a massive decay of quality and quantity. The flood spate that carried Monteverdi and Haydn, Michelangelo and Rubens to fulfilment no longer runs at either the same rate or depth.

Yet creative activity, whatever its quality, is at an all-time peak; Robert Hughes reports that there are about 200,000 'artists' in America alone, each making (at a conservative guess) fifty or so objects a year—ten million works. In other Western nations there is hardly a village without a craftsperson.[1]

However, putting all these green shoots aside, for the remainder of this short chapter I would like to turn to the work of a number of artists whose

work has not been inflated with false claims of its importance. In some cases I list these for the sake of specificity, but emphasize that there is nothing definitive about my choice.

The Visual Arts

In the overcrowded art scene of the twentieth and twenty-first centuries much has accelerated to the point of hysteria. Nonetheless, amongst so much that has been vulnerable to fashion, there have been artists and works of significant value. It is my hope that some of the latter are to be found in the following, necessarily incomplete list.

For beauty is permanent, and to be found in many extraordinary, often unexpected places. It could come from the work of Pablo Picasso (the etching *Minotauromachy*—see Plate XIV), Henri Matisse (*Le studio rouge*), Pierre Bonnard (*Nude in the Bath*), Marc Chagall (*At Dusk*), Georgio Morandi, Georges Braque, Georgio de Chirico, Joan Miró, Georgia O'Keefe, Mark Rothko and Arthur Boyd. There are also the English artists: Stanley Spencer, David Jones, Paul Nash, Winifred Nicholson and Cecil Collins. Other painters of distinction are Milton Avery, Morris Graves, Alan Davie, R. B. Kitaj, David Hockney, Howard Hodgson, Anselm Keifer and Andre Jackowski. I also delight in the photographs of Henri Cartier-Bresson, Edwin Smith, John Piper, Bill Brandt and Josef Koudelka.[2]

Amongst sculptors, there is the incomparable work of Constantin Brancusi, (*Maiastra* and *Endless Column*—see Plate XIII). Henry Moore, Isamu Noguchi and Andy Goldsworthy have also created work of great beauty.

The Crafts

Many cities, towns and villages have craftsmen and craftswomen of one kind or another—potters, jewellery and furniture makers, textile artists, weavers, bookbinders, knitters, wood turners, glass workers, metal workers, basket makers, wood turners, makers of books, leather workers—all struggling to survive and produce useful and beautiful work. There is also the small army of dedicated workers—hairdressers, gardeners, cooks, boat builders, plasterers, plumbers, carpenters, joiners, etc—seeking to fill the void left by the introduction of careless industrial processes with their own aesthetic labour. The sense of exuberance, of human commitment, of achievement in the

work of all these people can be electrifying.

The count of outstanding craftspeople is large, but I should like to mention the pleasure I have found in the beautiful pottery of Shoji Hamada, Kenkichi Tomimoto, Bernard Leach, Lucie Rie, Michael Cardew, Clive Bowen and Richard Batterham in particular.

Architecture

We all live in, work in and experience architecture on a daily basis. We don't have to visit an art gallery or listen to music, but no one in London, for example, can avoid seeing the towers of Canary Wharf. The decisions taken by architects therefore impinge on us more than any other art or craft.

The decisions about town planning and architecture taken in this country in the post-war years were on the whole disastrous, inflicting incalculable visual damage on our towns and cities: charmless streets bordered by inhumane buildings, concrete high-rises and impersonal office blocks. Even as recently as twenty years ago, virtually no one in this country was building anything covetable; architects had largely retreated into a shoddy mediocracy, filling our once 'green and pleasant land' with buildings both disenchanted and starved of spiritual meaning.

Recently, though, the profession seems to have undergone a quiet regeneration. The decades since the mid-eighties have seen an unparalleled surge of architectural creativity and confidence. Completely new possibilities have been opened up by technological innovations such as high-tech materials and computer-aided design. In consequence, architects such as Frank O. Gehry (*Vitra International Furniture Manufacturing Facility and Museum, Weil am Rhein, Germany 1986–89*) and Tadao Ando (*Naoshima Contemporary Art Museum, Japan 1989–92*) have designed some spectacular buildings. Other interesting architects include Jorn Utzon (*Sydney Opera House 1956–66*), Hans Scharoun (*Philharmonic Concert Hall, Berlin 1956–63*), I. M. Pei (*Louvre Pyramid, Paris 1982–89*), Renzo Piano (*Kansai International Airport, Osaka, Japan 1988–95*), Zaha Hadid (*Vitra Fire Station, Weil am Rhein, Germany 1989–93*), Ada Karmi-Melamede and Ram Karmi (*Supreme Court of Israel 1986–92*) and Norman Foster (*Reichstag 1993–99*).[3]

I am struck by the aggressive individualism of these buildings, with their emphasis on idiosyncratic and often sculptural expression. And as far as I can judge from photographs, they often seem to be characterized by a general lack of warmth, but their more positive qualities may be more evident when

experienced in three dimensions and in the flesh.

But I have no doubts about the beauties of such early Modernist buildings as Le Corbusier's *Villa Savoye* (1929–31) with its exquisite purity of design. Le Corbusier's pilgrimage church at Ronchamp (see Plate XII) in the mountains of central France (1950–55), Henri Matisse's *Chapel of the Rosary* at Vence in the south of France (late 1940s), the Baha'i Temple in New Delhi by Fariburz Sahba (1987), Imre Makovecz's Roman Catholic church at Paks in Hungary (1987), the King Saud mosque in Jeddah, Saudi Arabia by Abdel-Wahed El-Wakil (1989) and Philip Johnson's *Crystal Cathedral* in Los Angeles, are also remarkable. No less exhilarating is the Thorncrown Chapel in Eureka Springs, Arkansas, designed by the American Fay Jones in 1980.

Music

Great beauty is also to be found in the music of many twentieth-century composers: Gustav Mahler (died 1911), Claude Debussy (d.1918), Gabriel Fauré (d.1924), Giacomo Puccini (d.1924), Maurice Ravel (d.1937), Jean Sibelius (d.1957) and Richard Strauss (d.1949). Later composers whose work I greatly value include Olivier Messiaen (*Quartet for the End of Time*), Igor Stravinsky (*Canticum Sacrum*), Leos Janácek (*The Cunning Little Vixen*), Vaughan Williams (*The Lark Ascending*), Anton Webern (*Das Augenlicht*), Shostakovich (*Quartets*), Benjamin Britten (*Curlew River*), John Tavener (*Depart in Peace*), Henryk Gorecki (*Miserere*) and Arvo Pärt (*Cantus in memory of Benjamin Britten*). More recently, I have been discovering the work of Einojuhani Rautavaara (*Cantus Articus*), Giya Kancheli, Valentin Silvestrov and the Japanese composers Toru Takemitsu and Somei Satoh (*A Gate into Infinity*).

Gardens

The twentieth century has seen a renaissance of garden-making. I am listing a small selection of outstanding British examples, but to these should be added countless other gardens.

Hidcote Manor, Gloucestershire (Lawrence Johnston; 1907 onwards)
Bodnant, near Colwyn Bay (laid out by Henry Pochin, and followed by
 the second Lord Aberconway and his head gardener, F. C. Puddle)
Nymans, Sussex (Ludwig Messel and his son Colonel L. C. R. Messel)

Great Dixter (Nathaniel Lloyd and Edwin Lutyens)
Sissinghurst, Kent (Vita Sackville-West and Harold Nicholson; 1930s
 onwards)
Shute House, Shaftesbury (Sir Geoffrey Jellicoe; 1969–88)

Film

The slump in quality so marked in the visual arts is less in evidence in cinema. Original, imaginative—and beautiful—films are being produced with regularity in many countries of the world, and some of the ones I have seen are listed, but there are dozens of others which could be included.

The ones I admire include: Ingmar Bergman's *Wild Strawberries, Smiles of a Summer Night, Fanny and Alexander, The Silence* and *The Seventh Seal*; Krzysztof Kieslowski's *Three Colours Blue* and *Three Colours Red*, Akira Kurosawa's *Dersu Uzala, Ran, Ikuru, Seven Samurai*, and Satyajit Ray's *Pather Panchali, World of Apu, Charluta* and *The Music Room*. Stanley Kubrick's *Barry Lyndon*, Abbas Kiarostami's *Through the Olive Trees*, Rajan Khosa's *Dance of the Wind*, Nikita Mikhalkov's *Barber of Siberia*, Kenji Mizoguchi's *Ugetsu Monogatari*, Max Ophuls' *Letter from an Unknown Woman*, Jean Renoir's *La Règle du Jeu*, Carl Dreyer's *Ordet* and, unforgettably, Marcel Carné's *Les Enfants du Paradis*.

CHAPTER FIVE

The Birth of Ugliness

BEAUTY WAS IN THEIR SOULS

There was a time that lasted for many thousands of years when beauty clothed the Earth. People could be wretched, beset by fear, injustice and grey routine, but nothing inhibited their quest for something beyond the satisfaction of mere creature comforts and needs. It was a satisfaction that found natural expression in the crafts. As far as the present author can see, ugliness in Europe made its appearance sometime in the seventeenth century, and thereafter gained an unstoppable momentum.

There is now an embarrassment about this kind of statement that depends for confirmation upon memory or feeling: it will be vehemently denied, it will be scorned. It will be argued that only the handsomest things have survived the ravages of time and that I have been seduced by nostalgia. Yet however some may choose to argue otherwise, the historical evidence is incontestable. Before, say, the Italian Renaissance, beauty was not the exception but the rule.

Craft had always been the basic activity in human society and, as such, not only the carrier of beauty, elegance and grace into an otherwise harsh and drab existence but, in Philip Marsden's phrase, 'the glue that binds the quotidian to the transcendental'. An authority on the crafts, Kamaladevi Chattopadhyay, confirms my view. She observes that

> No aspect of life was too insignificant or humble to lay claim to beauty or acquire sanctity as a symbol of good omen. The use of special articles for special occasions in the way of clothes, jewels, vessels, etc., all of which had to have a certain quality to ensure a high standard even in daily life and use, meant a continuous outflow of creativeness, a sustained spirit of animation and freshness dispelling staleness and monotony.[1]

SOME SASHES FROM COLORADO

The archaeologist Jacquetta Hawkes substantiates this view. In *Journey Down a Rainbow,* she describes her discovery of some woven strips found in a cave near the little mining town of Durango, Colorado, where they had been lying for about fifteen hundred years.

> The sashes were woven by Basket Maker Indians out of the hair of their dogs. . . . How truly wonderful it is that a people living without so many of the things we regard as necessary, always uncomfortable and often in danger, should gather the hair of their dogs and weave sashes whose length, cunningly twisted fringes, and, above all, whose fine patterns far outshone the dull forms of necessity. . . . As I stood in this little museum I found I was comparing the world it represented with that of a New York store. Here, a few things supremely satisfying to those who made and enjoyed them, because they expressed something in the being of the makers, of their tribe and its tradition. There, a vast welter of things expressing absolutely nothing but cash value, jazzed up with scores of corrupt decorations plucked senselessly from their living contexts. If some of the Basket Makers' sashes were displayed on one counter of that store, then all the products of mass production and cultural scavenging would become virtually invisible, falling out of sight like dead leaves. These objects made by Indian women living obscurely among the mountains of Colorado would stand in New York regnant, seeming to show a confidence in their own existence and its power to command admiration and feeling. [2]

Then the author adds what amounts to a defence against all those who would accuse her of romantic nostalgia for a society that can be criticized in terms of its laborious manual servitude, serious medical inadequacy and lack of material abundance:

> I have to be severe with myself. I know that I should be frustrated, cut down, if I had to live in a pueblo with a few possessions such as these. I know, too, that a greater degree of social organization and technical skill has been needed to nurture the highest genius and human achievement. There could have been no Dante or Leonardo among the Indians.

Nevertheless, I am truthful when I say I would rather share in the life of a pueblo than in that of any of the little scurrying robots I saw in my vision. I believe it to be not only a happier life, but one more worthy of our kind.

THE IMPORTANCE OF BEAUTY IN THE PAST

Given the weight of contemporary opinion about the unimportance of beauty, I would like to devote some space to a consideration of its position in the past. To that end we will consider the evidence from ancient Egypt, China, Minoa, other civilizations and Europe itself.

The tomb of Tutankhamen, the royal burial chamber, dating from the height of Egyptian civilization, was found in 1922 almost exactly as it had been left some 3,300 years earlier. It was crammed with thousands of treasures, every one of which was of the most singular beauty. Consider, too, another hoard: the Qingzhou discoveries exhibited in the Royal Academy in 2002. These had been selected from a hoard of more than 400 Buddhist sculptures that had been unearthed in the small town of Qingzhou in eastern China. Although the majority of the pieces dated from the sixth century, others had been made over a period of 600 years from about 386 to 1126. For the visitor to this exhibition, it was obvious that the work on view had been made by anonymous craftsmen. Yet here were sculptures of unparalleled quality and heartbreaking beauty.

Or consider the ceramics, sculpture and jewellery of the Minoan civilization of the eighth century BC[3] or the Indian temple sculpture of the eleventh—both sophisticated cultures where the highest achievement might be expected to occur. But if that somehow 'disqualifies' them, then let us turn to the craft work of the peoples of the less sophisticated cultures of Africa, South America, India and the countries of the Far East. The grain storage and other domestic vessels made by Indian potters serving this vast country of 930 million people are not only skilful but superb, as we can see in Jane Perryman's authoritative *Traditional Pottery of India*.[4] The same is true of the fabrics of Africa,[5] and other countries of the East.

But no less attractive are the colourful and highly decorative costumes, quite free of precociousness or self-conscious elegance, which are illustrated in the photographs of *The Nomadic Peoples of Iran*.[6] Here are pictures of the tribes-people of contemporary Iran—Kurds, Lurs, Bakhtiaris, Qashqa'is, Mamivands

and Turkomen—whose appearance is more beautiful than that of any contemporary princess. Although incalculably poor, these peoples seem in no way deprived of human grace and dignity.

Few indeed are the modern Europeans who recognize that clothes are not merely to cover our nakedness in accordance with proper convention, but are also for decorum and adornment, as much so for men as for women, But one who did was Eric Gill, who wrote books about the subject.[7] Holding a belief about the unworthiness of the garments worn by the modern male, Gill himself wore a belted tunic or smock and did away with a collar and tie. He pointed out the contrast between the loose-fitting clothes worn by the men of India and the Arab countries of the Middle East, and those being worn by their Westernized contemporaries. The former are simple, free-flowing and of an ascetic simplicity; the latter, the cheap products of the factory, proposing a uniform urban anonymity. Dignity, he argued, has no place in the language of Modernity.[8]

Much the same trajectory from the simple, hand-made and local use of natural materials—wood, stone, clay and reeds—to the now more universal usage of factory-made building components—breeze-blocks and corrugated iron—is turning the diversity of the old vernacular environments into the indistinguishable and uniform habitat of many parts of the modern world. The brushwood dwellings of the bushmen of the Kalahari Desert, the thatched cottages of Japan, the whitewashed and barrel-vaulted houses of Tunisia, the exuberantly decorated houses of the Yemen—are being replaced by industrial products that have been made in factories some distance from the site. Yet the majority of vernacular houses are still characterized by great beauty and these, according to Paul Oliver in his study *Dwellings: The Vernacular House World-wide,* make up more than 90 per cent of all buildings in the world.[9]

Beauty likewise used to characterize the many communal creations assembled organically and over countless generations: innumerable landscapes (such as those in China, Tuscany and Peru), villages (for example Mont St Michel in Normandy, Saint-Cirq Lapopie in the valley of the Lot, or Chipping Campden in the Cotswolds)—entire settlements informed by a natural sense of unselfconscious harmony.

The selfsame delight in the beautiful can be seen in the city-portraits of Venice by the painters Guardi and Canaletto, in Samuel Scott's views of eighteenth-century London, in Nicholas Guerard's engravings of seventeenth-century Paris and Vermeer's oils of Delft. It can also be found in countless early

views of Dresden, Rome, Florence, Bath, Prague and St Petersburg; views which portray a seemliness and order far removed from the visual disorder of the contemporary urban townscape. Another work of glad beauty is Aelbert Cuyp's view of *Dordrecht from the North*, painted in the mid 1650s. It is a painting which presents a tranquil view of the town with its church and city gate seen from a river active with boats and ships. There is not a vulgar object in sight.

The same is true of the middle class interiors of this time, such as Vermeer's painting of *The Milkmaid*, the oils of Pieter de Hooch of about the same date or Martin Drolling's of 1817, where all is expressive of quietness and a civilizing comeliness. Beauty here is like the water in which fish live—a simple corollary of being alive—nothing special, but an unexceptional aspect of the fabric of everyday existence.

By a kind of osmosis or inhalation, the masons who built and beautified the village churches (see Plate XI), the wheelwrights who constructed the farmers' wagons, the potters and plasterers and saddle makers, silversmiths and joiners who fulfilled the local demand for the necessities of life and labour, drew their inspiration from the colour of a field of summer oats, the leaping gestures of a running hare or the choreography of a branching chestnut. Their genius lay in the intuitive translation of the forms of nature in the arts of hand.

But this delight in beauty is not limited to the visual; there is in addition the treasury of folk music, stories, tales and histories, invocations and prayers, runes and lays, of the various peoples of the world.

And so we could go on, discovering the tribal arts of Africa[10] and Peru, Russia and China, Japan and of course India, where at every level the vision of the beautiful continues to find expression in an unending and fertilizing stream. What other country can surpass the rural crafts of that great continent?

In my travels around India I have admired the humble but highly skilled work of craftsmen and women practising a wide variety of skills: embroidering wall-hangings, resist-printing cotton fabrics, shaping clay toys, painting lacquered wooden boxes and the walls of houses with images of their Gods.[11] In Mamallapuram in Tamil Nadu, I watched sculptor-artisans sitting on the roadside, carving statues of Vishnu and Shiva. In Benares I saw folk painters ornamenting the portals of houses with images of Ganesh, in Puri I also visited craftsmen making papier mâché masks of the city's all important God, Jagannath ('Lord of the Universe') and his brother and sister. And in the Rabari community of Kutch,[12] in the westernmost part of Gujarat, the women spend

long hours making garments and quilts, decorating them with cloth appliqué work and tiny mirrors. Yet living amongst these splendours of their own creation, the Rabari are almost immeasurably 'poor'.

Perhaps much of the Indian genius for beauty can be attributed to delight in beauty for its own sake; colour used because colour is lovely, decoration employed because it embellishes, forms chosen because they are both handsome and traditional, fulfilling a deep-seated feeling for harmony. But in India, the commoner impulse is a traditional and spiritual one: a ritual invocation to the gods. Appropriately, Stephen P. Huyler called his study of women's art in village India, *Painted Prayers*.[13]

THE DISESTABLISHMENT OF PARADISE

Man closed the gates of Heaven against himself and tried, with immense energy and ingenuity, to confine himself to the Earth. He is now discovering . . . that a refusal to reach for Heaven means an involuntary descent into Hell.
E. F. SCHUMACHER

So, when we are dulled, bored, an-esthetized, these emotions of bleakness are the reactions of the heart to the anaesthetic life in our civilization: events without gasping; mere banality. The ugly now is whatever we no longer notice, the simply boring.
JAMES HILLMAN[14]

Sometime between, say, Vermeer's *Milkmaid* of 1658 and Martin Drolling's quiet *Interior of a Kitchen* of 1817, a great change took place in northern Europe. The dominant European minds of the time began to see the human race not as a part of or as a member of Creation, but outside and opposed to it. They began to question the belief in a supersensory and super-rational God as the only true value and reality, and to replace this conviction with a new one—that the true reality and value was not transcendental but sensory. Beyond this sensory reality of the material order there was nothing but what we could see, hear, smell, touch and measure. Indeed in the briefest period of time only the measurable was considered real.

So Europeans were torn from their roots and cast adrift in a pathless and desacralized universe. By the end of the nineteenth century, the philosopher Nietzsche could proclaim that God was dead.

Several things stand out from this transformation. It was not that the religious mindset of the Middle Ages suddenly disappeared to be replaced by the

materialism of the scientific worldview with its new-found appetite for the utilitarian, the economic, the secular and quantifiable; fragments of the old craft-based theocentric civilization were maintained (and continue to exist) alongside the emergence of the new world-view. But if in 1260 (the date of the consecration of Chartres Cathedral) Europe was a deeply religious society, by the date of, say, Vermeer's View of Delft (see page 99), the new scientific order was well on the way to becoming the dominant philosophy of its time. From the early seventeenth century, the falling away of an imaginal reality had begun to gather momentum. Literalism was replacing the wisdom of vision and enchantment. Vermeer himself made use of the camera obscura and was seemingly associated with his Delft compatriot, the scientist Anthony van Leeuwenhoek, who used the telescope and microscope to great advantage.

But it was a slightly earlier and more important figure than Leeuwenhoek, Francis Bacon (1564–1642), who was to create the experimental-mathematical method which laid the foundation of subsequent progress in the physical sciences. It was a procedure alongside that of the Italian genius Galileo (1564–1624) and that of a later figure, Vermeer's contemporary, the French philosopher, René Descartes (1596–1650), who between them may be said to have established the scientific world-view.[15]

In 1637 Descartes proposed an idea that was to have the most serious consequences for the future of human-made beauty. It became the death-knell of all that could not be proved by measurement; the death knell of subjective judgements. Descartes emphasized the importance of all that, such as science, which was 'certain, evident knowledge', and that, in contrast, all that which was 'merely probable . . .' should be rejected. '(We) judge, that only those things should be believed which are perfectly known and about which there can be no doubt.'

This tendency to push sensibility into a sphere of private fancy—that is to say into a place where public obligations no longer apply—had already been envisaged by Galileo, whose procedures for analysing phenomena were to become the basis for the testing of all scientific theories. It was Galileo who asserted that to make accurate judgments concerning nature, scientists should limit themselves to the consideration of precisely measurable 'objective' qualities (for example size, shape, number, weight, motion) and ignore merely perceptible qualities (colour, sound, taste, smell, values, and therefore all aesthetic judgments), these being ephemeral and subjective and therefore merely personal. He held that the 'book of nature' had been written in the language of mathematics alone.

This grand book of the universe . . . is written in the language of mathematics, and its characters are triangles, circles, and other geometric figures without which it is humanly impossible to understand a single word of it; without these, one wanders about in a dark labyrinth.

It was a viewpoint or rather an ideology which was to lead to a clear demarcation between, on the one hand, the objective world, the impersonal dimension of pure 'facts' which could be perceived (and were measurable) by anyone, and, on the other hand, the subjective world which could only be experienced by the individual alone.

Some further words of Galileo serve to show the course the West, already in the sixteenth century, was setting itself to take.

If the ears, the tongue and the nostrils of those perceiving beings were taken away, the figures, the numbers and motions of bodies would indeed remain, but not the odours, or the tastes, or the sound, which, without the living animal, I do not believe are anything else than names.

Thus in Europe from the late seventeenth century onwards, whole areas of affection, emotion, intuition and imagination—the vast mythic, visionary and symbolic world with its all-pervasive numinous qualities—were jettisoned in favour of facts: the 'real' world. Such a narrow minded focus on rationality had one important consequence: the government of reason was to deny the possibilities of the irrational.

At a time of acute metaphysical turmoil, such advocacy is understandable and its consequences could not have been foreseen. Before the cataclysm of the Reformation, which in Europe looked so much like Cambodia's year zero, a unity of being welded religious, aesthetic and practical life into a seamless and indivisible whole. After it, Europe was to become a different place: greyer, uglier, more fragmented and ruled by what William Blake called 'a ratio of numbers'—a reliance upon human reason as the ultimate criterion of truth, limiting reality to the quantitative physical domain and restricting the relation between humans and nature to the level of the senses. Unsurprisingly, this attitude was to seep not only into such major spheres of cultural life as Puritanism but even into such lesser ones as art historical writing, which as Paul Hills has observed, 'continues to stress the dominance of 'Cartesian perspective' and to underplay the role of colour in Western art since the Renaissance.'

So after puritanical Protestantism set its face against the celebration of the

questing imagination, the secularizing thrust of the Western intellect took its place as the engine of future development. Expelled from the Church, one strain of the former went underground with the hermetic tradition, but it is hardly surprising that the majority of intellectuals, civic leaders and entrepreneurs of the time rejected the sacred, so perniciously had its powers been abused.

It was after the middle of the seventeenth century that European soul life began its long withering decline. T. S. Eliot has described the process as a 'dissociation of sensibility . . . from which we have never recovered.' It was then that ugliness was identified with 'reality' for the first time.

Yet it cannot be denied that the analytical procedures of Western thought emphasized at this time have brought astonishing gains for consciousness. These we admire and can acknowledge the extent to which our civilization has benefited from clear-headed rational thought uninformed by superstition, prejudice and ignorance. But valuable as it undoubtedly is, rationality also carries its own hidden limitations and its usage can become repressive and distorted over time. Many now living largely through the intellect have become emotionally dependent on a diet of raw eroticism and excessive violence. The cult of the ironic, distanced observer, aware of his awareness, is no replacement for the unanaesthetized heart which characterized the earlier centuries. Without soul there can be no relationship; without relationship there can be no soul.

A TREADMILL OF UGLINESS

Ugliness is a poison wherever it is found, and harmful to all concerned in its making, as well as in its use, therefore to be spurned at all costs.
C. F. A. VOYSEY

Until the period I have been discussing, the beautiful, like air and water, was everywhere taken for granted. And although I'm wary of pancultural truths, it seems obvious that in all societies the desire to create and love beauty in the temple, the church and the kitchen, in rituals, pageants, dances and processions was both deep and widespread. But in Europe after science and materialism had challenged God, after the Enlightenment had emphasized the importance of rationality, after Darwin had questioned our place in the universe, after rural populations had migrated from the countryside to the towns and industrialism had introduced mass and repetitive production,

the delicate fabric of beauty, first in this island and then across every part of the world, lost its former authority.

The consequences are to be seen everywhere—from Liverpool to Hong Kong, from Boston to Tokyo. In that great unsung masterpiece of English literature, *Lark Rise to Candleford,* Flora Thompson described how the change affected the cottages of the English farm workers at the moment that their world was about to disappear. 'To go from the homes of the older people to those of the besieged generation,' she wrote, 'was to step into another chapter of the hamlet's history. All the graces and simple luxuries of the older style of living had disappeared.... In their houses the good, solid, hand-made furniture of their forefathers had given place to the cheap and ugly products of the early machine age.' In *South from Granada,* his book about Andalucia at a slightly later period, the 1920s, Gerald Brenan observes a similar transformation. 'Historians, if such backwaters interest them, will note that the second decade of the twentieth century marked a wholesale destruction of peasant arts and customs in Southern Europe. German dyes replaced mineral ones in pottery, folk customs, country dances vanished. Uniformity came in. The roads built for the motorists put an end to the autochthonous life of the villages, and with that to the remnants of a culture that went back to classical times.'[16]

So first in England, then spreading across increasing segments of the world, beauty was imperceptibly replaced by ugliness: cheap products, sprawling suburbs, arid industrial estates and the monotonous vulgarity of factory-furnished interiors. Like a modern-day Hogarth, the photographer Martin Parr has documented this wasteland of contemporary Britain.[17] And two recent films, Sam Mendes' *American Beauty* and Alexander Payne's *About Schmidt* have contributed their own acerbic, darkly comic critique of the inanities and ugliness of conformist, wasteland America.

THE ROLE OF CAPITALISM

The new scientific order, building a world based on quantification, control and domination of the natural world, also prepared the ground for the development of a culture whose ethos encapsulates the most fateful force in the modern world: industrialism and now global capitalism.

The impulse to acquisition, the pursuit of gain, has in itself nothing to do with capitalism. As long ago as the early years of the first millennium, the

Roman writer Juvenal regretted how 'wealth is our divinity.' Max Weber agreed.[18] He suggested that the impulse of greed exists and has existed among 'waiters, physicians, coachmen, artists, prostitutes, dishonest officials, soldiers, nobles, crusaders, gamblers and beggars. One may say that it has been common to all sorts and conditions of men at all times and in all countries of the earth, wherever the objective possibility of it has been given. . . . But capitalism is identical with the pursuit of profit, and forever *renewed* profit, by means of continuous, rational, capitalistic enterprise.' For it must be so: in a wholly capitalistic order of society, an individual capitalistic enterprise which did not take advantage of its opportunities for profit-making would be doomed to extinction.

Inevitably it was those very 'advantages' which were to ring the death-knell of ornament and beauty. Beauty which is gratuitous must fall by the wayside in any society which not only replaces the sovereign importance of divinity with the sovereign importance of the human but seeks to maximize profit as the royal road to self-aggrandizement, luxury and social prestige. In such a society, beauty is to be ignored or sequestered in its ghettoes of beautiful things— museums and art galleries, concert halls and historic houses open to the public. But it is now seen to have a limited use, and it makes little profit. As a provincial printer, one of the characters in the Balzac novel *Lost Illusions*, declaims: 'Haven't they got any sense? Quality? Quality? What's that to me? They can keep their quality! For me, money is quality!'

It is obvious that capitalism and industrialism have introduced numberless benefits: spawned original technologies, stimulated the use of new materials and encouraged improved health and unprecedented material abundance. But one of the first and most depressing casualties of an overpowering industrial culture is the growth of the spirit of utilitarianism—and ugliness. Insensitive industrially produced materials have added their own malignant contribution to the ugliness of the modern world.

THE GUTTING OF THE CRAFTS

Soon after the advent of the machine, craftwork began to be marginalized as the vehicle of manufacture. So hand-work was largely gutted, a process reducing self-respecting artisans, with long traditions of autonomy and skill,

to the status of dependent wage-slaves. In time most native skills gave place to industrialized production and products, suffering in the process a devaluation from which they can never fully recover. It was a sea-change which replaced the heart-made and unselfconscious with the impersonal and rigid perfection of the machine. It also replaced skilful, self-expressive work with work that left little or no room for its maker to leave his or her individual mark on what was made.

A NOTE ON INDUSTRIAL DESIGN

Today, of course, there is a prominent category of industrial artefacts which, hugely seductive, fall under the broad heading of 'good design': graphics, audio and computer hardware, domestic equipment, vehicle designs and the like. These are often very handsome, but for all their merits—and a powerful motor bike and racing bicycle are excitingly designed machines—the products of the calculating intellect are no replacement for the beauty of the heartfelt products of the past. Our house has numerous labour-saving products such as a washing machine, a toaster and a petrol-driven lawnmower, but to turn to these for nourishment of the spirit can lead to grave disappointment. I will, of course, be told that washing machines and electric toasters were designed with one practical purpose in mind, but so are those little whisks for the Japanese tea ceremony (as on the cover of this book), and the snow-goggles from Northern Alaska reproduced in The Green Imperative by Victor Papanek.[19] These are eminently practical, and at the same time spiritually energizing.

There are many who will dismiss this opinion as little more than sentimental nostalgia. I sympathize with that response, but it fails to convince me. I would say that just as the present is incomparably more highly developed in the field of technology than, say, mediaeval Europe, ancient Japan or Moorish Spain, the latter cultures were incomparably more sophisticated in respect of the refinement of their aesthetics. I have only to compare the Katsura Imperial Villa in Kyoto and the Alhambra in Granada with the Pompidou Centre in Paris and the Empire State Building in New York, to sense a difference in the quality of their spirit's endeavour. Industrial society has gained much and has lost much, too. We have gained much, but lost those manifestations of the soul for which aesthetic decorum, good design and exquisite taste provide little adequate replacement.

I suspect there may be a general if unconscious acknowledgement of this loss, this hunger for deep beauty. Why else do millions travel great distances in search of it? Why do they climb the slopes of Exmoor to sit in silence overlooking the sea? Why do they wait in long queues for tickets to visit ancient monuments and travelling exhibitions of ancient artefacts? And where are they travelling to? To those places as yet uncorrupted by Progress: 'unspoilt' cities and stretches of 'undeveloped' countryside. But as Alain de Botton writes in *The Art of Travel*, 'Technology may make it easier to reach beauty, but it has not simplified the process of possessing or appreciating it.'[20]

MODERNISM AND THE MODERN CITY

The desert is not in Egypt; it is anywhere once we desert the heart.
JAMES HILLMAN

In the space available I can barely do justice to the damaging impact of architectural modernism in this and the previous century. It was introduced with fanfares of globalist propaganda by the Bauhaus[21] and Le Corbusier,[22] who envisaged their new style as both the symbol and the instrument of a radical break with the past. 'This architecture,' observes Roger Scruton, 'was conceived in the spirit of detachment from place, from history and from home. It was the "intellectual style", a gesture against the nation-state and the homeland, an attempt to remake the surface of the earth as a single uniform habitat from which differences and boundaries would finally disappear.'[23]

In 1908 Adolf Loos, another pioneer of Modernism, published a paper called 'Ornament and Crime' which paid no truck to the decorative arts. Ornament, he argued, was all right for children, criminals and primitive people, but what 'is natural for a Papuan and a child is degenerate for modern man. I have discovered the following truth and present it to the world: cultural evolution is equivalent to the removal of ornament from articles of everyday use. . . . The greatness of our age lies in its inability to produce a new form of decoration. We have conquered ornament, we have won through to lack of ornamentation.'

According to Loos, the only permissible elements were the materials which could be deployed for their intrinsic qualities alone: no symbolic or expressive transformation was to be allowed and certainly no superfluous decoration. Function was all: unadorned walls, clean shapes, rectangular lines were celebrated, but pattern, being neither functional or structural, was at best

superfluous, at worst subversive. Design, he believed, should be pragmatic and rational.

Similar ideas proliferated amongst the other pioneers of the Movement. Walter Gropius and Mies van der Rohe advocated the use of unaesthetic materials, rectilinear forms, engineering methods and standardization. They took pride in the Movement's stand against what the architect Lubetkin called 'subjectivity and equivocation'.

The years from 1925 were marked by an optimistic belief that the new technologies of industrialism, aided and abetted by the application of rational planning, would produce a qualitatively better world than the one that had climaxed in the rat-infested trenches of the First World War. So the Movement set about clearing away what Alezandro Lerroux described as 'the detritus of dead epochs'. Yet, however brave its intentions, the results of its progressive doctrine, like those of Fascism and Communism, were startlingly and even tragically inhumane.

Look at the inventive spires and towers of Wren's London churches, the decoration on the dome of the Sheikh Lutfullah mosque in Isfahan, the varied designs of the façades of the palaces of the Grand Canal in Venice, even the spectacular Gothic richness of Gilbert Scott's St Pancreas Station or the exotic splendour of William Burges's church at Studley Royal near Ripon (1871), and what do you find: exuberance, invention, delight. Look at the rectangular offices and apartment blocks, the 'rationally' designed hospitals and schools that have been built since the advent of Modernism and what do you discover: boredom, monotony and unfriendliness.

Love is not the word that springs to mind when one thinks of these buildings which seem, as the painter Cecil Collins observed, 'like diagrams of utilitarian engineering, hence the frequent feelings of emptiness, of nothingness, of lack of being, which oppress us.'

In his book *The Artful Universe*, the scientist John D. Barrow writes:

Distinguished architects, like Frank Lloyd Wright, have laid particular emphasis upon the desirability of creating canopies and refuges within buildings, and often set them in opposition to panoramic vistas, or even cascades of water, in order to heighten the feeling of security that these cosy alcoves create. Sloping ceilings, overhangs, gabling, and porches are all architectural features that accentuate the feeling of refuge from the outside world. . . . Their denial in many urban building projects has

had consequences which are all to plain to see. Concrete, exposed walkways, innumerable blind corners, greyness, and banal predictability, which offer no refuge from everyone else, and buildings that offer no enticement to enter: these abominations have led to depression, crime and emotional disequilibrium.[24]

In a striking passage in his book on Persia, James Morris describes the effect of the new industrial ideology on one city, Isfahan, but his observations have a world-wide application:

> The extraordinary is still the commonplace in this country, but it is no use pretending that the genius of the Persians has flowered in the twentieth century as it always did. Today the genius of the Persians, as we of the outside world cherish it, seldom flowers at all. Exquisite carpets are still made, but generally to antique patterns. Skilful miniatures are painted, but they are more craft than art. The architecture of modern Persia has generally been of a stunning banality, and scarcely a beautiful building has been erected for a century. . . . This is the taint of the West.[25]

It is a taint affecting many cities: Chicago, Istanbul, Osaka, Sydney, London, Malaga and Bombay, amongst those I have visited. Consider the case of Bangkok, once watered by curving riverways and tree-lined canals, now intersected by condominiums and shiny office blocks, straight-arrow corridors of asphalt and concrete, crowded with the steady ebb and flow of the human tide. Its river is biologically dead. The ancient city of Kyoto faces a similar fate: once famous for its temple gardens, forested shrines, lovely *shinese* (old shops), traditional inns, narrow, earth-walled alleyways and charming traditional streets of one and two story wooden townhouses (*machiya*), it is, according to Marc P. Keane, 'boringly unattractive or downright ugly'.[26] The *machiya* are being systematically torn down and bit by bit replaced by featureless apartment blocks that neither please the mind or nurture the soul. The city's special character, its particular genius, is being exchanged for money.

In *Cool and Crazy*,[27] a film about an aging male-voice choir from the weather-ravaged Norwegian town of Berlevåg, the members of the choir travel by coach through thousands of acres of dying forest to the Russian city of Murmansk, the home port of Russia's nuclear-powered ice-breakers. Passing through the

despoliation of this industrially polluted wasteland, one of the Norwegians makes the observation that he sees nothing in this environment to bring a smile to anyone's heart. It seems that smilelessness is characteristic of not only the environs of Murmansk but large swathes of the industrialized world.

Nonetheless, for all the undeniable monotony of many conurbations, the modern city can also reveal astonishing beauties. Wordsworth experienced an epiphany as he looked towards the City from Waterloo Bridge: 'Earth' he exclaimed, 'has not anything to show more fair.' A century later Claude Monet,[28] painting the Thames, the Houses of Parliament and even the bridge upon which the poet had stood in 1802, would have agreed; his pictures of the setting sun seen through the dense atmosphere of mist mingled with coal smoke from domestic fires and industrial furnaces, are magical. Today, that magic is still in evidence anywhere: the red shimmer of a traffic light reflected in the lacquered surface of a wet road, the nightscape of a city whose illumination resembles a scattering of jewels upon the firmament of earth, the shining fruit and vegetables in the brightly lit shops, the pubs throbbing with human conviviality, even the reflections of great clouds moving across the mirrored cliff-face of tall buildings—these, and much else, can be beautiful. Beauty appears wherever soul appears.

LOST BEAUTY IN THE COUNTRYSIDE

When human beings lose their connection to nature, to heaven and earth, then they do not know how to nature their environment or how to rule their world—which is saying the same thing. Human beings destroy their ecology at the same time that they destroy one another.
CHÖGYAM TRUNGPA[29]

Today the greenness of the world is running dry.
PETER LEVI[30]

Turning to the countryside where beauty and destruction also co-exist, it is evident that the polluting impact of modern commerce and technology on nature can only get worse.

The global despoliation, the species driven to extinction are so well known that I do not intend to rehearse them here; suffice it to say that almost every living system is nowadays in decline. In Britain, the devastation may be less dramatic than that in, for example, Brazil, but it has been noticeably worsening

the landscape which Constable delighted to celebrate. At least ninety-nine per cent of our species-rich hay meadows, fifty per cent of our ancient woodlands, fens and wetlands and 368,000 kilometres of our hedgerows have been lost since the 1940s. In the countryside around where I live, dandelions and nettles proliferate where cowslips, corn cockles and cornflowers once flowered.

Commenting before the worst excesses had been felt, H. J. Massingham wrote that 'the nation that defiles its own earth, its body and its sacred heart, is a parricide.' Fourteen years later (in 1954), at the conclusion of *The Lord of the Rings*, J. R. R. Tolkien likewise mourned the Earth's progressive mutilation. The returning hobbits for the first time see what had happened to their beloved home:

> It was one of the saddest hours in their lives. The great chimney rose up before them; and as they drew near the old village across the Water, through rows of new mean houses along each side of the road, they saw the new mill in all its frowning and dirty ugliness: a great brick building straddling the stream, which it fouled with a steaming and stinking outflow. All along the Bywater Road every tree had been felled.
>
> As they crossed the bridge and looked up the Hill they gasped. Even Sam's vision in the Mirror had not prepared him for what they saw. The Old Grange on the west side had been knocked down, and its place taken by rows of tarred sheds. All the chestnuts were gone. The banks and hedgerows were broken. Great wagons were standing in disorder in a field beaten bare of grass. . . . Sam burst into tears.[31]

As I do too, when I reflect on what is becoming of England.

AN UGLY CIVILIZATION

The car ploughed uphill through the long squalid straggle of Tevershall, the blackened brick dwellings, the black slate roofs glistening their sharp edges, the mud black with coal dust, the pavements black and wet. It was as if dismalness had soaked through everything.

The utter negation of natural beauty, the utter negation of the gladness of life, the utter absence of the instinct for shapely beauty which every bird and beast has, the utter death of the human intuitive faculty was appalling. The stacks of soap in the grocers' shops, the rhubarb and lemons in the greengrocers'; the awful hats in the milliners. All went by ugly, ugly, ugly, followed by the plaster-and-gilt horror of the cinema with its

wet picture announcements, 'A Woman's Love' and the new big primitive chapel, primitive enough in its stark brick and big panes of greenish and raspberry glass in the windows . . . Just beyond were the new school buildings, expensive pink brick, gravelled playground inside iron railings, all very imposing, and mixing the suggestion of a chapel and a prison. Standard five girls were having a singing lesson, just finishing the la-me do-la exercises and beginning a "sweet children's song". Anything more unlike a song, spontaneous song, would be impossible to imagine: a strange bawling yell that followed the outline of a tune. It was not like savages; savages have subtle rhythms. It was not like animals; animals mean something when they yell. It was like nothing on earth, and it was called singing. Connie sat and listened with her heart in her boots, as Field was filling petrol. What could possibly become of such people, a people in whom the living intuitive faculty was as dead as nails and only queer mechanical yells and uncanny will-power remained.

D. H. LAWRENCE[32]

In this chapter I have tried to draw attention to the growth of ugliness in the industrialized West and in the developing world; in particular, the growth of the featureless city and the loss of beauty in the countryside. But these are not isolated phenomena; they are manifestations of a culture that in some respects has become ugly to its very roots.

Signposts on the Road to Beauty

Beauty was lost in the West when the cosmos was lost, and as (Otto) Rank says about this latter loss, we all become neurotic with it. We also become willing victims of the consumer society's efforts to sell us ersatz beauty, as for example by way of perfectionism of luxury living.

MATTHEW FOX[1]

Numerous writers and film makers have intimated the decline of our over-ripe sensate civilization: Orwell's *Nineteen Eighty Four*, Fritz Lang's *Metropolis* and Ridley Scott's *Blade Runner* present pictures of a disturbing bleakness. In addition, Sir Martin Rees, a former President of the British Association for the Advancement of Science and a leading British cosmologist, has suggested that our species has only a 50/50 chance of surviving the new century.[2] According to him, the most likely threat to our survival will come at our own hands, through environmental catastrophe, nuclear or biological terror (or error), or developments in nanotechnology, in which self-replicating machines could devastate a continent within a few hours.

Anne Glyn-Jones's study of how civilizations decline, *Holding Up a Mirror*, likewise devotes a long, carefully researched chapter on the features of contemporary life—the recorded increase of violent crime, the extreme callousness of its perpetrators, the growing number of attacks on teachers and nurses, the rise in fraudulent applications for the dole, and so forth—which have so much in common with the features of a previous culture once morally, aesthetically and spiritually in decline—the late Roman.[3]

Why then does this chapter heading hint at some reasons for hope? There are several reasons. First, there is the slow rise in the number of those concerned about the degraded condition of the planet. More and more have also become aware of the problems associated with climate change, the calamitous increase in human population, the erosion of the Earth's biodiversity, the depletion of its natural resources and so forth. At the same time there are those who are now experiencing a sense of approaching crisis, a feeling that human life has reached a turning point of some kind.

Pitirim Sorokin, whose book *The Crisis of Our Age* has already been quoted, picks up at this point. His argument, based on research about the rise and fall of previous civilizations, prophesies the unstoppable end of our brilliant six-hundred-year-long sensate history—or at least its terminal outcome unless a world war can be avoided. If this catastrophe fails to occur, he writes, 'the emerging creative forces will usher humanity into a new magnificent era of its history.'

So what does Sorokin identify as the characteristics of the decaying sensate order, and what does he believe are the features of the potentially emergent

one? For an answer to the first question we do not have to look far within our own culture: its features already abound with the characteristics of decline in, for instance, the increasing subordination of quality to quantity and of inner content to means and techniques. The arts, he suggests, provide a further litmus test of the contemporary malaise; they are, he says, like a rudderless boat, 'tossed hither and thither by the shifting winds of fad, market demands, and (their) own quest for the sensational'.

Yet Sorokin claims that all is far from gloom; as in the past, the seeds of a new culture are even now germinating in the decay and transition of our time. The proposed remedy lies in the substitution of a more spiritual culture for the decadent sensate form.

> Virtually all the great world religions either first arose or else experienced their most vital renaissance in periods of profound crisis, as in ancient Egypt at the close of the Old Kingdom and at the end of the Middle Kingdom, or in Babylonia around the year 1200 BC. The phenomenon is illustrated more than once by the history of Hindu culture, where each notable crisis was met by a regeneration of Hinduism, or by the emergence or revival of Buddhism.
>
> The same principle is found in China, where the crisis of the seventh and sixth centuries BC was resolved by the advent of Taoism and Confucianism. Again, in the history of Hebrew culture the crises of the ninth to the fourth century BC owe their cure, or their partial alleviation, to the prophetic religions of Elijah and Elisha; Amos, Hosea and Isiah; Ezekiel and Jeremiah; and Ezra and his successors. Finally, to cite an additional instance, the crisis of sensate Graeco-Roman culture was terminated by the growth of Christianity. The respective societies were preserved from dissolution, be it noted, not so much through the 'practical and expert' manipulation of economic, political, genetic or other factors, but mainly through the transmutation of values, the spiritualization of mentality, and the ... ennoblement of social relations effected through the medium of religion.[4]

To avoid the otherwise inevitable catastrophe resulting from the failure to learn from history, Sorokin proposes a 'fundamental re-orientation of values [that is a] thoroughgoing change of mentality and conduct'. In other words, a *metanoia*. Before the First World War, the poet Rilke had already expressed his belief in the necessity for such a radical transformation; 'only through one of

the greatest and innermost renovations it has ever gone through will the world be able to save and maintain itself,' he wrote.[5] In subsequent years, libraries of books have been written giving expression to what the economist E. F. Schumacher has described as a 'metaphysical reconstruction'.[6]

So what form might this reconstruction, this new world-view or *Weltanschauüng*, take? Interestingly, studies of previous patterns of renewal have shown that these often arise out of that which has been most consciously despised and rejected. So in our case, since few aspects of life have been more ignored than soul, there is a real probability that just as in the Christian story the great renewal begins in the despised stable, with the son born outside the inn and of a race that was scorned by those in power, its hugely powerful realms could form the energizing heart of the next phase of cultural development. Soul and beauty, imagination and spirit could be the very elements that could regenerate our civilization. As we have seen, Sorokin identified this type as ideational.

Such a society would be characterized by its opposition to the hedonistic materialism that characterizes the West. Perhaps the main existing contender as maker and shaper of this culture might be Islam, but even within our own society there have been developments that give support to a more flexible and intuitive experience. Here Jung has played an important role, but other factors—the rise of feminism, of Buddhism and meditation, the distrust of traditional medicine, the return to the mystical roots of religion, and the widespread use of mind-expanding drugs—have played their role. Other factors which herald the twilight of Humanism and the birth of a new ideational culture could include the revulsion against corporate greed, the development of animal liberation and the numbers seeking a retreat from the rat race.

Recent decades have also seen the creation of a substantial body of studies (by authors such as David Bohm,[7] Morris Berman,[8] Fritjof Capra,[9] Edward Goldsmith,[10] Willis Harman,[11] Lewis Mumford,[12] Helena Norberg-Hodge,[13] Theodore Roszak,[14] Fritz Schumacher[15] and Ken Wilbur[16]) calling for a paradigm shift away from the reductionist approach of modern science. Notice should also be paid to the development of new understandings about the nature of the physical world revealed in, for example, the development of quantum physics, explored by Heisenberg, Bohr and others, James Lovelock's Gaia hypothesis[17] and Rupert Sheldrake's theory of morphic resonance.[18]

Not one of these developments could be said to be *the* blueprint of a new society, but taken as a whole they do signify the possibilities of a sea-change of momentous consequence.

A NEW WORLDVIEW AND ITS EFFECTS ON BEAUTY

Clearly it is not the eye, but the soul that sees. . . . And in the long centuries ahead may
we not develop a soul for beauties unthought of now?
SIR FRANCIS YOUNGHUSBAND[19]

So let us start by examining this potential sea-change in more detail. To help me undertake this task I have chosen to make use of some material which was used by Lindsay Clarke in his fascinating retelling of the story of *Parsifal*, material which he has kindly allowed me to use.[20] Under four related headings, the novelist describes his agenda for the development of Western consciousness. There is, he proposes:

A need to renegotiate the balance of power between the masculine and feminine principles (and not only in outward relations between the sexes, but inwardly, as aspects of our individual being, whatever our biological gender);

A need to renegotiate the relationship between civilization and the natural order (in particular the need to recognize that renewal often comes out of wildness, and sometimes in ways we don't recognize or consciously desire);

A need to renegotiate the balance between the ambitious claims of the ego and the larger, more exacting claims of the soul;

A need to renegotiate relations between conscious awareness and the neglected resources buried in the dreamworld of our unconscious shadow-side.

RENEGOTIATING THE BALANCE OF POWER BETWEEN THE MASCULINE AND THE FEMININE PRINCIPLES

The myth of the Goddess, the dominant cultural and religious force for many thousand years, has suffered a number of historical devaluations in the course of its long history. The first was when the orientation of the Goddess which dominated the Neolithic age was supplanted by the male-dominated Palaeolithic; the second was when the growth of scientific material-ism with its head-heavy emphasis on rationality and the coldly objective

weighing of fact, further subjugated the feminine perspective.

So dating from some time in the seventeenth century when objectivity became an aspect of extroverted consciousness, certain 'masculine' attributes such as will, reason, responsibility and the urge for power began to subjugate the more 'feminine' values of instinct, feeling, imagination, intuition. 'I think therefore I am,' pronounced Descartes in 1641, a defining sentence supporting the view that intellect holds the highest place in the pantheon of human faculties. If this were to be so it would follow—as it did for several hundred years—that both aesthetics and the magical dimension of life could be relegated to the least important position in the hierarchy of human attributes. For millions this was to weaken any vital sense of a spiritual dimension to life.

Yet sometime in the mid-seventies of the last century, when a movement of spirit renewal first began to flourish in the West, the feminine dimension started to make a return, to come more into its own. It is Goddess spirituality, and heralds a return to the long rejected inward dimension of the soul, the realm of beauty and the unconscious.[21]

Rationality as a model of consciousness has many virtues, but these are ones that underpin a lethal dualism; a dualism that divides the wholeness of life into two unrelated parts. Recent discoveries in subatomic physics are howeverm revealing the error of the belief in an absolute distinction between mind and matter, made first by Aristotle and Descartes, a distinction which implies the independence of an observer from that which is under observation. Since that discovery—the discovery that observer and observed are related, that everything is related, that we live in a world that is whole—our worldview has imperceptibly begun to change as it absorbs this new understanding. 'Only connect,' urged the novelist E. M. Forster.[22] 'What is within surrounds us,' observed Rilke.

RENEGOTIATING A NEW RELATIONSHIP WITH THE NATURAL ORDER

We must draw our standards from the natural world. We must honour with the humility of the wise the bounds of that natural world and the mystery which lies beyond them, admitting that there is something in the order of being which evidently exceeds all our competence.
VACLAV HAVEL

Turning from the *terra incognito* of a new balance between the masculine and feminine principles we arrive at another contemporary imperative: our need to reconsider the selfish greed which informs our relationship with nature.

Many of the books written on this subject—by, amongst others, Arne Naess, Thomas Berry, Albert Howard and John Muir—have called for a reconsideration of the human arrogance with which many of us now regard the animate earth and its multitudinous creatures. They have called for greater humility and reverence in face of the mysteries of nature: the conservation of endangered species, the preservation of forests and the wiser use of agriculture. These are attitudes which register an implicit belief that our cosmos is not a lifeless machine but a living organism.

Yet many expressing concern about the rape of nature are doing so on the basis of a pragmatic, utilitarian and anthropomorphic approach. With that understanding it is inevitable that the development of practical solutions—for example, the employment of new technologies for the control of pollution and the creation of new legislation to protect the environment—should be given priority. No one could possibly argue against the importance of this approach but there exists an older, deeper and more imaginative way of looking at and acting upon our responses to nature.

The kind of original participation that held that the substance of nature is divine because it came from and ultimately was the 'body of the Goddess' is now of course entirely lost to us; it can only be understood during rare moments of mystical union and through the agency of the imagination. Yet in so far as the latter powered the inspiration of the Romantics—Wordsworth, Caspar David Friedrich and van Gogh (see page 102)—all seeking to heal their alienation from nature, there is no reason why it should not continue to inspire us in our own day. As recently as the first quarter of the twentieth century, the composer Leos Janácek celebrated the miracle of Creation in the following words: 'I want to be in direct contact with the clouds,' he wrote, 'I want to feast my eyes on the blue of the sky, I want to gather the sun's rays in my hands, I want to plunge myself in shadow, I want to pour out my longings to the full: all directly.' His opera *The Cunning Little Vixen* is a paean of praise for all the creatures of the woodlands, the fields and hills of his beloved Moravian countryside.

No one who had felt such unsentimental but rapturous joy in the presence of nature could do other than respect it. Yes, trees have to be felled for wood, oceans fished for food and sheep shorn for their wool, but these are activities

which can either be approached with care or an impersonal greed; a choice can always be made. Janácek understood that to feel the world of nature with reverence was to water the seeds of creation and beauty.

In his book *A Vision of Nature*, Michael Tobias argues that the ecological crisis is nothing more than the externalization of an inner *malaise* which cannot be solved without the spiritual rebirth of Western society.[23] He suggests that the environmental crisis is a crisis of aesthetics, and makes the point that 'artistic appreciation of nature may be the key to our survival not only as individuals but as a species. . . . My argument is a simple one: that love, and its rapturous expression in art, as in life, is all that really matters.'

RENEGOTIATING A NEW RELATIONSHIP BETWEEN THE EGO AND THE SOUL

Turning to Lindsay Clarke's penultimate and final paragraphs—and I have amalgamated the two—we enter Jungian territory for the first time. For Jung, the ego was that part of the psyche primarily orientated towards adaptation to outward reality, the objective world. For him it was the centre or focal point of consciousness; the willing 'I' which carries a continuing sense of personal identity. Although Jung believed the personal ego was an indispensable part of every person's make up, in his eyes (and that of many others) it was far from being the only or entire part; dream was not part of it, nor the passion of the spirit, nor the world of symbol, nor imagination, nor the mythological substratum of the soul.

In contrast to the small, tight, daylight world of the ego, it is in fact the vast world of the soul wherein our intimations of ultimate matters—symbolic, aesthetic, spiritual—all reside; it is soul which nourishes the mysterious and shimmering glories of art, poetry, music and dance, so frequently and sadly neglected and dishonoured in our time. Consider the 23,000-year-old cave paintings and the complex mythologies of the first peoples; consider, too, the myths and legends of the ancient cultures and the treasury of the world's folktales which for millennia have enchanted and educated the peoples of all lands—these, like other manifestations of the unconscious, have their source in the image-creating activity of the soul. 'An artist has to be ravished by the archetypal unconscious or there is no art,' says Marion Woodman.[24]

However, just as the imagination cannot be summoned at will but has to

be sought, elicited, tracked in the shadowy underworld of subliminal image and symbolic implication, so the unconscious must also and always be conjoined with the intellect if life, art and work are to be whole. Feeling without thought is as futile and dangerous as thought without feeling. When either dominates, experience is thrown out of kilter. The new paradigm calls for their marriage in life, in art as well as science.

CONCLUSION

It is to be hoped that in the long run—and a transformation on the scale envisaged cannot happen overnight—the imaginative soul-life of our civilization can be transformed.

Recent decades in the West have seen an enormous development of scientific and technological pragmatism, but opposition to materialism is also gathering force; there has been a growth of interest in the sacred and in the many forms of ritual, ceremony and spiritual practice. The arts have also acted as a partial litmus test of contemporary attitudes, for in spite of a gadarene rush towards fashion, fame and money, some artists, like the composer Arvo Pärt, Peter Redgrove and the painter Cecil Collins, have practised a modernity imbued with spiritual values. This is surely evidence of what might be described as a fresh shift of paradigm at the grass roots. Sorokin has described this shift as one of supreme importance—'one of the greatest transitions in human history from one of its main forms of culture to another'. It is, he adds, a 'defection from the banner of sensate culture and values, a transfer of allegiance to ideational or idealistic culture, 'that is a culture independent of anything material and external. 'An adequate realization of the immense magnitude of the change now upon us is a necessary condition for determining the adequacy of measures and means to alleviate the magnitude of the pending catastrophe.'

Yet paradoxically the change is so gradual that it is virtually invisible; nothing noticeable can be observed. But it might go something like this. Perhaps a person feels unfulfilled with her work, exhausted by monetary commitments, travelling and a lack of time to do anything personal. She starts to meditate, becomes more conscious of her food and decides to grow some of her own. Another may develop an interest in Buddhism, go on a walking holiday, take up the practice of yoga and send his children to a Steiner school; yet others

may choose to be healed by an alternative therapist. Others join a protest about the destruction of ancient woodland to make way for a new road. And last but not least, yet others dream of moving to the countryside and taking up an expressive activity, perhaps painting or writing, for the first time. It is obvious that not one of these steps by itself is of any particular significance, but taken together they register a shift away from consumerist and metropolitan values towards a greater fullness of being, a fresh metaphysical orientation. They register the acceptance of a significant shift of worldview, more total and more revolutionary than any ebb and flow of politics.

It seems that we may be on the brink of a new cycle of civilization. Yeats described it as 'the rise of soul against intellect now beginning in the world'.

There are, of course, innumerable reasons why it may not evolve—fiscal crises, acts of terrorism, environmental degradation, climate change, the release of a noxious, fast-spreading pathogen, new communicable viruses, civic decay, debt and global disorder, or some combination of these—but as Sorokin understood, the shifts of human consciousness, like the pull of the tides, have a power, an inexorability, and an unmeasurability which nothing, but nothing, has the power to arrest. In this transformation lies the hope for beauty in our world.

The World will be Saved by Beauty

The environmental crisis is a crisis of aesthetics.
JAMES HILLMAN

'Is it true, Prince, that you once said that "beauty will save the world?",' Ippolit Terentiev asks Myshkin in Dostoevsky's novel *The Idiot*, and then mockingly adds: 'What kind of beauty will save the world?' 'The world will become the beauty of Christ,' Dostoevsky answers in one of his notes to another novel, *The Devils*. But Myshkin gives no answer to Terentiev's question; elsewhere in the novel he remarks: 'Beauty is an enigma.'

With this ambivalent response we are left with nothing but Dostoevsky's tantalizing observation which only someone with his originality of vision could have imagined in the first place.

That Dostoevsky valued beauty there can be no doubt. In *Mr. Dobroliubov and the Question of Art* he writes that 'The need for beauty and the creation which embodies it is inseparable from man, and without it man, perhaps, would not want to live in the world.' He adds: 'Man thirsts for it, finds and accepts beauty *unconditionally* and just because it is beauty; and he bows before it with reverence, without asking what it is useful for and what one can buy for it.' This, if inarguably true, still leaves the enigma of salvation unresolved.

So can, as Dostoevsky believed, beauty save the world? Truly, I don't find a shred of evidence that it has done so in the past and sadly doubt if it will do so in the future. Civilizations, like the early Japanese Heian, whose outlook on life was almost entirely aesthetic, were not saved by their commitment to loveliness from ultimate destruction. Nor was the great and civilized city of Baghdad saved from Timur's Mongol hordes in 1220 or the city of Cordoba, at one time the most civilized in Europe, from Christian attacks. Venice also declined in power and virility until at the very end of the eighteenth century, when Napoleon granted it to his opponents. Power has power over the beautiful.

Given, too, the majority of the problems currently facing humanity, it is alas self-evident that no infusion of beauty, however great, will lessen the flaws in human behaviour which have always induced so much ignorance and suffering—at least in the short term.

But, maybe 'save' can be interpreted in other than a literal manner. Maybe the beautiful can never be expected to withstand a brutal military attack; its value lies elsewhere: in its civilizing mission, its slow-burning capacity to sensitize and educate, to dignify, to lift living from the bourgeois realities of

costs and benefits to those more elevating aspirations—'the higher forms, which are divine', of which Pico della Mirandola spoke in his great oration on the *Dignity of Man*. Beauty has always been an ageless source of human regeneration. It has also and above all else, been the great teacher of *respect*, reverence if you prefer. To see the beauty of a child, a woman, a man, a tree, a butterfly, a landscape, is to value it, to love it, to have compassion for it. It is the numinous quality of beauty which not only issues a direct challenge to the values of our age but, as Dostoevsky suggested, can be the source of its salvation.

According to Bruce Wiltshire in *Wild Hunger: The Primal Roots of Modern Addiction*, the contemporary rejection of beauty lies at the root of the addiction which characterizes modern industrial society.[1] No one has yet proved the connection between addiction, beauty and current levels of psychosomatic disease, but to look at the present scale of emotional disturbance—suicide, impulsive behaviour, alcoholism, gambling and chronic fatigue—is to see a pattern of stress and the consequent search to escape from it. There may be no hard scientific data linking these factors, but there is a considerable amount of informal evidence in our streets and prisons. One might also remember the estimated figure I quoted in my Introduction—330 million people worldwide suffering from depression—as well as the increasing incidence of cancer, respiratory illness, stress disorders, birth defects, and falling sperm counts. Of course, there is no reason to assume that any of these diseases can be attributed to the growth of ugliness as a by-product of economic growth, but there is every reason to suspect that the absence of beauty is one of a number of contributory causes.

If so, it has to be said that if the consumerist culture has given generously with one hand—comfort, opportunities and liberation from drudgery for a start—with the other it has taken an incalculable amount. It has made us restless; has encouraged haste, ambition, stress and greed; it has promoted dissatisfaction with what exists and a desire for more—more money in particular. Yet however many products we choose to purchase, more never proves enough. However many appliances and gadgets with which we fill our homes, there is always a higher level of dissatisfaction. The feelings of timelessness and peaceful acceptance that our forebears took for granted have been undermined by a culture obsessed by hedonism, consumption and the acquisition of wealth.

For a century or more it seems that we have been running away from silence, stillness and beauty. For all that time, modernity has engendered a

culture that trivializes and feeds our discontent. In fact, many of us are currently speeding through life in a condition of amnesia, little aware of the happenings unfolding around us, little aware of the sensuous presence of the world. The sun shines, rain falls, trees gain and lose their leaves, night deepens and then fades into dawn, but it is too seldom that we pay attention to the beauty of these things. In the frantic and unending hustle of contemporary urban life, it is easy to become unaware of the possibilities of acceptance—a total acceptance—of things *as they are*—just life as it is.

BEAUTY AS AN ANTIDOTE TO RESTLESSNESS AND AMNESIA

It is one of beauty's sweetest attributes that its appreciation slows things down; it can never be savoured in a rush or fret. Quite the opposite; its enjoyment depends on patience, silence, calm and respect. And an openness of mind.

Yet it can be encountered anywhere and at all times: in a doctor's waiting room, in a queue at the supermarket till, in the garden, in a train. Travelling by rail from York to Devonshire as I recently did, I enjoyed the opportunity to regard the beauties of an English spring—its silky greens and gilded meadows. Here, across this field, a pinky cumulus soaring above umber-coloured woods; here, in Chesterfield, the shining roofs shitter-shattering in the afternoon light; here, a pin-point of red—the setting sun—spilling like a stain under a charcoal-grey envelope of cloud.

Delight in such beauty not only provides an experience which offers calm and self-forgetfulness but one that enables us to *feel*, to *see*, to *live* and to *cherish*. Turning away from our all-too-human desires and yearnings, our worries, our ever-churning intellects, our mind-absorbing calculations, we can return to the basic enjoyment of uncommitted being—no longer seeking to manipulate and exploit experience, but revering and enjoying the life we are living.

But the enjoyment of beauty can have other beneficial effects; it can help us ignore the past and forget the future. It can help us to regain our sanity and concentrate on the present, the *now*. *Nowness* is the magic of the present moment and the way to experience it is to realize that this very moment, this very point in your life, is always *the* occasion.

The same is true when we respond to the beauty of a work of art. No matter when it was created, we always appreciate it *now*. It is always *now*. *Always in the*

present moment, the never-returning moment. To be here and now, not separate from but a part of the life of the world, open and attentive to life, is the gift of the contemplation of beauty.

This sense of the interaction of the timeless and ephemeral is given fine expression in many of the *haiku* of the Japanese poet Basho.[2] Here is his most famous one, describing an actual if transient occurrence: an evening broken by a splash:

> An ancient pond
> A frog jumps in
> The sound of water

We find teachings about the here and now in the Western and Near Eastern traditions, as well as (and especially) in Zen Buddhism. They are also to be found in the sermons of Meister Eckhart and the poetry of Rumi, but their profoundest lesson can be found without reading but in the most neglected corner of our culture: by just looking. Traherne observes, 'We need nothing but open eyes, to be ravished like the Cherubims.'

SIMPLY TO SEE

The whole of life lies in the word 'seeing'.
TEILHARD DE CHARDIN

Other animals do not need a purpose in life. A contradiction to itself, the human animal cannot do without one. Can we not think of the aim of life as being simply to see?
JOHN GRAY[3]

He who has got the sense of beauty in his eye can find it in things as they really are.
RICHARD JEFFERIES

I come across a grassy bank studded with dozens, hundreds of flowering primroses, each plant luminous with the pallor of its milky yellow flowers, each flower simple and perfect in its own right, each miraculous in its own right. All the music ever written, all the books in the world, all the sacred texts and poems, are not more perfect than these. And yet the strangest thing of all is that it's all so ordinary. There is something absolutely ordinary about these primroses, this bank of grass, this rusty iron railing upon which a shred of sheep's wool is swinging in the wind. Ordinary and yet a passing imitation of Paradise.

The Hindus say of the city of Banaras that it stands at the centre of the earth

as the place of creation, and gathers together the whole of the sacred universe to itself. The same might be said of this bank studded with primroses.

REVERENCE FOR LIFE

The most beautiful experience we can have is the mysterious. It is the fundamental emotion which stands at the cradle of true art and true science. Whoever does not know it and can no longer wonder, no longer marvel, is as good as dead.
ALBERT EINSTEIN[4]

In Nature I sense the story everywhere, and beauty is the best name I know for it. I don't mean grace or symmetry or sublimity or any other particular measure of beauty, but all of those and more—the beauty of wholeness, of stars and land and the forms of life precisely as Nature has made them and is making them now, the beauty that Emily Dickinson called 'nature's fact'. This is the oldest beauty, the beauty essential to the meaning of the Greek term kosmos, the beauty whose derivation as a word relates it to 'bounty' and ultimately to the Sanskrit duvas, meaning 'reverence' or 'gift'. The beauty of the given world. The beauty that is always a becoming, life and death both dancing to it, one long and varied gesture reaching through time.
JOHN DANIEL[5]

The beginning of wisdom in any human activity is a certain reverence for the primordial mystery of existence.
THOMAS BERRY[6]

There are many ways to cultivate the yoga of reverence, but none more effectively than the quiet contemplation of the order, simplicity and elegance of nature and the sublime beauty of the arts. We can then begin to understand that satisfaction comes not from having and doing more and more, but by bringing more and more of ourselves into each act of contemplation. An uncomplicated, intuitive and wholehearted sense of wonder is the natural response to this experience.

Delight of this kind is no longer the simple pleasure of a connoisseur of life but—and increasingly—an attitude essential for its future preservation. It was the independent scientist James Lovelock who saw this most clearly. In his first book, *Gaia: a new look at life on Earth*, he writes:

> When we act according to this instinct in our dealings with our partners in Gaia, we are rewarded by finding that what seems right also looks good and arouses those pleasurable feelings which comprise our sense of beauty. When this relationship with our environment is spoilt or

mishandled, we suffer from a sense of emptiness and deprivation. Many of us know the shock of finding that some peaceful rural haunt of our youth where once the wild thyme blew and where the hedges were thick with eglantine and may, has become a featureless expanse of pure weed-free barley.[7]

Twenty years later, Lovelock's concern at this unthinking destruction had taken on a new urgency. In an address to the Gaia Society he said:

We have inherited a planet of exquisite beauty. It is the gift of four billion years of evolution. We need to regain our ancient feeling for the Earth as an organism and to revere it again. Gaia has been the guardian of life for all its existence; we reject her care at our peril. . . . If we could revere our planet with the same respect and love that we gave in the past to God, it would benefit us as well as the Earth.

A NEW KIND OF SPIRITUALITY

In ancient time the love of the beauty of the world had a very important place in man's thought, and surrounded the whole of life with marvellous poetry. Today one might think that the white races had almost lost all feeling for the beauty of the earth . . . and yet at the present time, in the countries of the white races, the beauty of the world is almost the only way by which we can allow God to penetrate us. . . . Real love and respect for religious practices are rare even among those who are most assiduous in observing them, and are practically never practised. On the other hand a sense of beauty, although mutilated, distorted and soiled, remains rooted in the heart of man as a powerful incentive. It is present in all the preoccupations of secular life. If it were made true and pure it would sweep all secular life in a body to the feet of God.

Moreover, if speaking generally, the beauty of the world is the commonest, easiest and most natural way of approach.
SIMONE WEIL[8]

How can the arts overcome the slow dying of men's hearts that we call the progress of the world, and lay their hands upon men's heart-strings again, without becoming the garment of religion as in old times?
W. B. YEATS[9]

Part of that reverence for Gaia, our Earth and its multitudinous forms, is dependent on the need for a readjustment of current attitudes to life on Earth—a transformation from the heart. That transformation, although it may not yet have gathered power, is surely incipient.

'My guess,' writes Janine Benyus, 'is that *Homo industrialis*, having reached the limits of nature's tolerance, is seeing his shadow on the wall, along with the shadows of the rhinos, condors, manatees, lady's slippers, and other species he is taking down with him. Shaken by the sight, he, we, are hungry for instructions about how to live sanely and sustainably on Earth.'[10]

In these pages you have met with little that describes the various technological solutions which are being explored so that we might develop self-sustaining ecosystems and, in general, continue to live without further diminishment of the Earth's biodiversity. These are obviously important, indeed essential. But perhaps in the end, it will not be a change of technology that will help us to become more resilient to human folly but a change of heart, a humbling that allows us to be attentive to nature's lessons.

To find our way back to a greater sanity we will need to practise a new way of looking at nature: not to learn *about* her, but to learn *from* her—to see her as our mentor. To do so we will need to slow down. We will need to understand that we are but one voice in the chorus of life on Earth. We will need to quieten the voices of our own self-regarding cleverness. We will need to contemplate the fathomless wonder and beauty of her splendour. Beauty is the keyword here: it is the *Open Sesame* which unleashes the awe bordering on reverence, the humility and the spirituality that are now needed for the survival of our civilization.

Beauty has no truck with greed or utilitarianism, power or glamour, or the idea of something as a 'resource'. Its emphasis is on the purity and comfort of the soul and, not least, its inextinguishable, soaring life.

In his *A Sand County Almanac*, Aldo Leopold pleads for this change of focus with an exemplary passion:

> Science contributes moral as well as material blessings to the world. Its great moral contribution is objectivity, or the scientific point of view. This means doubting everything except facts; it means hewing to the facts, let the chips fall where they may. One of the facts hewn to by science is that every river needs more people, and all people need more inventions, and hence more science; the good life depends on the indefinite extension of this chain of logic. That the good life on any river may likewise depend on the perception of its music, and the preservation of some music to perceive, is a form of doubt not yet entertained by science.[11]

It was another American, Walt Whitman, who earlier prophesied the birth of a new kind of religion. Priests of the old variety, he suggested, were a dying breed. Heaven was here on Earth and the physical and the spiritual could not be divided; they were, are, and always will be the same. In the future, he believed, religion would be a spirituality of experience rather than a dogmatic faith. The future would see a spirituality of meditation and the contemplation of beauty.

It is a spirituality of this kind in which, I suggest, could lie the healing of our Earth. 'There is no other way,' observes Aldo Leopold, 'for land to survive the impact of mechanized man, nor for us to reap from it the aesthetic harvest it is capable, under science, of contributing to culture.'

TO INCREASE THE SUM OF BEAUTY
IN THE WORLD

Every true artist has had real, direct, and immediate contact with the beauty of the world, contact that is of the nature of a Sacrament.
SIMONE WEIL[12]

Let the beauty we love be what we do.
RUMI

But reverence by itself is not enough; there is always a need to add our own contribution to the beauty of the Earth. To our celebration of the beauty of the ladybird and the marmoset, the leaping salmon and the flowering hawthorn, the beauty of Titian's *Bacchus and Ariadne* and the ceramic tiles from Iznak in the Rüstem Pasa mosque, we can contribute our own share, a beauty of our own making: the beauty of our gift to life. It could be a song or the making of a garden, a poem. a performance, a meal or, as the Navajo understand it, the gift of life itself.[13] Whatever we are, whatever we do, can become our gift to the world.

Some will protest that they are not 'artistic' enough to make this kind of offering, but this is nonsense. As a former art teacher I know how widely spread imaginative talent has always been. It's true that some cannot act or sing or paint—but, alas, what a tragically narrow understanding of creativity this has become! We may make wonderful food, be a warm-hearted hostess, grow prize-winning vegetables or iron shirts to perfection, yet suffer under the illusion that we are not the artists of life! Listen to the great cellist Pablo Casals, who understood that imaginative expression need not be considered

either a feature of the past or the prerogative of what our culture calls the artist. He understood that all of us possess a birthright access to the imagination; that creativity belongs to us all, to *every* man, woman and child, and not to the few alone.

> I have always regarded manual labour as creative and looked with respect—and yes wonder—at people who work with their hands. It seems to me that their creativity is no less than that of a violinist or a painter. It is of a different sort, that is all.

One of the saddest features of our time is that the toxins of Westernization are continuing to poison the once prevailing faith in our own creativity, a faith shared by generations of the poor. It was a faith that prevented the thwarted creativity which now engenders much destructiveness, emotional as well as physical. Yet once faith in our own creativity has been rekindled there is no reason, no excuse, for a day to pass without the pleasure—and the responsibility—of adding to the beauty of the world. And creative opportunities can be found in regard to everything. Every single act can be practised with—or without—imagination. Every single act can be done with care or carelessly. Every single act can add to or detract from the sum total of beauty in our home and district. Those who fail to practice their creativity are not only impoverishing their own existence; they are losing one of the deepest springs of our future vitality and hope.

TO REGAIN THE LOST DIGNITY
OF HUMANKIND

The new meaning of soul is creativity and mysticism. These will become the foundations of a new psychological type and with him/her the new civilization.
OTTO RANK[14]

In these pages I have emphasized the importance of a new way of viewing and valuing nature—not what we can *extract* from the natural world, but what we can *learn* from nature. To conclude this book I would like to turn to the place of the human in the web of life. I would like to emphasize the importance of a new way of valuing the human world.

When I contemplate the life of the nomads of Iran as documented in the photographs of Nasrollah Kasraian,[15] the word *dignity* springs immediately to

mind—so much so that it obliterates my knowledge of their hardships and economic poverty. In these images the nomads are seen to dress beautifully, to move with beauty, to live in a beautiful environment; their human dignity—one could say their human nobility—is synonymous with their appreciation of the beautiful. The same is true of all the tribal peoples: the pastoral nomads and gypsies of India, the tribals of Africa, Asia and the Amazon, the lost inhabitants of the North American continent and so on. Not for nothing were these peoples called *noble* savages. Beauty gave them dignity, and dignity added to their beauty.

The last thing I want to suggest is that we should return to a tribal culture, jettison the benefits of a post-industrial society and live in mud and thatch huts. No, even if I am accused (as I will be) of romanticizing the past, that is undesirable and, of course, completely impossible. It goes without saying that we cannot turn back the wheel of history nor erase the decisions and discoveries of the past. Rather, what I am suggesting is the value of considering, if not capturing, some of the wisdom of the tribal peoples and learning from their strengths. One of these is their delight in and commitment to beauty.

In contrast, we have only to look at our own world: the average urban and suburban high street—the goods in its furniture shops, the food in its fast-food outlets, its newsagents and tobacconist stores, its billboards and advertisements—to grasp that our culture, for all its attributes, is becoming a greedy, ugly and undignified one.

It would be foolish to suggest that the greatest civilizations of the past, those which cultivated beauty for its own sake, ever escaped the blight of delusion which characterizes human life. The fourteenth century, when so many of the great cathedrals were under construction, was (according to Barbara Tuchmann[16]) as violent, destructive, greedy, depraved and fallible as our own. Its concern for money, possessions and the flesh was the same as at any other time. A similar imperfection marred the life of later cultures renowned for their exquisite beauty. Shah Abbas of Persia, who conceived the incomparable maidan in Isfahan, ordered the death of his eldest son, whilst the eyes of his other children were gouged out under his orders. Sigismondo Malatesta, who surrounded himself with scholars and commissioned the great Renaissance architect Alberti to design the Tempio Malatestiano in Rimini (1446 onwards), was another monster; 'unscrupulousness, impiety, military skill, and high culture have been seldom combined in one individual as in Sigismondo Malatesta,' wrote the historian Jacob Burckhardt.[17]

Contradictions are part of life, not merely a matter of conflicting evidence. Yet whatever the barbarities of such individuals and the moral failings of the generality of humankind, there has also existed the profoundest aspiration for spiritual grandeur. There existed the insistent principle that the life of the spirit was at least as important as the here and now, as material life on Earth; there was a preoccupation and quest for beauty. The peoples of those times looked to heaven, and created with it in view. Side by side with the quotidian, they sought and achieved a transcendent glory.

It is an aspiration the Westernized world now rarely seeks to acknowledge. We no longer look upwards. We can no longer build an Amiens, a Salisbury Cathedral, or compose with the grandeur of a Tallis or a Bruckner. What music echoes the grandeur of their aspirations? What monuments have we made to suggest that we desire permanence? The greatest twentieth and twenty-first-century engineering projects, say the Petronas Towers in Kuala Lumpur and the Hongkong and Shanghai Bank, are exciting achievements but they can hardly be described in terms of the repose and dignity of spirit which characterizes the mosques, the temples and cathedrals of the Middle Ages. A similar diminution of spirit is to be found in other aspects of modern industrial life. To generalize, it could be said that our education lies in thrall to the market economy and to managerial and functional dictates. Our art is benighted by a clinical cynicism. Our Earth is being desecrated; our culture debased. Perhaps the full catastrophe has been camouflaged by the power of money over everything and the spectacular achievements of technology, but the inhuman environments and fouled-up landscapes remain as a legacy to be redeemed. How are we to set about this work? How can we be loyal to the source of life?

THE IMPORTANCE OF HOZHO

Constrained by no limit, (Thou, Man) shalt ordain for thyself the limits of thy nature. . . . As maker and moulder of thyself, thou mayest fashion thyself in whatever shape thou shalt prefer. Thou shalt have the power to degenerate into lower forms of life, which are brutish. Thou shalt have the power, out of thy soul and judgment, to be reborn into the higher forms, which are divine . . .
PICO DELLA MIRANDOLA

So what can we do to escape from this treadmill of mediocrity, this failure of imagination, this ubiquitous spiritual squalor? Can we build a culture that

becomes a permanent and proper place for humankind? Can we build a civilization that celebrates the splendour and dignity of the human being, let alone the sublimity of our noblest aspirations? Perhaps.

But how? Perhaps the necessary rehabilitation can begin with an acknowledgement of the most ignored and least respected element in modern technological and economic life—the soul—the realm of the unconscious, anima, the imagination which gives depth, colour and beauty to our lives. Perhaps we might begin by listening to Dostoevsky and his vision of the world's salvation. Christianity began in the neglected stable and our redemption could begin in a no less improbable and lowly place.

For it is a fact that our crisis is one of the psyche, not politics, nor economics, technology and the environment. It is not only the Earth but we who need to be healed—to become whole again. The quest for beauty can make a significant contribution to that healing. For the love of beauty heals and comforts, nourishes and inspires. It absolves and celebrates. It can help us to recover our dignity. It is the bridge between time and eternity, earth and heaven.

But the quality which we call beauty must always grow from the realities of our life: how we live, what we eat, the rooms in which we live and the work we choose to undertake. To add re-enchantment and fullness to ourselves and to the world, to recover the lost dignity of the human, to redeem the ugliness around us, to beautify and ennoble what is mean and cynical and sick—to turn lead into silver and, if we can, into gold—we must, as Kenji Miyazawa writes 'set fire to the greyness of our labour with the art of our own lives'.[18] It is not art by itself that we need—music, painting, drama—but play, ceremony, free-form interaction; a vision of life as poetry. We must practice what the Navajo have called *hozho*.

Gary Witherspoon, who has devoted his life to the study of the Navajo, points out that the Navajo word *hozho*, usually translated as 'beauty', actually means more than that. It refers to a total environment (*ho*) that includes beauty, harmony, happiness, and everything that is positive. Life for the Navajo consists of constantly taking steps to enhance *hozho*, to live in *hozho*, and in due course to die and be incorporated into the *hozho* that permeates the universe. As a consequence, the anthropologist David Maybury-Lewis observes that Navajo culture is a way of life that requires the individual not merely to create beauty sporadically but to think it, act it, and live in it constantly.[19] This is clear in the prayer that the Navaho recite daily, and with which, in another version, I began this book:

With beauty before me I walk
With beauty behind me I walk
With beauty above me I walk
With beauty below me I walk
From the East beauty has been restored
From the South beauty has been restored
From the West beauty has been restored
From the North beauty has been restored
From the zenith in the sky beauty has been restored
From the nadir of the earth beauty has been restored
From all around me beauty has been restored

To which I say Amen. Beauty shows forth an affirming spiritual flame. It helps us to transcend ourselves. It helps us to stay alive in the world. It helps us to be true to ourselves. Let us see it restored.

Notes & References

FOREWORD

1 The quotation comes from *Ode on a Grecian Urn*. Some commentators have pointed out that the two lines are meant as a message or reassurance to man from the urn, without intrusion by the poet.

PREFACE

1 Quoted in an obituary in *The Independent* on 29 April 2003. Max Nicholson was probably the most significant European conservation figure of the last century.
2 Thomas Hoover, *Zen Culture*, Arkana, 1978.
3 From an interview between Marc Riboud and Lauris Morgan-Griffiths in *The Independent* magazine, 28 June 2003.
4 An idea suggested by the scientist James Lovelock.

INTRODUCTION

1 John Ruskin (1819–1900), an important and still relevant social and art critic. The quotation comes from *Fors Clavigera* (published in 1871), and is entitled *The White-Thorn Blossom*.
2 William Richard Lethaby (1857–1931), author of *Form in Civilization* and an influential educationalist.
3 The quotation is from *Thought of the Heart*, 1984. See also *The Essential James Hillman*, ed. Thomas Moore, Routledge, 1989.
4 John Armstrong is the author of *Move Closer: An Intimate Philosophy of Art*. The opinion quoted comes from an essay printed in the *National Art Collection Fund's Quarterly*, Autumn 2001.
5 Rachel Carson, *Silent Spring*, Penguin Books, 1991 (first published 1962).
6 Quoted in *Spirit and Place*, Christopher Day, Architectural Press, 2002.
7 See *Britain on the Couch*, Oliver James,

Arrow Books, 1998.
8 This study by the National Institute of Mental Health was reported in *The Week*, 28 June 2003.
9 This study, conducted by Professor Christopher Dowrick, was also reported in *The Week*.

CHAPTER ONE

1 See *Wilderness Earth's Last Wild Places*, ed. Patricio Robles Gil, Cemex, 2003.
2 St Matthew's Gospel, Ch.6 v.28.
3 A *hadith* is a saying of the Prophet.
4 Dionysios the Areopagite, often referred to as Pseudo-Dionysios (*c.*500), a mystical theologian whose writings were influential in the Middle Ages.
5 From one of Keats's letters of December 1817.
6 John Shaw Nielson (1872–1919), leading Australian poet. *The Orange Tree*, written in 1919, is probably his most famous work.
7 Eric Gill (1882–1940), sculptor, letter-carver, wood engraver and type designer. His controversial, if rather didactic, writings have been published as *A Holy Tradition of Working* (Golgonooza Press, 1983).
8 Ananda K. Coomaraswamy (1877–1947), orientalist, philosopher, art historian, traditionalist and social critic. See Bibliography.
9 Soetsu Yanagi (1889–1961), founder of the Japanese folk-craft movement. His *The Unknown Craftsman A Japanese insight into Beauty* (Kodansha International, 1973) is essential reading.
10 Vinoba Bhave (1895–1982), one of the most notable spiritual figures in India after Gandhi. His *Talks on the Gita* was published in 1981 by Sarva-Seva-Sangh-Prakashan, Varanasi.
11 St Theophilus (late 2nd century), leading

theologian who set before the pagan world the idea of God.

12 Quoted in K. Rasmussen, *The Netsilik Eskimos*, Copenhagen, 1931.

13 Erich Hertzmann, 'Mozart's Creative Process in *The Creative World of Mozart*, ed. Paul Henry Lang, Oldbourne Press, 1964.

14 Gustav Mahler (1860-1911), Austrian composer. The quotation was written in 1896 (source unknown).

15 Ludwig von Bertalanffy, the father of General Systems Theory.

16 The photograph appears in *Wilderness: Earth's Last Places*. See Chapter 1 Note 1.

17 See page 80 for a discussion of Angkor Wat.

18 *Pathway Icons: The Wayside Art of India* by Priya Mookerjee, Thames and Hudson, 1987.

19 *Sgraffito* decoration is a ceramic technique in which slip is scratched or cut away to reveal the clay body underneath.

20 T. S. Randhawa, *The Last Wanderers: Nomads and Gypsies of India*, Mapin Publishing Pvt Ltd, 1996. See also Carol Beckwith and Angela Fisher, *African Ceremonies*, Harry N. Abrams Inc, 2002.

21 David Maybury-Lewis, *Millennium Tribal Wisdom in the Modern World*, Viking, 1992.

22 G. Lowes Dickinson, *The Greek View of Life*, Methuen, 1960.

23 David Abram, *The Spell of the Sensuous*, Vintage Books, 1997.

24 Patrick Harpur, *The Philosopher's Secret Fire*, Penguin Books, 2002.

25 John Cowper Powys, *The Art of Happiness*, The Bodley Head, 1935.

26 Naguib Mahfouz (1911–2002), Egyptian author of *The Cairo Trilogy*. The quotation comes from the middle volume, *Palace of Desire*, Everyman's Library, 2001.

27 Henryk Skolimowski, *The Participatory Mind*, Arkana, 1994.

28 William Ralph Inge (1860–1954) was Dean of St Paul's, who had sympathies with Platonic spirituality.

29 Chögyam Trungpa, *The Sacred Path of the Warrior*, Shambhala, 1988.

30 Robinson Jeffers (1887–1962), American poet.

31 Used by Ezra Pound in his *Canto XC*.

32 Morris Graves (1910–2001), American painter of mystical birds and flowers.

33 Plotinus (*c*.205–70) was an influential Neoplatonist philosopher and mystic. See *The Enneads*, trans. Stephen MacKenna, Faber & Faber, 1930. See also page 65.

34 See Note 9.

35 See Note 25.

36 *Zen Mind, Beginner's Mind*, Weatherhill 1976.

37 *The Doors of Perception and Heaven and Hell*, Chatto & Windus.

CHAPTER TWO

1 From *A Sketch in the Park*, started by Virginia Woolf in April 1939 and abandoned in November 1940, four months before her death.

2 Wilfred Thesiger, *Arabian Sands*, Longman Green, 1959.

3 John Ray (1628–1705), father of natural history in Britain.

4 Dorothy Wordsworth (1771–1855), sister and constant companion of Wordsworth. Her *Journals* are eloquent.

5 Richard Feynmann, *The Character of Physical Law*.

6 See Chapter 1 Note 24.

7 Peter Sterry (1613–1672), one of a group of Platonists associated with the University of Cambridge.

8 Graham Farmelo, 'It all adds up to Beauty' in *The Guardian*, 26th January 2002.

9 For example, the position of the leaves on a stem designed to allow each leaf to receive the maximum amount of sunlight, has a rotation angle commonly of 137.5, a figure none other than the Golden Proportion related to the perimeter of a circle. The Fibonacci numbers also appear when the number of petals of certain common flowers are examined: the iris has 3 petals, primrose 5, ragwort 13, daisy 34 and michaelmas daisy 89. See Ian Stewart, *What Shape is a Snowflake: Magical Numbers in Nature*, Weidenfeld & Nicholson, 2001.

10 Eric Newton, *The Meaning of Beauty*, Longmans Green, 1950.

11 Rabindranath Tagore (1861–1941), poet, songwriter, educationalist and social reformer. Source of quotation unknown.

12 Titus Burckhardt (1908–1984), art historian. *Chartres and the Birth of the Cathedral*, Golgonooza Press, 1995.

13 Seyyed Hossein Nasr, *Islamic Art and*

Spirituality, State University of New York Press, 1987.

14 Richard Tarnas, *The Passion of the Western Mind*, Ballantine Books, 1993.

15 See Chapter 1 Note 33.

CHAPTER THREE

1 Pitirim A. Sorokin (1889–1968), pioneer of sociological research. See his *The Crisis of Our Age*, Oneworld Publications, 1992, quoted on page 71.

2 Ibn Khaldun (1332–1406), great Islamic scholar who sought to establish a philosophy of history.

3 Large thirteenth-century bronze statue of the Buddha in Kamakura, Japan.

4 The Royal Portal, dated 1145–1155, is one of the greatest sculptural ensembles of European architecture.

5 Alexander Gottlieb Baumgarten (1714–1762), philosopher who identified the aesthetic.

6 See *The Ohlone Way* by Malcolm Margolin, Heyday Books, 1978.

7 Stephen Huyler, *Meeting God*, Yale University Press, 1999.

8 See Chapter 1 Note 8.

9 See Stella Kramrisch, *The Presence of Shiva*, Princeton University Press, 1981.

10 *Rule of St Benedict*, Sheed & Ward, 1976.

11 Albert Einstein, *Ideas and Opinions*, Crown New York, 1982.

12 George Henderson, *Chartres*, Penguin Books, 1968.

13 See Chapter 1 Note 7 .

14 From *A Vision*, 1925.

15 Titus Burckhardt, *Sacred Art in East and West* Perennial Books, 1967.

16 Robert Payne, *Journey into Persia*, Heinemann, 1951.

17 Shakti Maira, 'Buddhist Aesthetics' in *Resurgence* No 217, March/April 2003.

18 G. B. Sansom, *Japan: A Short Cultural History*, Charles E. Tuttle, 1997.

19 See Leonard Koren, *Wabi-Sabi for Artists, Designers, Poets & Philosophers*, Stone Bridge Press, California 1994.

20 In San Marco the monks' cells are placed along one side of a first floor corridor. Fra Angelico's work dates from 1436 onwards.

21 Nancy Wilson Ross, *Buddhism A Way of Life and Thought*, Collins, 1981.

22 Loraine Kuck, *The World of the Japanese Garden*, Weatherhill, 1968.

23 See Nikolaus Pevsner, *The Leaves of Southwell*, Penguin Books, 1945.

24 Bellini's *Agony in the Garden* is in the National Gallery, London.

25 Annie Dillard, American author of *Pilgrim at Tinker Creek* and other books. See *The Annie Dillard Reader*, HarperPerennial, 1994.

26 Piero della Francesco (1410/20–92), *The Flagellation*, Galleria Nazione de Marche, Urbino.

27 Vitruvius (*fl.* 40 BC), Roman architect and author of only surviving Roman treatise on architecture.

28 *Summer* is in the Musée du Louvre, Paris.

29 *View of Delft* is in the Royal Cabinet of paintings, Mauritshuis, The Hague.

30 *The Copper Fountain* is in the Musée du Louvre, Paris.

31 Samuel Palmer, *The Valley thick with Corn* is in the Ashmolean Museum, Oxford.

32 *The Starry Night* is in the Museum of Modern Art, New York.

33 Robert Hughes, *Nothing If Not Critical*, Harvill Press, 1999.

34 *Still Life with Apples and Oranges* is in the Musée d'Orsay Paris.

35 See Lionelli Venturi's *Cézanne, his art, his life*, Paul Rosenberg, 1936.

36 Humphrey Jennings (1907–1950), documentary film maker and author. See *Pandaemonium: The Coming of the Machine as seen by contemporary observers*, André Deutsch, 1985.

37 Ingmar Bergman, *Introduction: The Seventh Seal* (screenplay), Faber, 1993.

CHAPTER FOUR

1 See Chapter 4 Note 33.

2 See John McDonald (ed.), *Peter Fuller's Modern Painters Reflections on British Art*, Methuen, 1993.

3 Dan Cruickshank (ed.), *Architecture: 150 Masterpieces of Western Architecture*, Aurum Press, 2000 and Philip Jodidio, *New Forms of Architecture in the 1990s*, Taschen, 1997.

CHAPTER FIVE

1 Kamaladevi Chattopadhyay (1903–1988), chair of the All India Handicrafts Board and senior vice-president of the World Crafts Council. The quotation is from her book *Handicrafts of India*, Indian Council for

Cultural Relations, 1985.

2 Jacquetta Hawkes wrote *Journey Down a Rainbow* with her husband J. B. Priestley, Heinemann-Cresset, 1955.

3 See *Aegean Art* by Pierre Demargne, Thames & Hudson, 1964.

4 *Traditional Pottery of India* by Jane Perryman, A & C Black, 2000.

5 See *African Textiles* by John Gillow, Thames & Hudson, 2003.

6 *The Nomadic Peoples of Iran* ed. Richard Tapper and Jon Thompson, Azimuth Editions, 2002.

7 Eric Gill, *Clothes*, Jonathan Cape, 1931.

8 After his return from Western Europe in 1697, Peter the Great demanded the removal of beards and the wearing of European clothes instead of Russian dress. In Turkey, Mustafa Kemel (1881–1938) encouraged the Europeanization of dress, as did Reza Shah in Iran, from 1925.

9 Paul Oliver, *Dwellings*, Phaidon Press, 2003.

10 See *Africa The Art of a Continent*, ed. Tom Phillips, Prestel, 1996.

11 Nora Fisher (ed.), *Mud, Mirror and Thread Folk Traditions of Rural India*, Mapin Publishing Pvt Ltd, 1995.

12 *Rabari: A Pastoral Community of Kutch*, Francesco d'Orazi Flavoni, Indira Gandhi National Centre for the Arts, 1990.

13 *Painted Prayers: Women's Art in Village India*, Stephen P. Huyler, Thames & Hudson, 1994.

14 See Introduction Note 3.

15 There are a multitude of studies concerning the making of the scientific world view. See Lewis Mumford's *The Pentagon of Power*, Secker & Warburg, 1971, and Morris Berman's *The Re-enchantment of the World*, Cornell University Press, 1981.

16 Gerald Brenan, *South from Granada*, Penguin.

17 Val Williams, *Martin Parr*, Phaidon Press, 2002.

18 Max Weber, *The Protestant Ethic and the Spirit of Capitalism*, Unwin University Paperbacks, 1971.

19 Victor Papanek, *The Green Imperative: Ecology and Ethics in Design and Architecture*, Thames & Hudson, 1995.

20 Alain de Botton, *The Art of Travel*, Penguin, 2003.

21 The Bauhaus, founded by architect Walter Gropius in Weimar, Germany in 1919, was an influential school of design which set out to train craftsmen and artists in co-operative effort.

22 Le Corbusier (1887–1965), arguably the most influential architect of the twentieth century. His ideas and architecture have had a deleterious effect on our cities, though he did design a few wonderful buildings.

23 Roger Scruton, *The West and the Rest*, Continuum, 2003.

24 John Barrow, *The Artful Universe*, Oxford University Press, 1995.

25 Jan Morris, *Persia*, Thames & Hudson, 1969.

26 Marc P. Keane, author of *Japanese Garden Design*.

27 *Cool and Crazy*, a film by Knut Erik Jensen, 2001.

28 Monet lived in the Savoy Hotel overlooking the Thames in 1899, 1900 and 1901.

29 Chögyam Trungpa, *The Sacred Path of the Warrior*, Shambhala, 1988.

30 Peter Levi, *The Flutes of Autumn*, Harvill Press, 1983.

31 J. R. R. Tolkien, *The Return of the King*, George Allen & Unwin, 1955.

32 D. H. Lawrence (1885–1930), *Lady Chatterley's Lover*, Penguin Books (first printed in Florence in 1928).

CHAPTER SIX

1 Matthew Fox, *Original Blessing*, Bear & Company, 1983.

2 Martin Rees, *Our Final Century*, William Heinemann, 2003.

3 Anne Glyn-Jones, *Holding Up a Mirror: How Civilizations Decline*, Imprint Academic, 1996.

4 Pitrim Sorokin, *The Crisis of Our Age*, Oneworld Publications, 1992.

5 See Chapter 1 Note 2.

6 E. F. Schumacher, *Small is Beautiful*, various editions.

7 David Bohm, *Wholeness and the Implicate Order*, Routledge & Kegan Paul, 1980.

8 Morris Berman, *The Reenchantment of the World*, Cornell University Press, 1981.

9 Fritjof Capra, *The Turning Point*, Wildwood House, 1982.

10 Edward Goldsmith, *The Way: An Ecological World-View*, Green Books, 1996.

11 Willis Harman, *Global Mind Change*,

Knowledge Systems, 1988.

12 Lewis Mumford, *The Pentagon of Power*, Secker & Warburg, 1973.

13 Helena Norberg-Hodge, *Ancient Futures Learning from Ladakh*, Sierra Club Books, 1991.

14 Theodore Roszak, *Where The Wasteland Ends*, Faber, 1973.

15 E. F. Schumacher, *Small is Beautiful*, various editions.

16 Ken Wilbur, *Eye to Eye: The Quest for the New Paradigm*, Shambhala, 1990.

17 A hypothesis which proposes the self-regulation of planet Earth.

18 For details of his theory, see Rupert Sheldrake's *A New Science of Life*, Inner Traditions, reprinted 1995.

19 Sir Francis Younghusband, explorer. The quotation comes from *Kashmir*, Adam & Charles Black, 1909.

20 Lindsay Clarke, *Parzival and the Stone from Heaven*, HarperCollins, 2001.

21 Edward C. Whitmont, *Return of the Goddess*, Routledge & Kegan Paul, 1983.

22 'Only Connect' is the epigraph to E. M. Forster's *Howard's End* (1910).

23 Michael Tobias, *A Vision of Nature: Traces of the Original World*, Kent State University Press, 1995.

24 See Marian Woodman's *Conscious Femininity*, Inner City Books, 1993.

CHAPTER SEVEN

1 Bruce Wiltshire, *Wild Hunger: The Primal Roots of Modern Addiction*, Rowman & Littlefield.

2 Matsuo Basho (1644–1694), Japan's most famous poet. See his *The Narrow Road to the Deep North*, Viking Press, reprinted 1967.

3 John Gray, *Straw Dogs: Thoughts on Humans and Other Animals*, Granta Books, 2002.

4 Albert Einstein, *Ideas and Opinions*, Crown, 1982.

5 John Daniel, *Winter Creek: One Writer's Nature History*, Milkweed Editions, 2002.

6 *The Dream of the Earth*, Sierra Club Books, 1988.

7 James Lovelock, *Gaia: A new look at life on Earth*, Oxford University Press, 1979.

8 Simone Weil (1909–43), *Waiting on God*, Fontana Books, 1951.

9 From Yeats' *Ideas of Good and Evil*.

10 Janine M. Benyus, *Biomimicry: Innovation inspired by Nature*, Quill William Morrow, 1997.

11 See Aldo Leopold's *A Sand County Almanac*, Oxford University Press, 1949.

12 See 8 above.

13 See Clyde Kluckhohn and Dorothea Leighton, *The Navajo*, Doubleday & Company, 1962.

14 From *Beyond Psychology*, Dover Publications, 1958.

15 See Chapter 5 Note 6.

16 Barbara Tuchman, *A Distant Mirror: The Calamitous 14th Century*, Penguin Books, 1979.

17 See Jacob Burckhardt's *The Civilisation of the Renaissance in Italy*, Phaidon Press.

18 Kenji Miyazawa, *Life as Art*.

19 See Chapter 1 Note 21.

Bibliography

CHAPTER ONE

Ananda Coomaraswamy, 'That Beauty is a State', essay in *The Dance of Shiva*.
David Cooper (ed), *A Companion to Aesthetics*, Blackwell, 1992.
G. W. F. Hegel, *Philosophy of Fine Art* (trans. Osmaston), 4 volumes, 1920.
James Hillman, *The Thought of the Heart*, Spring Publications, Dallas, 1987.
David Hume, *A Treatise on Human Nature*, ed. Selby-Bigge, Clarendon Press, 1960.
Immanuel Kant, *Critique of Judgement*, trans. J. C. Meredith, Clarendon Press, 1964.
Eric Newton, *The Meaning of Beauty*, Longmans Green, 1950.
Plato, especially *Phaedrus, Symposium, Ion* and *Republic*, trans. Jowett.
Plotinus, *Enneads*, trans. Stephen MacKenna, Faber & Faber, 1956.
Kathleen Raine, *Defending Ancient Springs*, Golgonooza Press, 1985.
Herbert Read, *On Beauty*, Dallas Publications, Dallas.
George Santayana, *The Sense of Beauty*, Scribner, 1902.
Roger Scruton, 'Art's Value' in *What Philosophers Think*, Julian Baggini & Jeremy Strangroom (eds.), Continuum, 2003.
Wendy Steiner, *The Trouble with Beauty*, Heinemann.
Soetsu Yanagi, 'Towards a Standard of Beauty', essay in *The Unknown Craftsman*, Kodansha International, 1973.

CHAPTER TWO

Philip Ball, *The Self-made Tapestry*, Oxford University Press, 1999.
John D. Barrow, *The Artful Universe*, Penguin Books, 2001.
Janine M. Benyus, *Biomimicry: Innovation inspired by Nature*, Quill/William Morrow, 1997.
Charles Darwin, *The Origin of Species*, Penguin Books, 1985.
James Gleich, *Chaos: Making a New Science*, Penguin Books, 1988.
James Lovelock, *Gaia: A New Look at Life on Earth*, Oxford University Press, 1979.

CHAPTER THREE

A Short Interlude on Sorokin

Anne Glyn Jones, *Holding up a Mirror: How Civilizations Decline*, Imprint Academic, 1999.
Pitirim A. Sorokin, *The Crisis of Our Age*, One World Publications, Oxford, 1992.

North American Indian

Ralph Coe, *Sacred Circles: Two Thousand Years of North American Indian Art*, Arts Council, 1976.
Anna Lee Walters, *The Spirit of Native America*, Chronicle Books, San Francisco, 1989.
Various authors, *American Indian Art: Form and Tradition*, Walker Art Center, Minneapolis, 1972.

Classical Aesthetics

Reinhard Lullies, *Greek Sculpture*, Thames & Hudson, 1957.
A. K. Lawrence, *Greek Architecture*, Penguin Books.

The Hindu View of Art

Richard Blurton, *Hindu Art*, British Museum Press 1992.
Alice Boner, *Principles of Composition in Hindu Sculpture*, Motilal Banarsidass Publishers, Ltd, Delhi, 1990.
Ananda Coomaraswamy, 'The Dance of Shiva', essay published in *The Dance of Shiva*), Munshiram Manoharlal Publishers, 1970.
Ananda Coomaraswamy, *The Transformation of Nature in Art*, Dover Publications, 1956.
Diana L. Eck, *Benares : City of Light*, Routledge & Kegan Paul,1983.
Stella Kramrisch, *The Presence of Shiva*, Princeton University Press, 1981.
Richard Lannoy, *Benares Seen from Within*, Callisto Books, 1999.
Alistair Shearer, *The Hindu Vision; Forms of the Formless*, Thames & Hudson, 1993.
Rana P. B. Singh (ed), *Banaras (Varanasi) Cosmic Order, Sacred City, Hindu Traditions*, Tara Book Agency, 1993.

Art and Beauty in the Middle Ages

William Anderson, *The Rise of the Gothic*, Hutchinson, 1985.
Luciano Bellosi, *Duccio: The Maesta*, Thames & Hudson, 1999.
Titus Burckhardt, *Chartres and the Birth of the Cathedral*, trans. William Stoddart, Golgonooza Press, 1995.
Kenneth John Conant, *Carolingian and Romanesque Architecture 800–1200*, Penguin, 1956.
Ananda Coomaraswamy, 'The Mediaeval Theory of Art' in *Traditional Art and Symbolism*, ed. Roger Lipsey, Princeton University Press, 1977.
Painton Cowen, *Rose Windows*, Thames & Hudson, 1979.
Umberto Eco, *Art and Beauty in the Middle Ages*, Yale University Press, 1986
Jean Favier, *The World of Chartres*, Thames & Hudson, 1990.
Lucien Herve, *Architecture of Truth*, Phaidon Press Ltd, 2001.
Judith Hook, *Siena: A City and its History*, Hamish Hamilton, 1979.
John James, *Chartres: The Masons who Built a Legend*, Routledge & Kegan Paul, 1982.
Terryl N. Kinder, *Architecture of Silence*, Harry N. Abrams Ltd, 2000.
Patrick Leigh Fermor, *A Time to Keep Silence*, Penguin Books, 1982.
Emile Male, *The Gothic Image: Religious Art in France in the Thirteenth Century*, Fontana, 1961.
John White, *Duccio: Tuscan Art and the Mediaeval Workshop* Thames & Hudson, 1979.

The Islamic Experience of Beauty .

Wilfred Blunt, *Isfahan: Pearl of Persia* Elek Books, 1966
Titus Burckhardt, *Sacred Art in East and West*, Perennial Books Ltd, 1976.
Titus Burckhardt, *Art of Islam: Language & Meaning*, World of Islam Festival Publishing Company, 1976.
Sylvia Crowe and Sheila Haywood, *The Gardens of Mughal India*, Thames & Hudson, 1972.
Markus Hattstein and Peter Delius (eds.), *Islam: Art and Architecture*, Konemann, 2000.
Seyyed Hossein Nasr, *Islamic Art and Spirituality*, State University of New York Press, 1987.
Seyyed Hossein Nasr, *Knowledge and the Spiritual*, Edinburgh University Press, 1981.

Zen Aesthetics

Anne Bancroft, *Zen: Direct Pointing to Reality* Thames & Hudson, 1979.

Rand Castile, *The Way of Tea*, Weatherhill, 1979.

Joe Earle (ed.), *Infinite Spaces: The Art and Wisdom of the Japanese Garden*, Galileo, 2000.

Horst Hammitzsch, *Zen in the Art of the Tea Ceremony*, Element Books, 1979.

Thomas Hooper, *Zen Culture*, Arkana, 1977.

Leonard Koren, *Wabi-Sabi for Artists, Designers, Poets & Philosophers*, Stone Bridge Press, 1994.

Loraine Kuck, *T he World of the Japanese Garden*, Weatherhill, 1984.

Kakuzo Okakura, *The Book of Tea*, Dover, 1964.

Nancy Wilson Ross, *The World of Zen*, Vintage Books, 1960.

Junichiro Tanizaki, *In Praise of Shadows*, Vintage, 2001.

Soetsu Yanagi, *The Unknown Craftsman: A Japanese Insight into Beauty*, Kodansha International Ltd, 1972.

The Art of the Sensate Cultures

Bernard Berenson, *A Sienese Painter of the Franciscan Legend* London, 1909.

Bruce Bernard (ed.), *Vincent by Himself*, Orbis Publishing, 1985.

Carlo Bertelli, *Piero della Francesca*, Yale University Press, 1992.

Anthony Blunt, *Artistic Theory in Italy 1450-1600*, Clarendon Press, 1962.

Ben Broos and others: *Johannes Vermeer* National Gallery of Art, Washington, 1995.

Chardin exhibition catalogue, Royal Academy of Arts, London, 2000,

Kenneth Clarke, *Piero della Francesco*, Phaidon Press Ltd, 1952.

Lawrence Gowing, *Vermeer*, Giles de la Mare Publishers, 1997.

Geoffrey Grigson: *Samuel Palmer: The Visionary Years*, Kegan Paul, Trench, Trubner & Co, 1947.

Raymond Lister: *Samuel Palmer: his life and art*, Cambridge University Press, 1987.

Alain Merot, *Poussin*, Thames & Hudson, 1990.

John Rewald, *Cézanne: A Biography*, Thames & Hudson, 1986.

Pierre Rosenberg, *Chardin*, Prestel, 1999,

Meyer Schapiro, *Paul Cézanne*, Harry N. Abrams, 1965.

Edward Snow, *A Study of Vermeer*, University if California Press, 1994.

Richard Verdi, *Nicolas Poussin*, Royal Academy of Arts, London, 1995.

CHAPTER FOUR

Dan Cruickshank (ed), *Architecture: The Critics' Choice*, Aurum Press, 2000.

Christopher Day, *Spirit & Place*, Architectural Press, 2002.

Peter Fuller, *Theroia: Art and the Absence of Grace*, Chatto & Windus, 1988.

Suzi Gablik, *Has Modernism Failed?*, Thames & Hudson, 1984.

Suzi Gablik, *The Reenchantment of Art*, Thames & Hudson, 1991.

Mel Gouding and William Furlong, *Song of the Earth*, Thames & Hudson, 2002.

Tanya Harrod, *The Crafts in Britain in the Twentieth Century*, Yale University Press, 1991.

Robert Hughes, *Nothing If Not Critical*, Harvill Press, 1999.

Philip Jodido, *New Forms: Architecture in the 1990s*, Taschen, 1997.

David Pearson, *New Organic Architecture*, Gaia Books, 2003.

Roger Scruton, *The Intelligent Person's Guide to Modern Culture*, Duckworth, 1998.

John Tavener, *The Music of Silence: A Composer's Testament*, Faber & Faber, 1999.

Michael Tucker, *Dreaming with Open Eyes*, Aquarian/Harper SanFrancisco, 1992.

CHAPTER FIVE

Morris Berman, *The Reenchantment of the World*, Cornell University Press, 1981.
Peter Blake, *Form Follows Fiasco: Why Modern Architecture Hasn't Worked*, Boston, 1977.
Fritjof Capra, *The Turning Point*, Wildwood House, 1982.
René Guénon, *The Reign of Quantity* Penguin Books, 1972.
Lewis Mumford, *The Pentagon of Power*, Secker & Warburg, 1971.
Neil Postman, *Technopoly: The Surrender of Culture to Technology*, New York, 1992.
Kirkpatrick Sale, *Rebels Against the Future*, Quartet Books, 1996.
Val Williams, *Martin Parr*, Phaidon Press, 2002.

CHAPTER SIX

Thomas Berry, *The Dream of the Earth*, Sierra Club Books, 1988.
Marilyn Ferguson, *The Aquarian Conspiracy*, 1989.
Edward Goldsmith, *The Way: An Ecological World-View*, Green Books, 1996.
Willis Harman, *Global Mind Change*, Knowledge Systems, 1988.
Victor Papanek, *The Green Imperative: Ecology and Ethics in Design and Architecture*,
 Thames & Hudson, 1995.
Theodore Roszak, *Where the Wasteland Ends*, Faber & Faber, 1972.
Edward Whitmont, *Return of the Goddess*, Routledge & Kegan Paul, 1983.

CHAPTER SEVEN

David Abram, *The Spell of the Sensuous*, Vintage Books, 2002.
Fyodor Dostoevsky, *The Idiot*, Penguin Books.
Andy Fisher, *Radical Ecopsychology: Psychology in the Service of Life*, State University of New York
 Press, 2002.
Etienne Gilson, *The Arts of the Beautiful*, Dalkey Archive Press, 2000.
Robert Louis Jackson, *Dostoevsky's Quest for Form: A Study of his Philosophy of Art*,
 Yale University Press, 1966.
John Lane, *A Snake's Tail Full of Ants: Art, Ecology and Consciousness*, Green Books, 1996.
Thomas Moore, *Care of the Soul*, Harper Collins, 1992.
George Steiner, *Real Presences*, Faber & Faber, 1989.

Index